People

1000

BIGGEST MOMENTS
in POP CULTURE

1974-2011

Contents

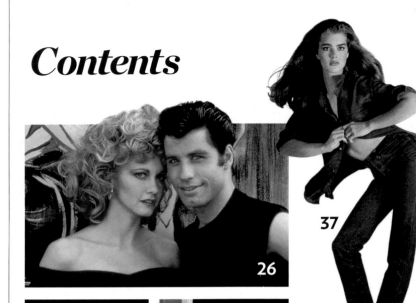

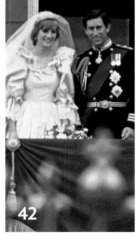

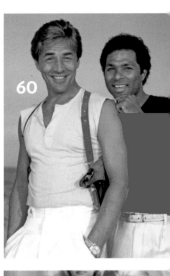

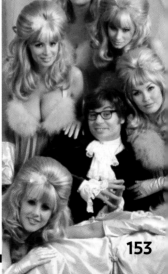

26

37

60

153

42

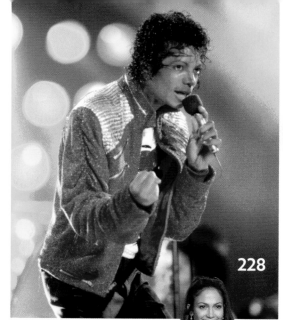

228

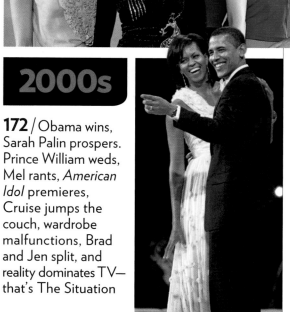

161

2000s

172 / Obama wins, Sarah Palin prospers. Prince William weds, Mel rants, *American Idol* premieres, Cruise jumps the couch, wardrobe malfunctions, Brad and Jen split, and reality dominates TV— that's The Situation

1990s

98 / *Friends* and *Seinfeld* thrive, grunge explodes, O.J. is acquitted, *Titanic* rises, Bill Clinton meets Monica Lewinsky, wands choose wizards, and the truth is out there (but the heart wants what the heart wants). It that your final answer?

176

224

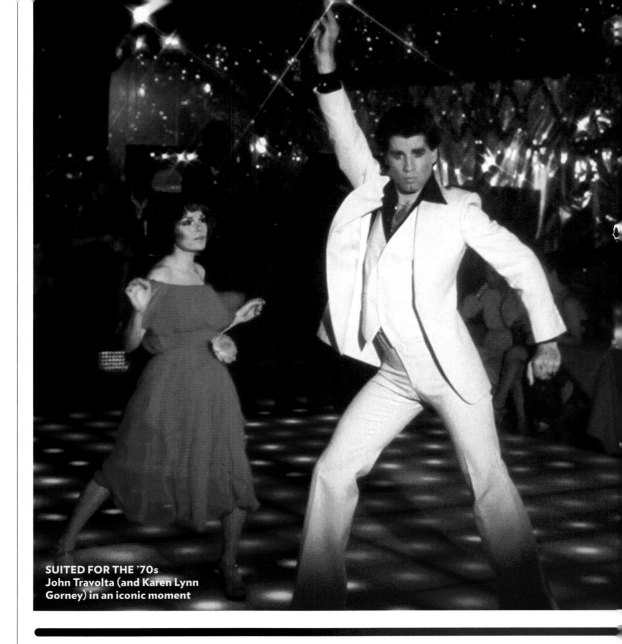

SUITED FOR THE '70s
John Travolta (and Karen Lynn
Gorney) in an iconic moment

POP
goes the culture

JUST WHEN YOU THOUGHT IT WAS safe to go back in the water. May the Force be with you. Pet rock, hanging chad. You like me; you really like me. SpongeBob, Chernobyl, Spuds McKenzie. I didn't inhale. If it doesn't fit, you must acquit. Ze plane! Ze plane! La vida loca. I wish I knew how to quit you. Slim Shady. Bennifer. Tsunami. Hammer pants. Yeah, baby! I'll be back. Every breath you take. Is that your final answer? No soup for you!

If you spent much of the past few decades awake, odds are you know some, most, even all of the above. And that leads to a helpful definition: Pop Culture, in the broad sense, is what gets talked about: from ads, fashion and silly TV moments to politics, scandals and life-changing news events. But it's not only what we talk about,

it also influences *how* we talk: the language, references and humor we use, certain the person we're talking to will understand.

And there's more of it, every year. Phrases and headlines that were unknown in January are, by June, part of the national vocabulary. On march the factoids, by the dozens, scores, hundreds.

Or, in the case of this book: one thousand, starting with 1974, the year PEOPLE began (Nixon resigns; "Marcia, Marcia, Marcia!"), and continuing to the present ("sexual napalm," Justin Bieber, President Mubarak ousted in Egypt).

How many do you know?

How many have you forgotten?

If you're like most people, you'll be amazed at how much you didn't know you knew.

Without further ado…let's review!

FOR THE **'70s**

turn
page

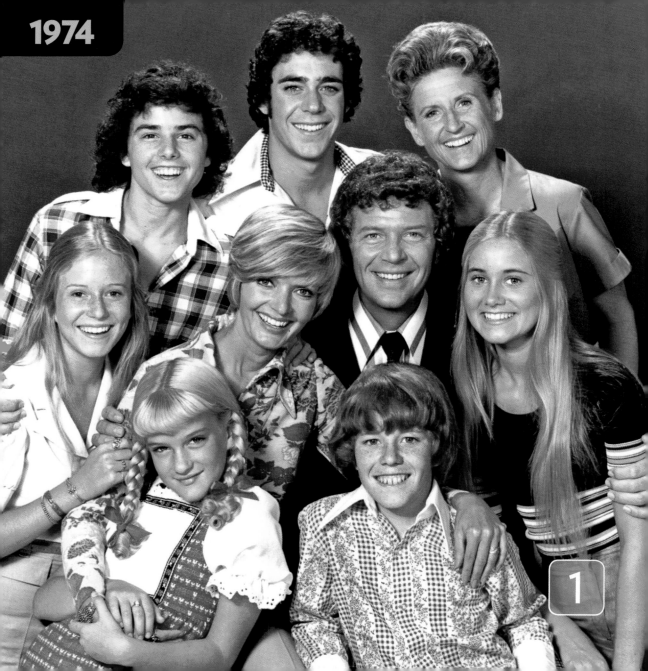

1974

1 / "Marcia! Marcia! Marcia!"
Gen-X touchstone *The Brady Bunch* closes shop after 117 episodes and, it's estimated, 117 valuable lessons

2 / Richard Nixon resigns
"To leave office before my term is completed is abhorrent to every instinct in my body," he says in his Aug. 8, 1974, resignation speech. But after a steady drumbeat of tawdry and/or criminal revelations following the Watergate break-in of June 17, 1972—including payoffs, a cover-up and White House tapes that even a Republican senator labeled "deplorable, disgusting and immoral"—it becomes clear to Nixon, the only President ever to resign, that the only alternative was impeachment

3 / "Forget it, Jake. It's Chinatown"
At the end of the modern noir classic *Chinatown*, private detective Jake Gittes (Jack Nicholson) is told to accept the fact that justice doesn't always prevail

4 / *Texas Chain Saw Massacre*
Horror classic begins. (Kids! Don't go out in the woods!)

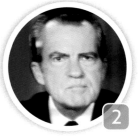

5 / Rumble in the Jungle
Seven years after losing his title for refusing to be drafted, Muhammed Ali, 32, defeats George Foreman in Zaire

6 / Fanne Foxe
Washington, D.C., police stop a car driving with its lights off and discover, inside, drunken Congressman Wilber Mills and stripper Foxe, a.k.a. "The Argentine Firecracker." She jumps out and dives into D.C.'s Tidal Basin; the very-married Mills, long called "the most powerful man in Congress," resigns as Chairman of the Ways and Means Committee

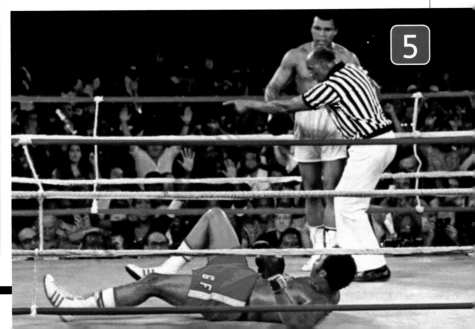

7 / *All in the Family*
reigns as America's No. 1 show—a position it will hold for five years

8 / **Beverly Johnson**
becomes the first African-American woman on the cover of *Vogue*

9 / **Mikhail's great leap**
On a trip to Canada with the Soviet Union's Bolshoi Ballet, Mikhail Baryshnikov, 26, defects. He quickly becomes a principal dancer with the American Ballet Theatre, and later its artistic director

10 / **Alexander Solzhenitsyn**
Nobel-winning author, who exposed secrets of the Soviet Union's past in *The Gulag Archipelago*, expelled from Soviet Union

11 / **CB radios**
are everywhere, good buddy

12 / **"I know it was you, Fredo. You broke my heart"**
After a fateful kiss, Michael Corleone (Al Pacino) tells his brother (John Cazale) that he knows who the family traitor is in *Godfather II*. Later, hapless Fredo will sleep with the (fresh water) fishes in Lake Tahoe, Nev.

13 / **OPEC ends oil embargo**
begun in '73 to protest U.S. support for Israel during the Yom Kippur war; the stoppage lasted six months

#1 *NEW YORK TIMES* BESTSELLER
ERICA JONG
fear of flying

"Fearless and fresh."—John Updike

14

14 / *Fear of Flying*
Erica Jong's novel about a woman indulging her sexual fantasies becomes a bestseller

15 / **Hank Aaron hits home run No. 715**
Slugger breaks Babe Ruth's 39-year-old mark in front of 53,775 Atlanta Braves fans and team mascot Chief Noc-a-Homa

16 / **"God's gonna getcha"**
Maude, starring Bea Arthur, begins

9

17 / **Evel Knievel jumps the Snake River Canyon almost!**

The famous motorcycle daredevil's rocket-propelled vehicle makes it halfway over the gorge; a parachute brings Knievel safely back to Earth

18 / **Karen Silkwood dies**

An activist and employee of Kerr-McGee's plutonium processing plant in Crescent, Okla., who claimed that unsafe conditions had exposed her to radiation, dies in a mysterious auto accident while on her way to meet a reporter. An investigation by the Atomic Energy Commission causes the plant to close for a couple of weeks. Meryl Streep will later star in a movie about Silkwood's life

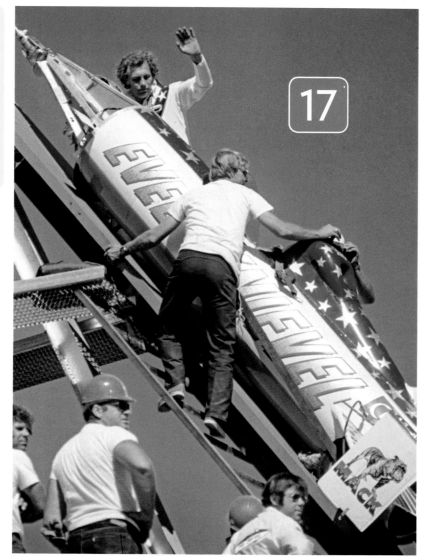

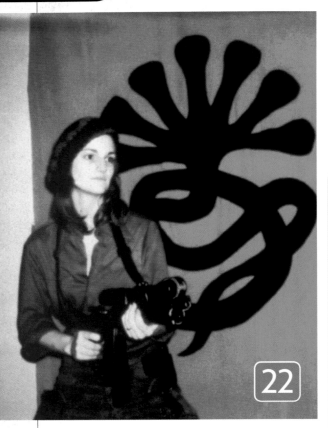

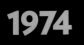

21 / Everybody was "Kung Fu Fighting"

It was "a little bit frightening/ but they fought with expert timing." Also, it became a hit novelty song

22 / Patty Hearst captured

The newspaper heiress, kidnapped in 1974 by the self-styled radicals who called themselves the Symbionese Liberation Army, later joined with her captors and, famously, participated in a bank robbery. A nationwide hunt ends with her arrest in 1975. She later claims that psychic and sexual abuse led her to join the SLA. She was sentenced to 7 years for armed robbery; her term was commuted by President Jimmy Carter after 22 months.

23 / The Total Woman

Author Marabel Morgan's 10-million seller claims it's "only when a woman surrenders her life to her husband, reveres and worships him and is willing to serve him, that she becomes really beautiful to him" and recommends, when he returns from a long day at work, that she wrap her naked body in Saran Wrap and greet him at the front door. Feminists across America have a collective coronary

24 / "Ah, sweet mystery of life, at last I've found you!"

Madeline Kahn discovers passion in Mel Brooks' *Young Frankenstein*

19 / The Towering Inferno

Campy disaster movie stars everyone from Paul Newman and Steve McQueen to Fred Astaire and O.J. Simpson

20 / Whip Inflation Now

In an attempt to tame galloping inflation of 11 percent annually, the government issues WIN ("whip inflation now") buttons

25 / **Dyn-O-mite moment**
Good Times' J.J. Walker, and his catchphrase, enjoy a blast of fame

26 / *The Six Million Dollar Man*
Lee Majors scores as an ex-astronaut who, injured in a crash, comes back as a semi-cyborg superagent

27 / *Happy Days* premieres

28 / **55 mph**
becomes the national speed limit, to conserve fuel

29 / **Ford pardons Nixon**
Criticized by many, newly installed President Gerald Ford says he did it to help the nation move past the Watergate scandal

30 / **Streaking the Oscars**
Nakedly exhibitionistic fad, popular on college campuses, reaches its peak when Robert Opal, 33, streaks the Academy Awards

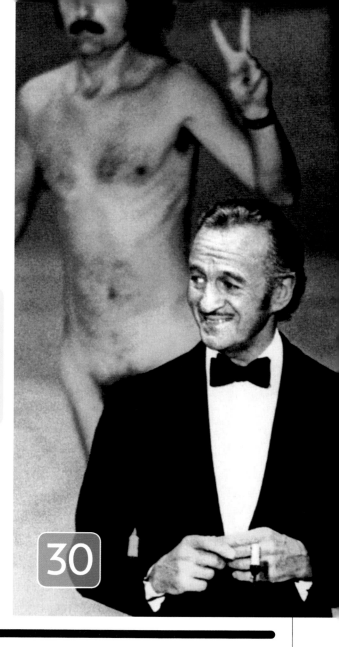

25

30

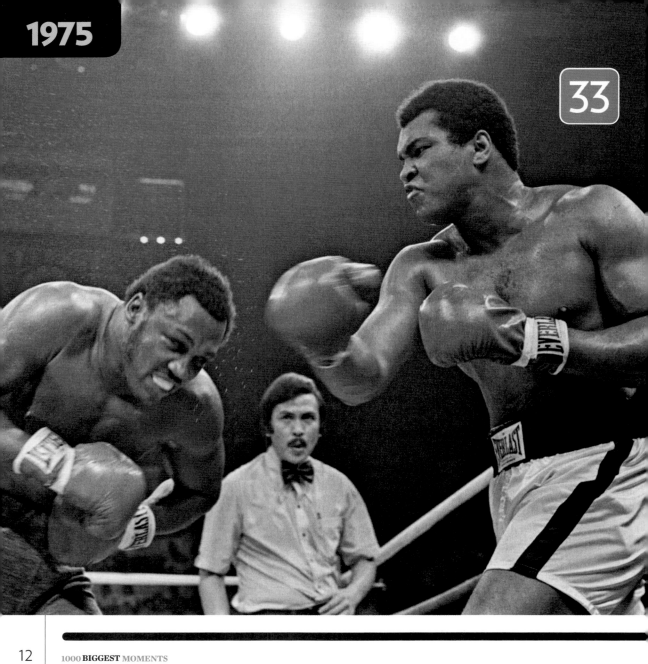

33

31 / **Pet Rocks rock America**

Fad "pets"— good at "stay," not so good at "roll over"—make inventor Gary Dahl a millionaire at 38

31

32 / **Fall of Saigon, April 30**

After years of combat and more than 58,000 American deaths, the last days of the Vietnam War are a sad and riveting spectacle of rooftop helicopter evacuations

34 / **Stagflation**

An economic perfect storm— high unemployment and rocketing prices— gets a big name

33 / **The Thrilla in Manila**

"Old Joe Frazier, I thought you was all washed up."
"Somebody told you wrong, pretty boy."

So went the taunts that opened round seven of one of the most thrilling, and brutal, matches in boxing history. Ali had derided Frazier as "ugly," "ignorant," a "gorilla"; Frazier, genuinely offended, vowed to "whip [Ali's] half-breed ass."

Frazier's trainer threw in the towel after 14 rounds, after both men had endured pain beyond belief. "I hit him with punches that would bring down the walls of a city," Frazier said later. "Lawdy, he's a great champion."

Ali, humbled, offered respect: "That's one helluva man, and God bless him"

35 / **"Love to Love You Baby"**

Donna Summer's classic disco anthem memorably simulates a journey to passion's peak 22 times in 17 minutes

36 / **Cher and her blond Cher-alike, Greg Allman, marry**

File for divorce days later, reunite, then split permanently

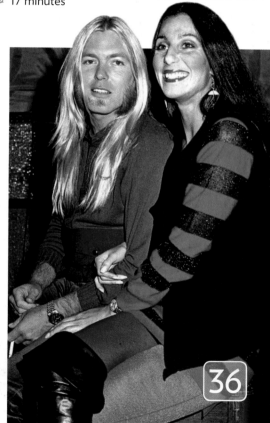

36

37

40 / "Ford to City: Drop Dead"
The *New York Daily News* sums up President Gerald Ford's response to New York City's request for financial help. Luckily, Treasury Secretary William Simon offers a solution: "We're going to sell New York to the Shah of Iran. It's a hell of an investment"

41 / *Born to Run*
Bruce Springsteen releases a classic

42 / Bay City Rollers
Girls go nuts for plaid-clad Scot lads

43 / "Live from New York, it's *Saturday Night*!"
Saturday Night Live debuts with a sketch about an English instructor trying to teach his student to say, "I would like to feed your fingertips to the wolverines"

37 / "I'd rather be dead than sing 'Satisfaction' when I'm 45"
Mick Jagger, 33, speaks too soon

38 / *One Flew Over the Cuckoo's Nest*
Playing the sane man in a mental ward will bring Jack Nicholson his first Oscar

39 / Jimmy Hoffa disappears
The gruff labor legend heads for lunch with a mobster and is never seen again

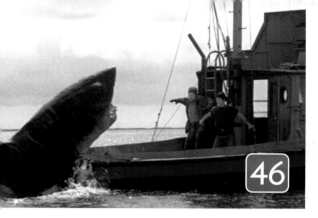

46

44 / Liz and Dick II
Larger-than-life lovers Elizabeth Taylor and Richard Burton—whose marriage finally crashed, after 10 years, in 1974—call the calling-off off and marry again (it lasts, alas, nine months)

45 / Starsky & Hutch
Buddy cops make a hit for ABC

46 / "You're gonna need a bigger boat"
Jaws earns over $470 million and stokes fear of sharks and ominous cello music

47 / Mood rings,
whose liquid crystals change color with body temp, are a monster fad

48 / Squeaky Fromme and Sara Jane Moore
Seventeen days apart, two women try to assassinate President Gerald Ford. Fromme, an associate of Charles Manson's, served 34 years and was paroled in 2009; Moore, released in 2007, later told *Today*'s Matt Lauer, "I am glad that I didn't kill [Ford], but I don't regret trying"

49 / Sonny and Cher's divorce
becomes final

50 / Francisco Franco dies
Europe's last fascist dictator ruled Spain for 36 years

51 / Rocky Horror Picture Show
Made for $1.2 million, transsexual Transylvanian cult hit will earn more than $140 million

52 / Welcome Back, Kotter premieres
John Travolta—pre-*Saturday Night Fever*, pre-*Grease*, pre-*Urban Cowboy*—finds fame as hood-with-a-heart Vinnie Barbarino

53 / est
Thousands attend psychoguru Werner Erhard's seminars hoping to "get it." Skeptics wonder if "it" actually exists

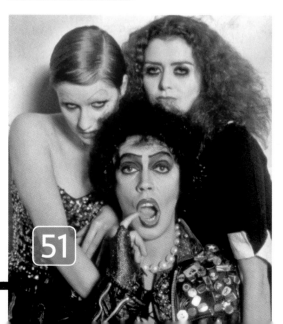

51

54 / Perfect 10
Romanian pixie
Nadia Comanici
enchants the world by
scoring a perfect 10
seven times—the
first ever awarded in
Olympic gymnastic
competition

55 / Bruce Jenner
wins the Olympic
decathlon

56 / "Yo, Adrian!"
Rocky KO's audiences,
Sylvester Stallone
becomes a star

**57 / "You talkin'
to *me*?"**
Taxi driver Travis Bickle
(Robert DeNiro) talks
tough to the mirror

**58 / Mark "The
Bird" Fidrych**
Detroit pitcher talks to
baseballs, manicures
the mound, rejects balls
he believes have "hits
in them"—and becomes
one of the game's
biggest stars

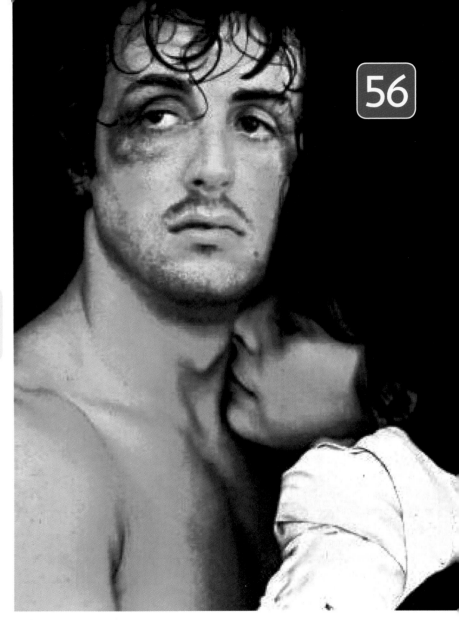

56

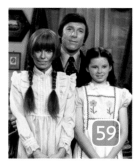

59 / *Mary Hartman, Mary Hartman*
Soap parody has a huge following—and, of course, an Evil Twin (Martin Mull as Garth—not to be be confused with Barth—Gimble)

60 / Farrah Hair
After *Charlie's Angels'* Sept. 22 premiere, Farrah Fawcett, 29—all leonine hair and Panavision smile—becomes a national obsession. "Any time you have a hairstyle that makes you feel very womanly and sexy, it will take over the world," says her stylist José Eber. "And in that particular case it did"

61 / "I'm mad as hell and I'm not going to take it anymore"
Anchorman Peter Finch goes messianic in *Network*

62 / *Laverne and Shirley* debuts
The *Happy Days* spin-off, starring Penny Marshall and Cindy Williams, becomes America's No. 1-rated sitcom

63 / Elizabeth Taylor weds Senator John Warner
For Taylor, marriage No. 6 lasts nearly six years

64 / Frog love
Jim Henson's Muppets make their prime-time television debut; pulchritudinous Miss Piggy ("My beauty is my curse!") is anything but ambivalent about the amphibian of her dreams, Kermit

65 / *Hotel California*
The Eagles' mellow sound offers a disco antidote

66 / *Frampton Comes Alive*
Power-pop poster boy has the fastest-selling live album to date

67 / Chairman Mao dies
China less red

68 / Earl Butz
After telling a stunningly racist "joke" about blacks and "loose shoes," America's Secretary of Agriculture is forced to resign

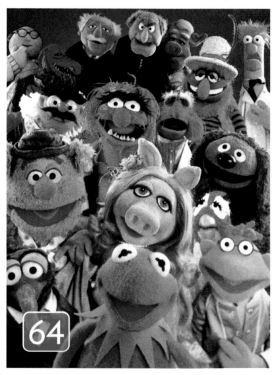

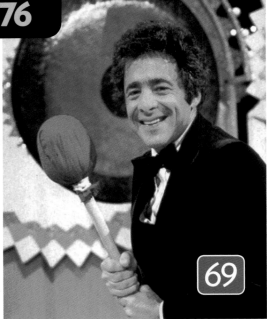

69

69 / *The Gong Show*
Count Banjula—who plays a banjo while hanging upside down—and a zillion other odd-lot acts find their time to shine

70 / Howard Hughes dies
Once a daredevil pilot who dated movie stars, the billionaire dies an eccentric recluse, his 6′4″ frame weighing barely 90 pounds

71 / Entebbe
A daring Israeli raid rescues 103 hostages held aboard a hijacked jet in Uganda. One commando dies: Jonathan Netanyahu, older brother of Benjamin, now Israel's prime minister

72 / "Me Decade"
Tom Wolfe, in a *New York* magazine article, names an era

73 / "I can't type. I can't file. I can't even answer the phone"
Piqued that she wasn't invited to the wedding of powerful congressman Wayne Hays (D-Ohio), Elizabeth Ray, 32, tells the *Washington Post* that the only requirement of her $14,000-a-year job on his staff is to have sex with him. Adds the wannabe actress: "[I've] been giving Academy Award performances once a week for two years." Hays, 65, resigns from office

74 / TMI from America's Commander-in-Chief
"I've looked on a lot of women with lust," President Jimmy Carter says in a *Playboy* interview. "I've committed adultery in my heart many times"

75 / ABBA's bouncy Europop conquers Earth
Quartet becomes, briefly, the most profitable corporation in Sweden

76 / Apple sells its first computer
for $666.66

77 / The Hamill Wedge,
'do made famous by America's Olympic skating medalist, offered a cropped option to Farrah hair

77

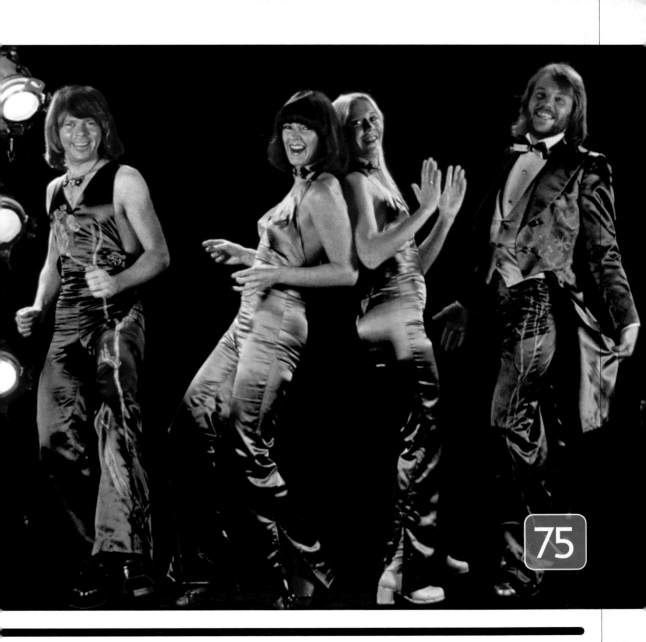

75

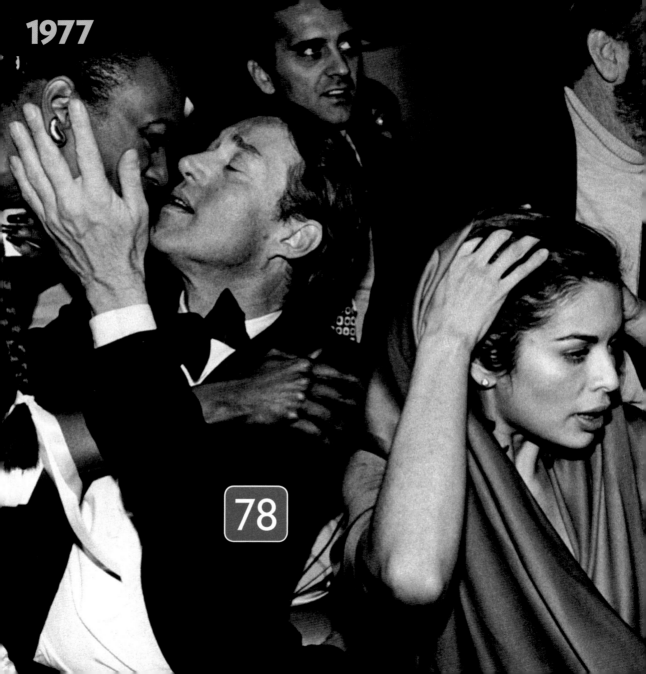

78

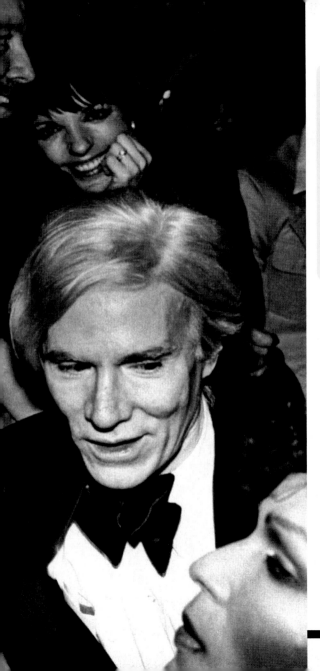

78 / Studio 54
Entrepreneurs Steve Rubell and Ian Schrager mix coke, music and velvet-roped exclusivity to create the party palace of the disco era. A "celebrity wrangler" is hired to lure stars to the scene and paid per perceived value (Alice Cooper: $60; Sylvester Stallone: $80)

79 / Elvis dies, Aug. 16
The King expires in his Graceland bathroom, his body showing more than a trace of the 12,000 pills his doctor had prescribed to Presley and his entourage in the preceding 20 months. "[Elvis] had a self-destructive vein," says longtime girlfriend Linda Thompson, who left shortly before the end, "and I couldn't bear to watch him self-destruct"

80 / "May the force be with you"
George Lucas founds an empire with a story-driven special-effects extravaganza that smacks pop culture in the forehead and makes it pay attention. One factoid among thousands: Harrison Ford beat out Nick Nolte and Christopher Walken for the role of Han Solo

81 / The Fonz
Henry Winker—playing *Happy Days* greaser-with-a-heart-of-gold—has his moment

82 / Billy Beer
President Jimmy Carter's down-home bro cashes in with self-branded brew

83 / Jiggle TV
Term for shows, like *Charlie's Angels,* whose attractions (to men) include action scenes of bikini'd or braless women

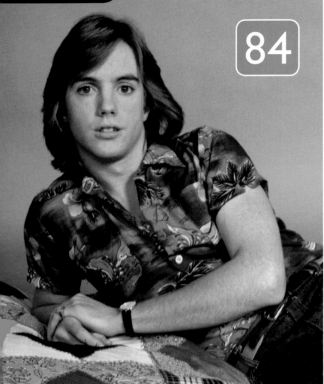

84

87 / "Stayin' Alive"
Australia's Bee Gees kick it up a few octaves and create a signature sound of the disco era

88 / "Well excuuuuse me!"
Steve Martin, 32, blows up

89 / *Annie Hall*
Woody Allen's love letter to New York makes Diane Keaton a star and her whimsical fashion sense a trend

90 / Son of Sam
New York City serial killer, who taunted police with letters signed "Yours in murder, Mr. Monster," is captured

91 / The Sex Pistols
Punk's peak? When they recorded "God Save the Queen" and Sid Vicious carved "Gimme a fix" into his chest

84 / (Sigh!) Shaun! (Sob!)
The teen idol, wrote a critic, "can provoke riotous rites of weepy nubility every time he bats his well-turned eyelashes." Kids: Think blond Bieber in bell-bottoms

85 / *Smokey and the Bandit*
Good ol' megahit stars Burt Reynolds as (metaphorically speaking) the Roadrunner and Jackie Gleason as Wile E. Coyote

86

92 / *Saturday Night Fever*

Disco's *Citizen Kane* makes white suits (briefly) hip and John Travolta a megastar. He adapts well. "God, if somebody is not going to live life to the fullest," he asks, en route to acquiring three planes, a Rolls and a ranch, "why did you want it?"

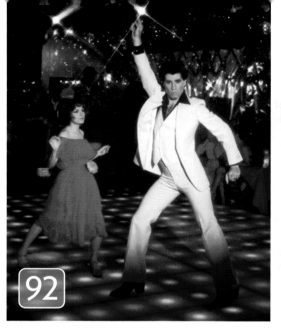

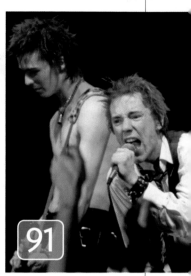

93 / *Roots*

ABC shoots a miniseries about slavery, gets cold feet, decides to burn it off on eight consecutive nights—and creates a once-in-a-generation phenom

94 / *Close Encounters of the Third Kind*

Steven Spielberg's meet-the-ET's hit grosses $300 million. Factoid: The tiny aliens were played by 6-year-old girls in rubber suits

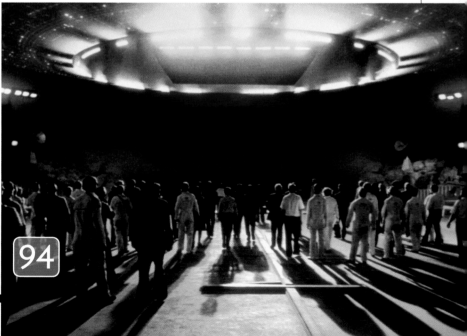

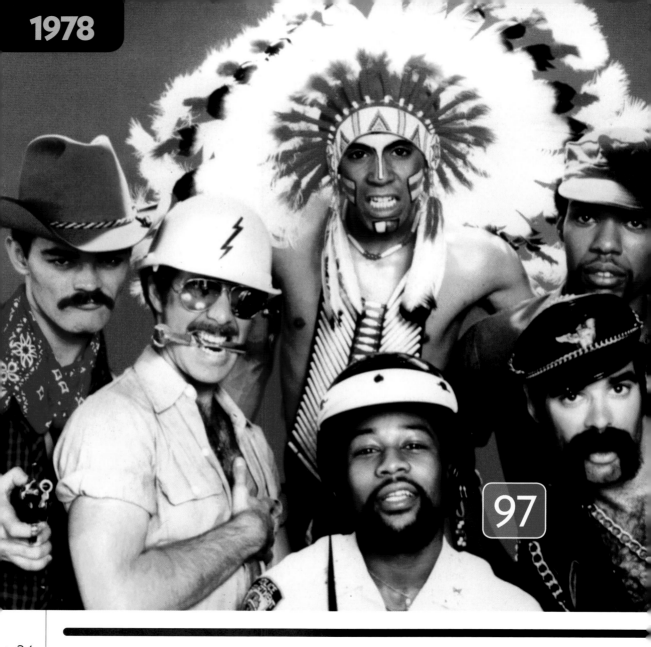

97

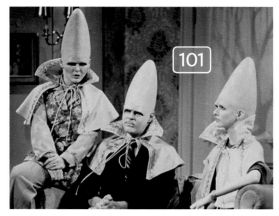

101

95 / "Just when you thought it was safe to go back in the water ..."
Jaws 2 has a killer marketing tag line

96 / Louise Brown, the world's first "test tube" baby, is born in England

97 / Macho, macho men
Village People (left, in one of many eventual iterations) release "Macho Man" and "Y.M.C.A."; America goes to (high) camp

98 / "Know when to hold 'em, know when to fold 'em"
Kenny Rogers has his biggest hit with "The Gambler"

99 / Princess Caroline marries playboy beau Phillippe Junot

100 / "Food fight!"
The signal for cafeteria mayhem in *Animal House*, the frat-boy classic that also includes the advice "Fat, drunk and stupid is no way to go through life, son"

101 / "We're from France"
Beldar, Prymaat and Connie—*Saturday Night Live*'s alien Coneheads—divert suspicion by explaining they're from out of town

102 / "Ze plane! Ze plane!"
Fantasy Island's Tattoo announces the arrival of Charo or other guest stars

103 / Hot tubs sprout everywhere

104 / Superman
Square-jawed Christopher Reeve scores as the man in tights

105 / "Nanoo! Nanoo!"
The exuberant cry of Mork (Robin Williams), *Mork & Mindy*'s intergalactic dork from Ork, echoes across the land

105

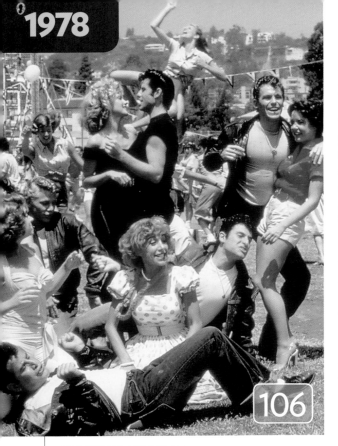

106

108 / **Hubert Humphrey dies**

109 / *Dallas* **premieres**
and the world can't get enough of oil baron J. R. Ewing's guiding philosophy: "Once you get rid of integrity, the rest is a piece of cake"

110 / **Garfield**
Cartoonist Jim Davis' hard-to-please feline lands in 850 newspapers and moves more than $15 million in trademarked merch

111 / **Aldo Moro**
Former Italian Prime Minister kidnapped and murdered by radical communists

112 / **Lisa Halaby**
26-year-old American marries Jordan's King Hussein, 42, becomes Queen Noor

113 / **Charlie Chaplin's body stolen**
Grave robbers try to extort money from his family. They're caught, and his corpse is recovered

114 / **Camp David Accords**
At a Jimmy Carter-sponsored negotiation, Egypt and Israel sign a peace treaty

115 / **Morris the Cat dies**
Fans mourn finicky 9 Lives pitchcat

116 / **Funky Tut**
Riffing on the craze sparked by U.S. exhibitions, Steve Martin, in pharonic dress, performs "King Tut" on *SNL* and sells a million copies

117 / **Karol Wojtyla**
becomes Pope John Paul II

106 / *Grease* **happens**
Ultimate high-school musical mesmerizes audiences, causing many not to notice that "senior" John Travolta is 24 and classmate Stockard Channing 34

107 / **"What choo talkin 'bout, Willis?"**
Tiny prime-time sensation Gary Coleman, 10, seeks elaboration from his brother, Todd Bridges, on *Diff'rent Strokes*

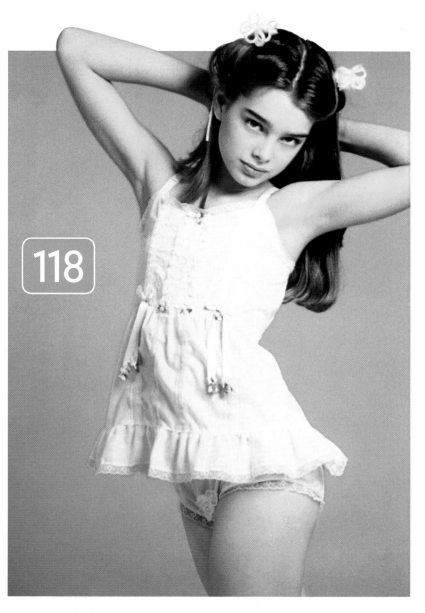

118

120

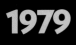

121 / Christie Brinkley launches a streak of three consecutive years as the cover girl on the SPORTS ILLUSTRATED swimsuit issue

123 / Pink Floyd releases *The Wall* Seminal teen-angst album will stay on *Billboard*'s top 200 chart for 125 consecutive weeks

125 / *Kramer vs. Kramer* Dustin Hoffman scores in a weepy about a divorced dad who unexpectedly finds himself with sole custody of his adorable son

126 / LaCoste Preppy trend takes hold; alligators everywhere

127 / Linda Ronstadt & Jerry Brown California's liberal governor, 41, and the hyperpopular "When Will I Be Loved" rocker, 32, outed as a couple

128 / Gloria Vanderbilt jeans are de rigueur on stylish derrières

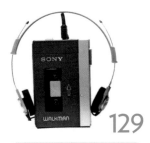

129

130 / "Da Ya Think I'm Sexy?" Rod Stewart suppresses modesty and finds disco success. Years later, looking back at pictures of himself in his Spandexed '70s glory, he jokes, "It's a fine figure of a man, you must admit"

131 / Gas lines Revolution in Iran causes fuel shortages and enormous hours-long lines at stations across the U.S.

132 / "My Sharona" A great riff makes The Knack No. 1 on Billboard's Hot 100 chart for six weeks straight. (In 2005 the song is found to be on President George W. Bush's iPod)

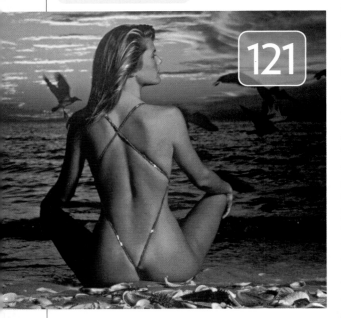

121

122 / ESPN makes its first broadcast on Sept. 7 (the initials stand for Entertainment and Sports Programming Network)

124 / *Nightline* ABC program begins as Iran hostage crisis coverage, morphs into 32-year—and still going—news show

129 / Ear food Sony introduces the Walkman cassette personal stereo, great-granddad of every iPod on the planet today

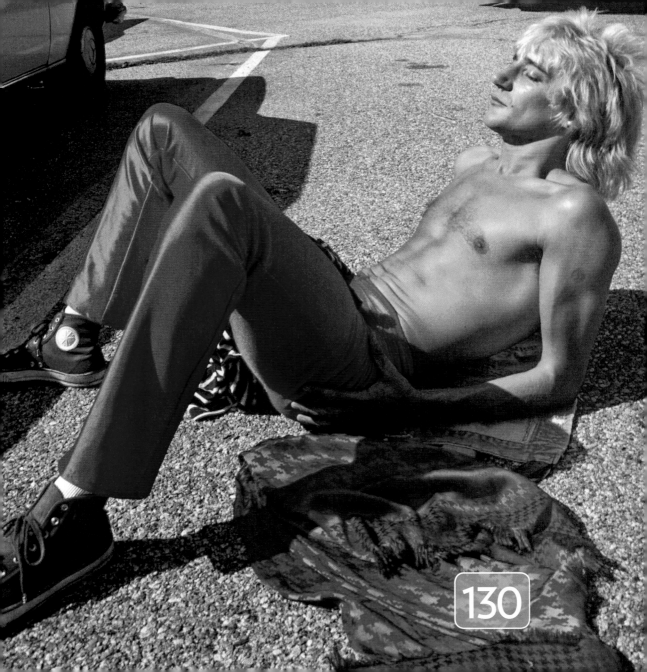

130

133 / Megan Marshack
Former V.P. Nelson Rockefeller dies of a heart attack in a town house with a woman not his wife. Marshack has never talked about that night

135

134 / Twinkie Defense
Popular name for a legal tactic used by a lawyer for Dan White, a former San Francisco supervisor who shot and killed his ex-colleague Harvey Milk and mayor George Moscone. The lawyer argued that White's mental state was diminished due to depression, and eating junk food was a factor

135 / Iran Hostages
Radicals attack the U.S. embassy in Tehran; 52 Americans are held hostage for 444 days

136 / Rhodesia
becomes Zimbabwe, after gaining independence

137 / *Sweeney Todd*
Unlikely musical about a homicidal Victorian barber and human-meat pies enchants Broadway

138 / "I love the smell of Napalm in the morning"
Gung-ho Lt. Col. Bill Kilgore (Robert Duvall) utters the most famous line in director Francis Ford Coppola's heart-of-darkness Vietnam epic, *Apocalypse Now*; Martin Sheen (right) stars as a Special Forces officer sent to assassinate a colleague (Marlon Brando) who's gone rogue

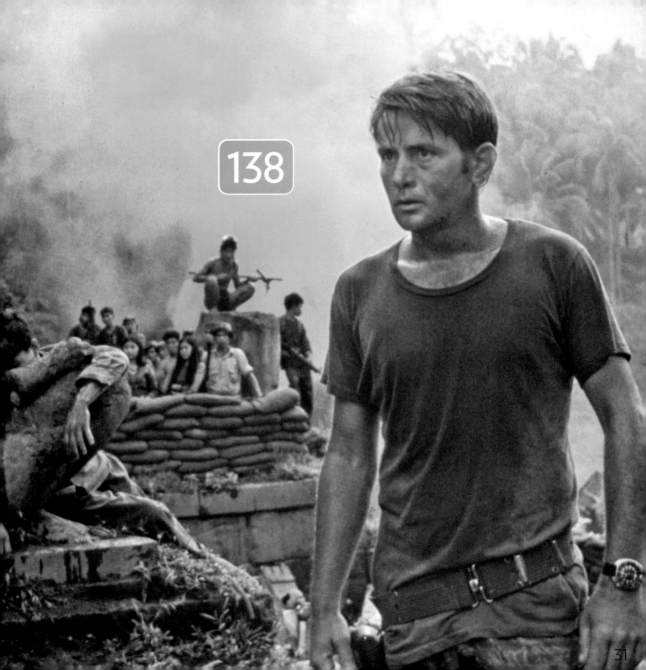

138

139 / John Wayne dies
The Duke, born Marion Robert Morrison, 72, wanted his epitaph to be "Feo, fuerte y formal," which he (loosely) translated from Spanish as "ugly, strong and dignified"

140 / Cornrows
Bo Derek, and her beaded hairdo, become stars in director Blake Edwards' *10*. The movie also does wonders for Dudley Moore and sales of Ravel's "Bolero"

140

141 / Margaret Thatcher
The Iron Lady is elected Prime Minister of Great Britain, the only woman to ever hold the job, and keeps it for more than 11 years. A close ally of Ronald Reagan, she fiercely pursued similar conservative agenda

142 / Mother Teresa
wins the Nobel Peace Prize

143 / Sid Vicious dies
Punk-music avatar and Sex Pistols bassist, awaiting trial for stabbing his girlfriend, Nancy Spungen, to death, succumbs to a heroin overdose in New York

144 / *The China Syndrome*
Jane Fonda's movie about a nuclear plant crisis gets a scary PR push from Three Mile Island (see No. 148)

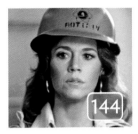

145 / Who concert tragedy
Eleven people are crushed to death outside the Riverfront Coliseum in Cincinnati. The city later bans festival seating and general admission

146 / Norma Rae
Feisty Sally Field organizes a union in a textile plant (and will win her first Oscar)

147 / Lord Mountbatten assassinated
The last Viceroy of India, uncle to Queen Elizabeth II's husband, Prince Philip, and mentor to Prince Charles, dies when a bomb set by the Irish Republican Army demolishes his fishing boat

148 / **Three Mile Island**

A chain of mishaps at Pennsylvania nuclear plant sparks fears the core will melt and spew radiation for miles. Engineers manage to end the days-long crisis but not the political fallout: Since then, no nuclear plants have been constructed in the U.S.

149 / **The Skylab is falling**

Citizens of Earth—with generous help from media hype—panic as a derelict, 77-ton NASA space station is about to crash through the planet's atmosphere and rain debris across a wide stripe of the globe. Luckily, most of the wreckage falls harmlessly into the Indian Ocean—though some drops near tiny Esperance, Australia, which fines NASA $400 for littering

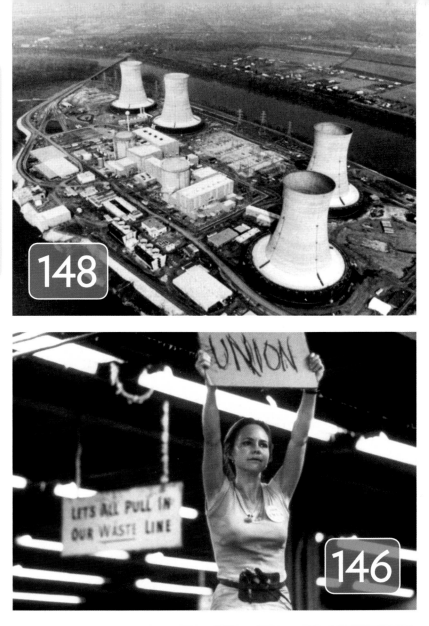

148

146

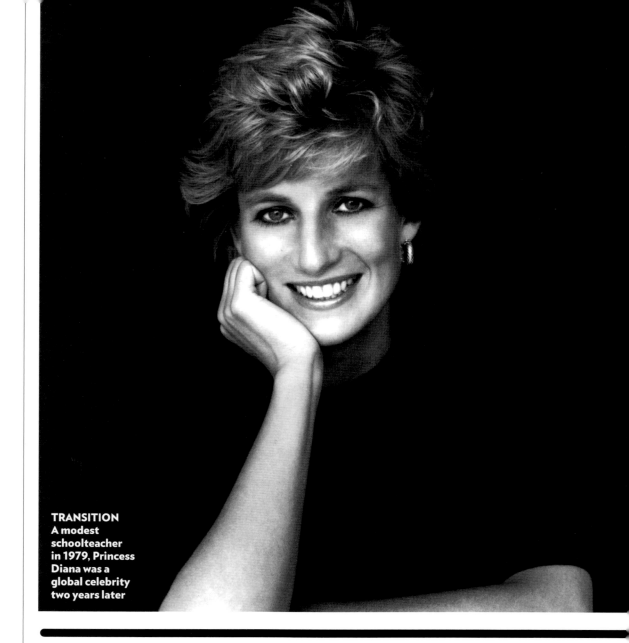

TRANSITION
A modest schoolteacher in 1979, Princess Diana was a global celebrity two years later

Michael moonwalked, the Berlin Wall fell, New Coke fizzled, E.T. phoned home, and in When Harry Met Sally, *director Rob Reiner's mom said, "I'll have what she's having." Through it all, you looked mah va lous*

'80s

150 / "Voodoo economics"
The memorable description of Ronald Reagan's economic policies is coined by George H.W. Bush, before he became Reagan's running mate

151 / Who shot J.R.?
Dallas's season-ending ploy becomes a global sensation as fans can't wait to find out who plugged evil oilman J.R. Ewing (Larry Hagman). More than 83 million Americans tune in to find the answer; in Turkey, parliament quits early so politicians can race home to watch. (P.S. Mary Crosby did it!)

152 / "No, *I* am your father!"
Luke Skywalker discovers, to his dismay, where to send that Father's Day card in *The Empire Strikes Back*

153 / *American Gigolo*
Richard Gere has a hit—and memorable shirtless moments—as a pay-for-playboy

154 / Christopher Cross
"Sailing" and "Ride Like the Wind" brand the singer's name onto America's collective cortex

155 / "Fame! I'm gonna live forever!"
Kids-with-a-dream film, based on New York's High School of the Performing Arts, becomes a hit, launching a song, a TV series, an off-Broadway show and, in 2009, a remake

156 / "You know what comes between me and my Calvins? Nothing"
Brooke Shields, 15, shills seductively in a jeans advertisement

151

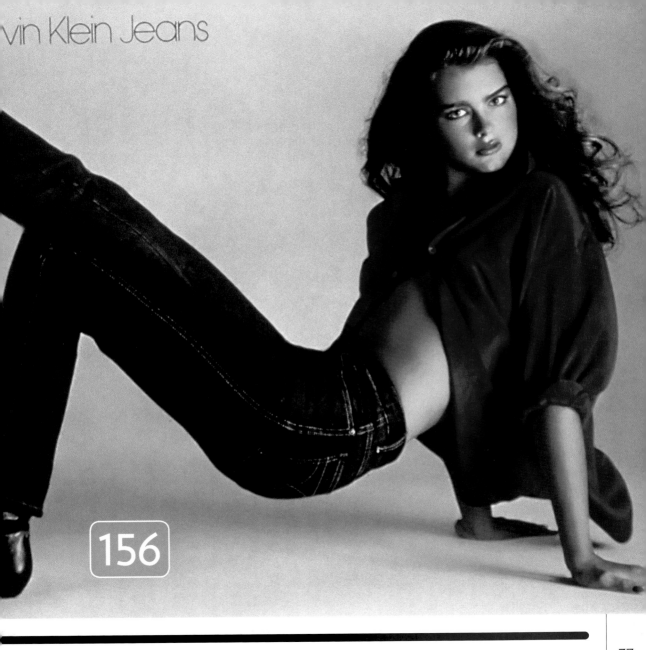

vin Klein Jeans

156

157 / The Miracle on Ice
In an astonishing upset, unheralded American amateurs defeat the Soviets and win Olympic gold

158 / "It's not too late to whip it. Whip it good"
Devo's S&M-on-the-farm video becomes an MTV staple and makes "Whip It" a hit

159 / Post-It Notes introduced in the U.S.
Nation's ability to remember things jumps appreciably

Don't forget!

159

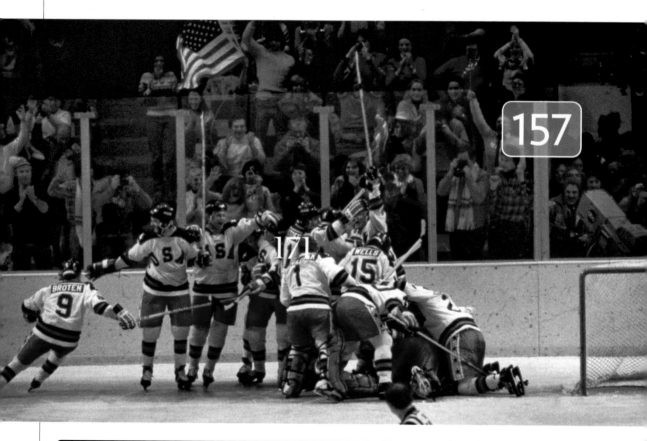

157

160 / "So I got that goin' for me, which is nice"
Bill Murray, as *Caddyshack* groundsman Carl Spackler, memorably describes hauling clubs for the Dalai Lama ("big hitter, the Lama") and the benefits promised to him in the afterlife

161 / *The Blues Brothers*
Jake (John Belushi) and Ellwood (Dan Aykroyd) expand their *SNL* skit into a soul-music movie hit

162 / CNN begins

163 / John Lennon dies
On Dec. 8 at 10:50 p.m., deranged gunman Mark David Chapman, 25, shoots the beloved Beatle outside his Manhattan apartment building. Chapman is sentenced to 20 years to life

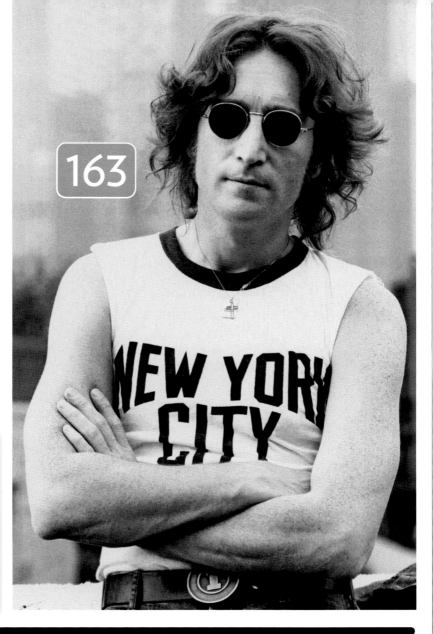

164 / *The Official Preppy Handbook*
Tongue-in-cheek guide to the world of pink and green, Mumsie, Pater, Buffie and Biff becomes a hit

165 / "Heeeere's Johnny!"
Jack Nicholson lets his maniacally homicidal side shine through in *The Shining*

166 / Ronald Reagan elected
The former movie star and California governor stomps Jimmy Carter, 44 states to 6

167 / Yuppies
Journalist Dan Rottenberg claims the first published use of the word in *Chicago* magazine

168 / Herman Tarnower murder
The doctor and author of the bestselling *The Complete Scarsdale Medical Diet* is shot and killed by his mistress Jean Harris, 56, the otherwise very proper headmistress of the Madiera School for girls in McLean, Va. She claims she had intended to kill herself and that, when he struggled with her for the gun, it went off accidentally. A jury—concluding, apparently, that four shots is *a lot* for an accident—convicts her of second-degree murder

164

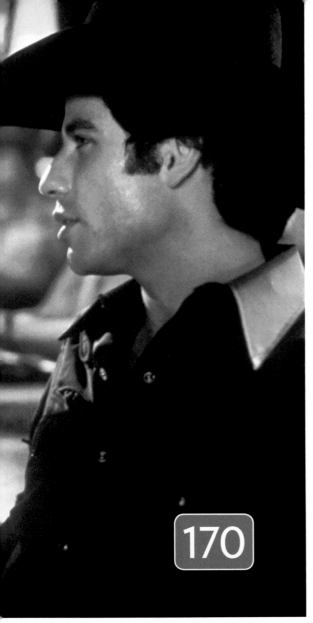

170

169 / ***Blue Lagoon***
Brooke Shields, continuing her streak of hey-she's-too-young-to-be-doing-*that* projects (*Pretty Baby*, Calvin Klein ads)—which, coincidentally, always seem to generate an exceptional amount of publicity—stars in a movie about two innocent children, stranded on an idyllic desert island, who grow into teenagers, wear not a lot and discover *strange feelings* for each other

170 / ***Urban Cowboy***
Saturday Night Fever in a honky-tonk; the hit film, starring John Travolta and Debra Winger, is all about tight jeans, two-steppin' and ridin' life like it's a mechanical bull (which, post-*Cowboy*, start appearing in bars across the country)

171 / **Mount St. Helens erupts** spectacularly, killing 57 and turning 230 square miles of Washington State into a moonscape

172 / ***Heaven's Gate***
Director Michael Cimino's budget-busting film about 19th-century Wyoming land wars becomes one of the great bombs in movie history, contributing to the eventual downfall of United Artists studios

173 / **"Looks like I picked the wrong week to quit sniffing glue"**
Airplane!, a spoof of disaster movies, earns more than $83 million, sparks a genre and turns "I speak jive" and "Do you like movies about gladiators?" into classic laugh lines

174 / "Here is the stuff of which fairy tales are made"

So spake the Archbishop of Canterbury. And, yea, all that's missing is a glass slipper as Lady Diana Spencer, 20, a former kindergarten teacher who once slept with Charles' picture by her bed, royally weds the 32-year-old heir to the British throne on July 29, 1981. Years later Di will reveal that she thought about backing out after learning of her husband's everlasting love for Camilla Parker Bowles, only to be told by her sister, "Bad luck, Duch, your face is on the tea towels!"

175 / "Let's Get Physical"

Let me hear your body talk: Olivia Newton-John has a monster hit

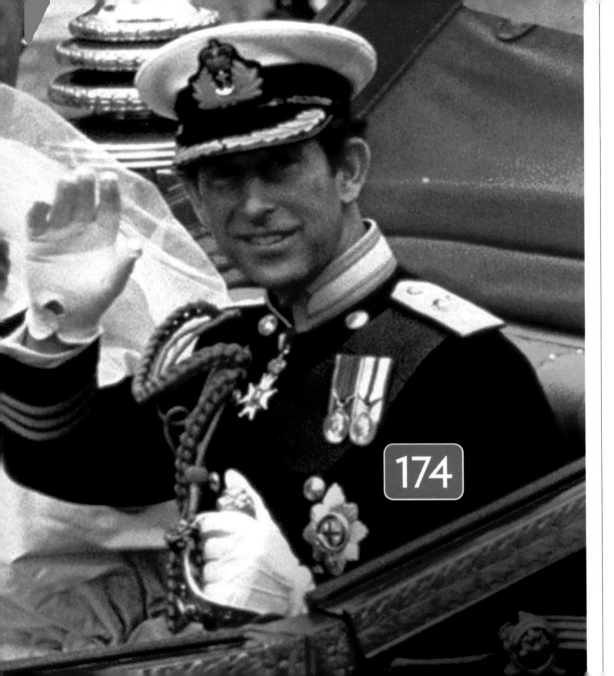

174

178

178 / Rubik's cube
Hungarian sculptor Erno Rubik's maddening puzzle turns the world into cubic rubes; a book offering the solution sells an astonishing 7 million copies

179 / "I shall alert the media"
Sir John Gielgud, as deeply droll butler Hobson, responds to spoiled rich guy Dudley Moore's announcement that he has decided to take a bath, in the comedy hit *Arthur*

176 / "Bette Davis Eyes"
Kim Carnes' ditty about hypnotic orbs is the song *du jour*, No. 1 for nine weeks and Grammy's Record and Song of the Year

177 / Natalie Wood dies
The Splendor in the Grass and *West Side Story* star drowns off Santa Catalina Island, Calif., where she had been sailing with her husband, actor Robert Wagner, and actor Christopher Walken. Apparently, Wood had fallen overboard at night while trying to move a dinghy. "I'm frightened to death of the water," she said in an interview weeks before. "I can swim a little bit but I'm afraid of water that is dark." Some witnesses reported hearing, at midnight, a woman scream, "Help me! Somebody help me!"

180 / Sandra Day O'Connor
becomes the first female U.S. Supreme Court Justice

181 / "Honey, I forgot to duck"
Lying in the ER after being shot by would-be assassin John W. Hinckley Jr., President Ronald Reagan reassures his wife, Nancy, he'll be okay by quoting boxer Jack Dempsey, who said the same thing to his wife after losing the 1926 heavyweight championship to Gene Tunney

182 / 101 Uses for a Dead Cat
Macabre cartoons by Simon Bond, dubbed by Time "the Charles Addams of ailurophobia," spend six months on *The New York Times* Best Seller list and cast the author into the cat lovers' litter box of shame

183 / Smurfs up!
The original blue man group, the Smurfs (or, as they are known in their creator's native Belgium, Les Schtroumpfs) hit their stride, scoring a cartoon show that is later joined by a Marvel Comics series and six TV specials

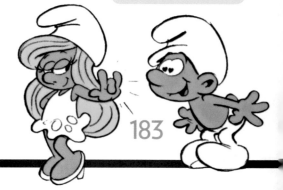

183

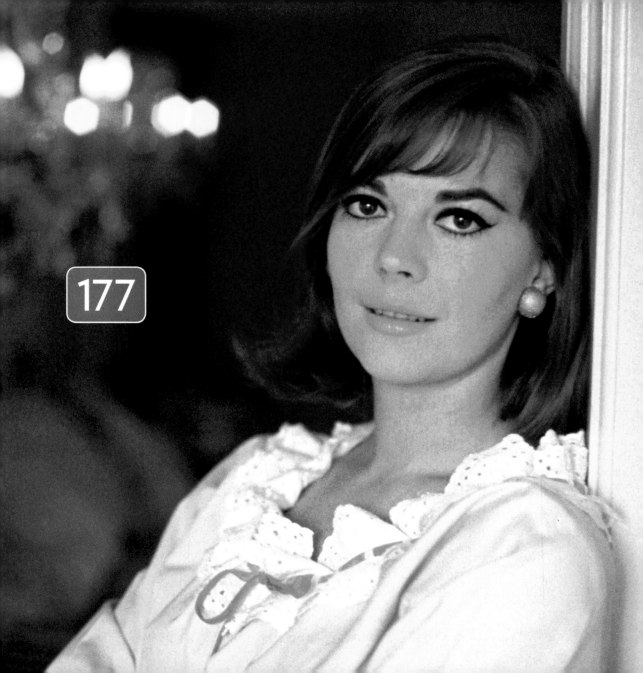

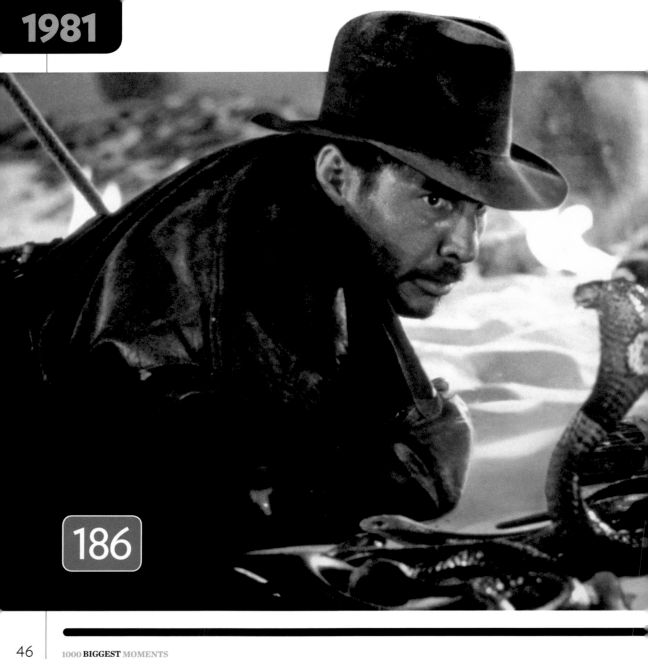

186

184 / The *other* big wedding

Charles and Di *who*? Millions of *General Hospital* fans (including Elizabeth Taylor, who guest-starred) make the wedding of Luke and Laura (Anthony Geary and Genie Francis) one of the most-watched shows in soap opera history

185 / "And that's the way it is"

Anchorman Walter Cronkite, "the most trusted man in America," signs off the *CBS Evening News* for the last time and turns the job over to Dan Rather

186 / "Snakes. Why'd it have to be snakes?"

Indiana Jones fights a phobia, and Nazis, in *Raiders of the Lost Ark*

187 / Jack Henry Abbott

Norman Mailer and others successfully campaign for the parole of felon Jack Henry Abbott, 37, whose book of prison writings, *In the Belly of the Beast,* has drawn critical praise. Six weeks later, told he can't use the employees-only restroom at a Manhattan restaurant, Abbott stabs a man to death

188 / Valerie Bertinelli weds Eddie Van Halen

189 / "Let's be careful out there"

Hill Street Blues Sgt. Phil Esterhaus sends the officers out with a daily benediction. The NBC drama, which looks at the lives of police on and off the beat, revolutionizes cop shows

190 / *Falcon Crest* begins

Nighttime TV gets even soapier

191 / Billie Jean King

Tennis legend King is outed when a former lover, Marilyn Barnett, demands title to King's Malibu beach house and half her earnings for the seven years she says they were together. A judge dismisses Barnett's case and calls her use of love letters from King "close to extortion." King calls the experience "shattering"

192 / Bulimia,

which derives from Greek words for "ox hunger," begins to enter the national vocabulary

193 / "They'rrrre Heeeeere!"
Poltergeist, written by Steven Spielberg and starring Heather O'Rourke as a little girl who talks to spirits through the TV, teaches a valuable lesson: Do *not* build a housing subdivision over a graveyard

194 / Farrah and Lee Majors divorce
Once, she insisted that her *Charlie's Angels* contract guarantee she would be home in time to cook him dinner. But her success, she said later, altered their relationship: "I'm not that dependent anymore." Their divorce follows a long separation and her increasing public involvement with Majors' former friend, actor Ryan O'Neal

195 / "Gag me with a spoon!"
Frank Zappa's 14-year-old daughter, Moon Unit, introduces Valspeak to the world in the novelty hit "Valley Girl"

196 / "Where everybody knows your name"
Cheers begins

197 / *Late Night with David Letterman*
launches; the host introduces world to the Velcro suit, the Monkey Cam and the joy of throwing bowling balls off a five-story building

198 / *Tootsie*
Dustin Hoffman has a signature hit as a frustrated actor who can't get arrested until he puts on a dress

199 / Vietnam War Memorial
Initially reviled by some as an insufficiently heroic "black gash," Maya Lin's modern granite sculpture, inscribed with the names of more than 58,100 dead and missing, soon becomes hallowed ground and one of the most-visited sites in Washington, D.C.

198

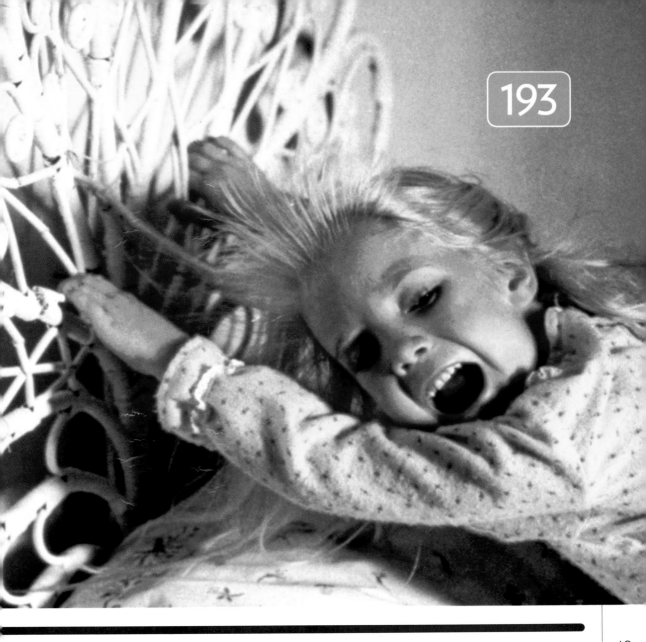

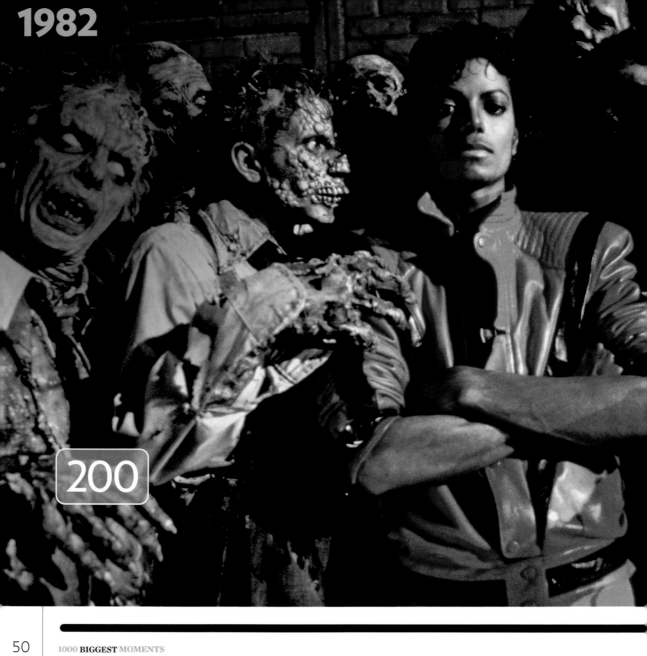

200

200 / *Thriller*
Michael Jackson releases the monumental album, packed with hits like "Billie Jean" and "Human Nature," that will become the bestselling of all time and make him a megastar

201 / *Real Men Don't Eat Quiche*
Bruce Feirstein's book, subtitled *A Guidebook to All That Is Truly Masculine*, condemns gold chains, yogurt and "meaningful dialogs" and stays on the bestseller lists for more than a year

202 / Pac Man
The arcade game—the name comes from Japanese slang for "chomp"—quickly eats up $1 billion in quarters in its first year, and even inspires a Top 10 novelty hit, "Pac Man Fever"

203 / Pulitzer divorce
Allegations of kinky sex and carefree coke, mixed with old money and society names, made the Palm Beach divorce of tycoon Peter Pulitzer, 52, and third wife Roxanne, 31, catnip to reporters. Responding to one particularly bizarre allegation, Roxanne admits that, yes, it's true she slept with a large trumpet, but only in hopes that "the dead would speak to me through it"

204 / Deely Bobbers
Goofy, alien-looking antennae, with little balls on the end, are selling at the rate of 10,000 a day

205 / Now and (almost) forever
Cats begins an 18-year run on Broadway

206 / "E.T., phone home"
Diminutive Extra Terrestrial makes a love connection with audiences, earns more than any movie of the decade: $434,974,579

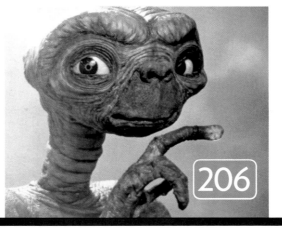

206

207 / John DeLorean,
developer of the futuristic, stainless steel DeLorean sports car, is busted for allegedly trying to fund his business via a cocaine deal. He is acquitted two years later. The business fizzles, but the DeLorean car becomes a star in *Back to the Future* and its sequels

208 / Falklands War
erupts. Argentina stakes a military claim to South Atlantic islands that Great Britain has claimed for 150 years. Before it's over, more than 900 are dead, including 368 Argentine sailors who are lost when Britain torpedoes the cruiser *General Belgrano*. Prince Andrew sees active service as a helicopter pilot

209 / Newman's Own

Paul Newman begins to bottle his Newman's Own salad dressing, the first in a line of foodstuffs that he will market, with all profits going to charity. By the time of his death in 2008, he will have donated more than $200 million to worthy causes. The key to success? "There are three rules for running a business," Newman and partner A.E. Hotchner wrote in their book *Newman's Own*. "Fortunately, we don't know any of them"

210 / Pritikin diet

The Pritikin Program for Diet and Exercise—which advocates straight-from-nature foods like fruits, vegetables, beans and brown rice—sells 10 million copies

211 / *Conan the Barbarian*

Ex-bodybuilder Arnold Schwarzenegger, sporting huge pecs, a nice hat and delightfully imitable dialog ("der lamentations of der vimen!"), becomes an action star

212 / *Family Ties,*

a sitcom about '60s liberals trying to raise their young Republican offspring, makes Michael J. Fox a star

213 / Gravity boots

Special footwear that allows users to hang upside down—the better, allegedly, to improve posture and blood flow to the brain—are a (very brief) trend

214 / Strawberry Shortcake

Little kids go nuts for a doll that smells like strawberries

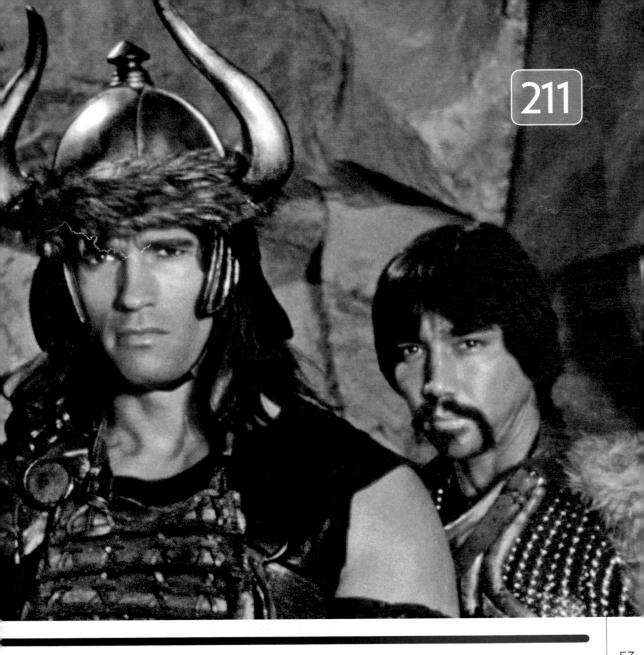

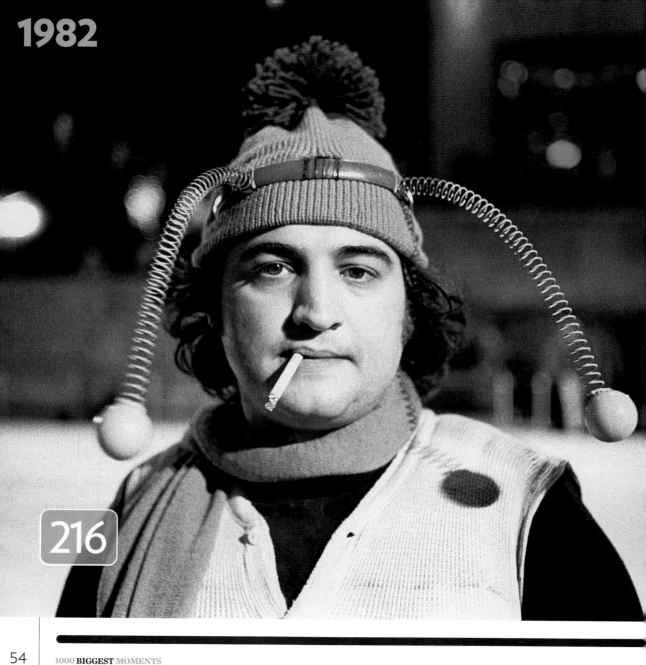

1982

216

215 / **"I'm Larry. This is my brother Darryl. This is my other brother Darryl"**
Newhart, starring, conveniently, Bob Newhart as a Vermont innkeeper surrounded by quirky locals, premieres and will run for eight years. In an inspired finale, he wakes up in bed, looks over and sees Suzanne Pleshette, his wife from his earlier *The Bob Newhart Show*. "Honey," he says, "you won't believe the dream I just had"

216 / **John Belushi dies**
The wildly talented comic actor's out-of-control life ends at 33 in sadly predictable fashion, of an overdose of heroin and cocaine

217 / **"Up Where We Belong"**
Audiences love *An Officer and a Gentleman*; Richard Gere gets the girl (Debra Winger); Louis Gossett Jr. gets an Oscar

218 / **Grace Kelly Dies**
after losing control of her car on a mountain road. Some 100 million will watch, via TV, the funeral of the Hollywood star who became a Princess

219 / **Jane Fonda's workout**
works out spectacularly for Jane Fonda, selling 17 million copies and helping to popularize the VCR

219

220 / **Poisoned Tylenol**
Seven die after taking Extra-Strength Tylenol laced with cyanide. The culprit will never be found; tamper-proof pill-bottle caps will torment users ever after

221 / *St. Elsewhere* **premieres**
and, by adding grit and following the nonwork lives of its characters, does for doctor shows what *Hill Street Blues* did for the station-house drama

222 / **The Little Prince**
Prince Charles and Princess Diana welcome 7 lb. 1 1/2 oz. Prince William, who, his father notes, "has the good fortune not to look like me"

223 / *The Big Chill*

Sensitive proto-yuppies face life postcollege; angst and sex ensue. Classic trivia: The dead guy in the opening credits—whose face is never seen—is played by Kevin Costner

224 / **Cabbage Patch Kids**

The Christmas gotta-have is a dough-faced doll that comes with "adoption" papers; shortages lead to toy-shop tussles and traumatized tots

225 / **Astronaut Sally Ride**

becomes the first U.S. woman in space

226 / **"Teflon President"**

Affable Ronald Reagan escapes blame for soaring national debt and other issues, earning a nickname that sticks

227

227 / **"Girls Just Want to Have Fun"**

The love child of Popeye and Betty Boop, singer Cyndi Lauper conquers the charts with an infectious hit and a controversial philosophical claim

228 / **Moonwalk**

No, not *that* one. This was the other-worldly moment when Michael Jackson unveiled his trademark time-and-space defying move on the *Motown 25* TV special, pushing Michaelmania into the stratosphere. Soon, a fevered *New Republic* writer will call him "bigger than Sinatra, Elvis, the Beatles, Jesus, Beethoven—all of them." Whew!

229 / **Wacky Wallwalkers**

Sticky, octopus-shaped hunks of soft gooey rubber that appear ambulatory as they slide down vertical surfaces are a bona fide fad with 240 million blobs sold

230

230 / **"I pity the fool"**

The A-Team's newly minted star Mr. T, sporting a 'frohawk and much, it seems, of Fort Knox, shows empathy

231 / **Pine tar!**

Invoking an obscure rule, Yankees manager Billy Martin gets a two-run ninth-inning home run by the Kansas City Royals' George Brett nullified for covering his bat in pine tar. Brett's furious protest in response lives forever in highlight reels

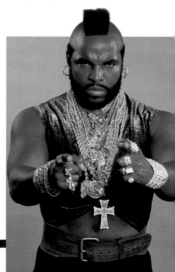

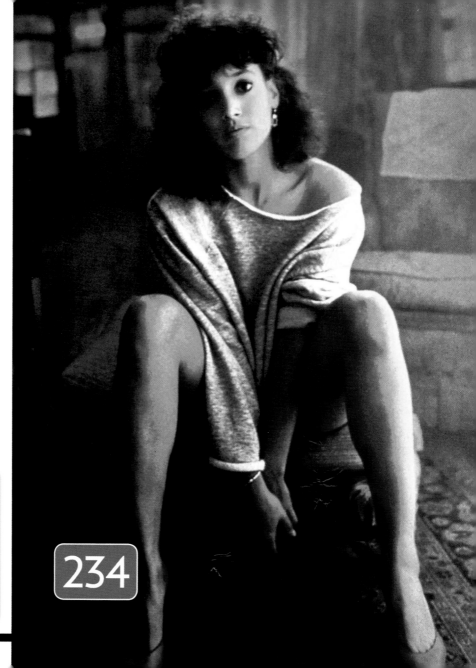

232 / "I have a black, I have a woman, two Jews and a cripple"
Interior Secretary James Watt's flippant remark about the diversity of a Federal coal-leasing commission leads to his resignation

233 / *Goodbye, Farewell and Amen*
*M*A*S*H* goes out with a smash after 11 seasons. The final episode, directed by star Alan Alda, is seen by 106 million, making it the most-watched show in TV history, a record that will stand until 106.5 million tune in the 2010 Super Bowl

234 / *Flashdance*
A blue-collar gotta-dance fable makes a star out of Yale freshman Jennifer Beals (and a trivia answer out of Marine Jahan, a body double with a hypnotic tush)

234

235 / Karen Carpenter Dies
The golden voice behind "We've Only Just Begun" passes away at 32 from anorexia—introducing many Americans to that word for the first time

236 / "Hey, Vern!"
Rubber-faced comic Jim Varney thrives on TV as pesky pitchman Ernest P. Worrell

237 / Korean Air flight 007
strays into Soviet airspace and is shot down without warning by its fighter jets, killing 269

238 / *Thicke of the Night*
Genial Canadian talk show host goes up against Johnny Carson, gets squashed

239 / "Beat It"
Michael Jackson's hit—with a riff by Eddie Van Halen—launches a hot video (and a great parody, "Eat It," by Weird Al Yankovic)

240 / Samantha Smith
Ten-year-old Mainer writes to Soviet Premier Yuri Andropov to express her fears of nuclear war and—surprise!—gets a personal note in reply, followed by an all-expense-paid trip for her and her parents to visit the Soviet Union, where she is hailed as a heroine of peace

241 / Beirut Bombing
In the bloodiest day for Marines since Iwo Jima, 241 American servicemen, stationed in civil-war-wracked Lebanon, die in a suicide bombing of their barracks

242 / The Gimli Glider
Owing to technical problems and miscalculations, Air Canada Flight 143, a Boeing 767 with 69 people aboard en route from Montreal to Edmonton, runs out of fuel halfway through its flight. In a remarkable feat of aviation, pilot Robert Pearson glides the 300,000-lb. aircraft to a safe landing at an abandoned WW II airfield

243 / "Every Breath You Take"
The Police bust out with a ubiquitous hit, spend nine weeks at the top of Billboard's Hot 100

244 / "The Evil Empire"
Reagan calls the Soviet Union as he sees it

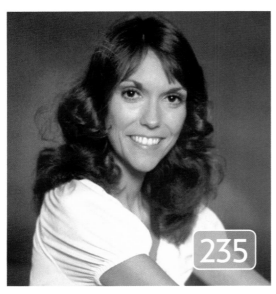

235

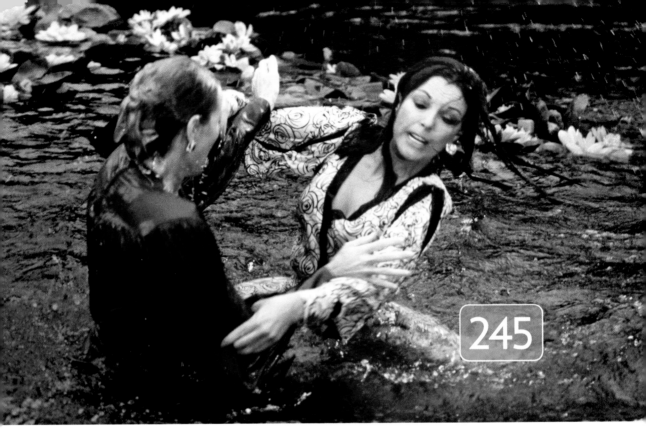

245

245 / Catfight!
Alexis (Joan Collins) and Krystle (Linda Evans) go at it in the lily pond, arguably the high-water mark of *Dynasty's* grip on America

246 / Hitler Diaries
Germany's *Stern* magazine pays more than $3 million for the right to publish Adolf Hitler's secret diaries, only to discover that the holy grail of historic finds is actually the work of a Stuttgart forger

247 / "Go ahead, make my day"
A dozen years after *Dirty Harry*, Clint Eastwood returns as .44 Magnum-carrying cop Harry Callahan in *Sudden Impact* and adds a new catchphrase to the canon

248 / Risky Business
Sliding memorably into frame, Tom Cruise sings Bob Seger's "Old Time Rock and Roll" in tighty-whities, becomes a star

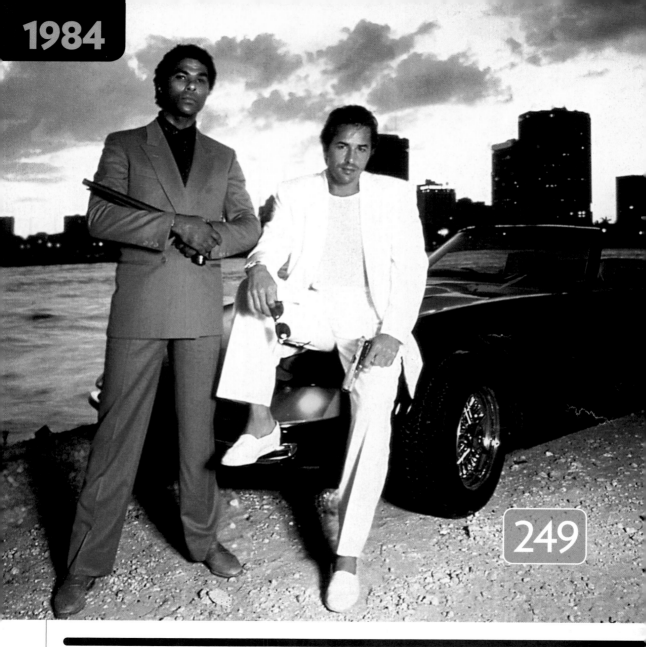

249

249 / *Miami Vice*
Famously conceived as "MTV cops," stars Don Johnson (Sonny Crockett) and Philip Michael Thomas (Ricardo Tubbs) nab crooks while wearing pastel and no socks

250 / Dr. Ruth
Blunt talk from a woman who looks like your dear old granny makes the 4'7" sex guru a sensation. Bonus fact: She claims she trained as an Israeli sniper and can assemble a submachine gun blindfolded

251 / "The numbers all go to 11"
Spinal Tap's Nigel Tufnel (Christopher Guest) explains why *his* amp is special

252 / Cowabunga!
Teenage Mutant Ninja Turtles take off

253 / "I'll be back"
Back-from-the-future cyborg Arnold Schwarzenegger makes an Austrian-accented promise and *The Terminator* a megahit

254 / The *Footloose* dance
When he's 90, Kevin Bacon will still be asked to re-create his apex terpsichorean moment

255 / Trivial Pursuit
Two Canadian newspapermen invent an insanely addictive game. An astonishing 20 million are sold this year

256 / "Champagne wishes and caviar dreams!"
Cheesy bluster and a plummy accent make Robin Leach's *Lifestyles of the Rich and Famous* a gawker's delight

257 / Beauty queen Vanessa Williams
becomes the first black Miss America—then, 10 months later, resigns her crown when years-old nude photos of her are published in *Penthouse* magazine

258 / "She had large dark eyes, a beautiful smile and a great pair of fins"
Splash, a whopper of a man-fish love story starring Tom Hanks and Daryl Hannah, lives up to its name at the box office

256

259 / Small Victory
Pint-size (4'9") dynamo gymnast Mary Lou Retton strikes gold at the Los Angeles Olympics

260 / Soul legend Marvin Gaye shot and killed
by his father during a violent domestic dispute

1984

261 / "Like a Virgin"
Madonna writhes on the MTV Video Music Awards stage in a wedding dress and a Boy Toy belt buckle, lighting up critics and—surprise!—sales

262 / Bernie Goetz
plugs four would-be muggers on a subway car in crime-ravaged New York City and is at once condemned as a vigilante and hailed as a hero

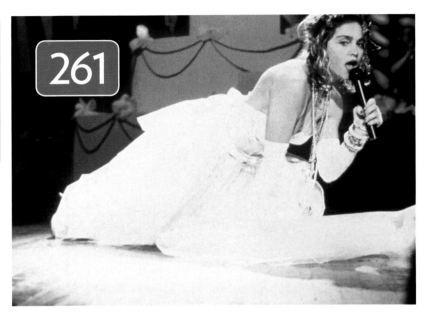

261

264

263 / "Born in the USA"
Once-stringy rocker Bruce Springsteen returns with pumped biceps and a sing-along chorus, takes country by storm

264 / "Where's the Beef?"
Chicago Grandma Clara Peller, 82, becomes famous in a Wendy's commercial

265 / "My fellow Americans, I'm pleased to tell you today that I've signed legislation that will outlaw Russia forever. We begin bombing in five minutes"
Not realizing he's sitting next to a live mike, Ronald Reagan makes an awkward joke that later takes some 'splaining

266 / Who ya gonna call?
When there's something strange in the neighborhood? *Ghostbusters* scares up otherworldly box-office profits

267 / The Cosby Show
revolutionizes TV with a simple idea: a sitcom about an African-American family in which the plots, and jokes, are virtually never about race. *Cosby* becomes the No. 1 show on television and runs for eight seasons

268 / Mayflower Madam
Descended from a very old-money family, Manhattanite Sydney Biddle Barrows, 32, tries to make some new money from the oldest profession, gets busted for running an escort service and enters the tabloid hall of fame

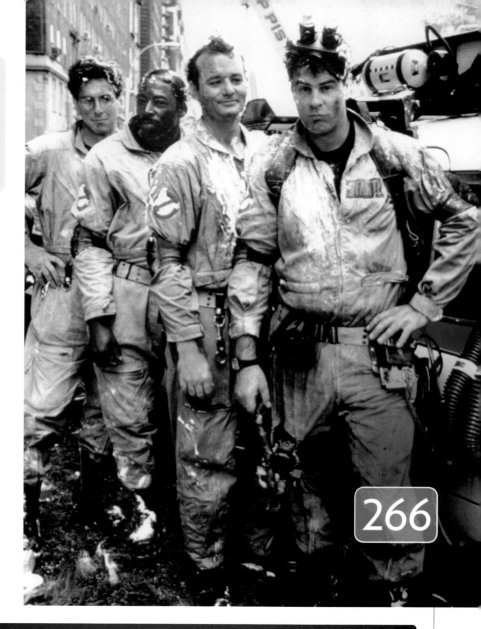

266

269 / Wild about Harry

Brits cheer the birth of 6-lb. 14-oz. Prince Henry Charles Albert David, second son of Princess Di and Prince Charles and third in line to the British throne

270 / "Can I borrow your underpants for 10 minutes?"

Sixteen Candles' protonerd Anthony Michael Hall asks Molly Ringwald a stunning question (and gets an even more stunning answer)

271 / "Wax on, wax off"

Obeying his sensei (Pat Morita), *The Karate Kid's* Ralph Macchio gets a lesson in polishing a car—and, though he doesn't know it, in martial arts

272 / Mary Decker and Zola Budd

In an agonizing moment, American Decker, 26 and a multi-world-record holder, tumbles to the ground after colliding with South African-born Budd, an 18-year-old phenom who runs barefoot, in the 3,000-meter final, destroying both women's hopes of a medal

273 / Gender chameleon

Flamboyant Brit George O'Dowd, better known as Boy George, and his band Culture Club score a hit with "Karma Chameleon"

274 / Richard Burton,

legendary actor (*Cleopatra, Becket*) and ex-husband of Elizabeth Taylor—twice—dies at 58

275 / "Do They Know It's Christmas?"

Hoping to raise money to fight famine in Ethiopia, Bob Geldof organizes leading musicians, including Bono, George Michael and Sting, and records and releases a single. "Do They Know It's Christmas?" raises over $10 million; Geldof gets a knighthood

276 / Break dancing

Crowds gather to watch hip-hoppers break out a new dancing style. Somewhere, Arthur Murray is scratching his head

277 / "Wake Me Up Before You Go-Go"

Wham!'s super-sunny Brit pop introduces George Michael and his micro shorts to U.S. audiences

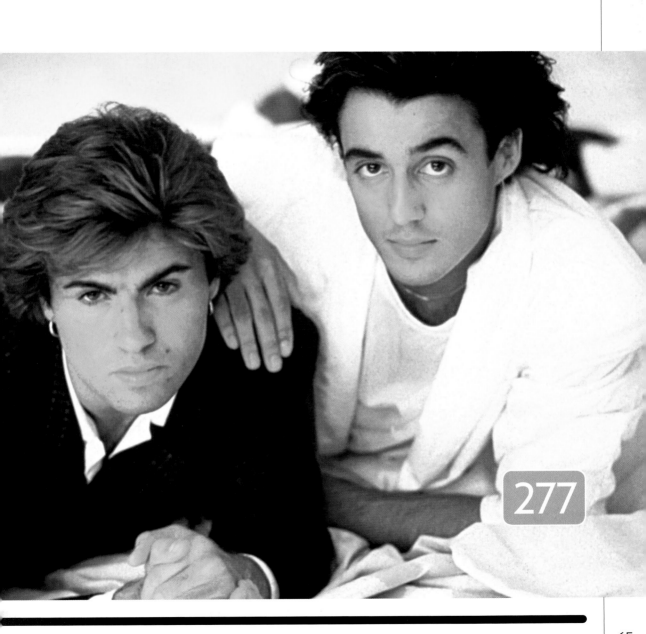

277

278 / *The Breakfast Club*
Through the course of a memorable Saturday stuck in detention, five teens—each a member of a different clique—learn a Valuable Life Lesson. The John Hughes film becomes part of Gen-X lore

279 / "We are living in a material world and I am a material girl"
Madonna has a new hit, and a nickname

280 / *Titanic rediscovered*
2.5 miles below the surface of the Atlantic, 370 miles off Newfoundland, 73 years after the great ship went down with 1,517 people aboard

281 / Home Shopping Network
goes national. Cubic zirconium shares soar

282 / *Back to the Future*
makes Michael J. Fox a movie star

283 / Madonna and Sean Penn wed
on a Malibu bluff before 200 invited guests (including Cher and Andy Warhol) and an armada of paparazzi helicopters. Says Penn later: "I consider myself very human and very moral, and I would have been very excited to see one of those helicopters burn and the bodies inside melt." Ah, love!

284 / Uptown wedding
Champagne corks pop and blue-collar schlubs everywhere take heart when Everyman rocker Billy Joel weds sun-kissed cover girl Christie Brinkley

285 / Brat Pack!
The term (applied to Rob Lowe and others) first appears in a *New York* article about privileged young actors

286 / "Please check your egos at the door"
An all-star cast, including Bruce Springsteen, Bob Dylan and Tina Turner, assembles to record "We Are the World," a "love song," as co-composer Michael Jackson called it, that sells 20 million copies and raises millions of dollars for African famine relief

287 / Bhagwan Shree Rajneesh
Indian cult leader and Rolls-Royce lover flees his Oregon commune after being indicted for immigration violations. A few days later, he and a few followers, known for their brightly colored robes, are captured in a Learjet on a North Carolina airstrip with $58,000 in cash and jewelry worth $1 million

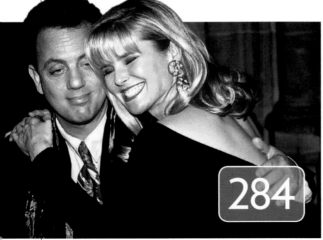

284

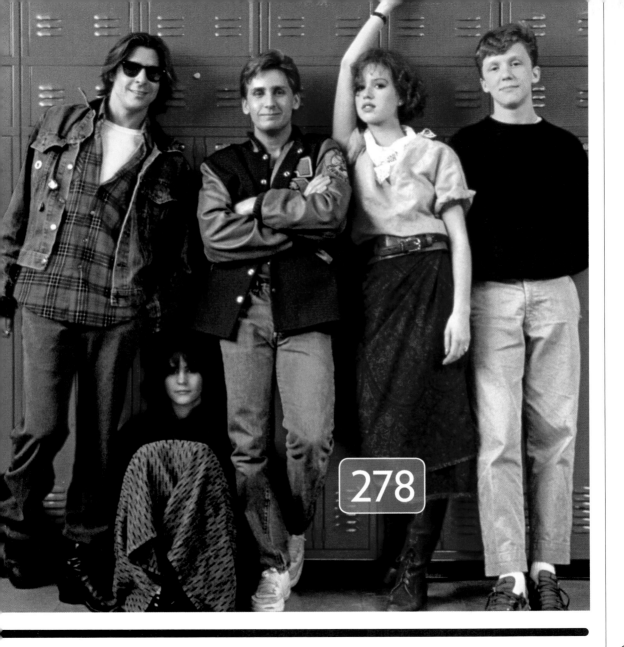

278

288 / The Refrigerator

Weighing in at 325 pounds, immovable Chicago Bears rookie lineman William "Refrigerator" Perry shows his footwork on the team's hit "Super Bowl Shuffle" video, then goes on to score a touchdown in the Bears' championship win

289 / David & Maddie

TV fans take to *Moonlighting's* screwball detectives Bruce Willis and Cybill Shepherd. The biggest mystery: Will they or won't they?

290 / Michael Jackson buys the Beatles' song catalog

for $47.5 million, outbidding an exasperated Paul McCartney

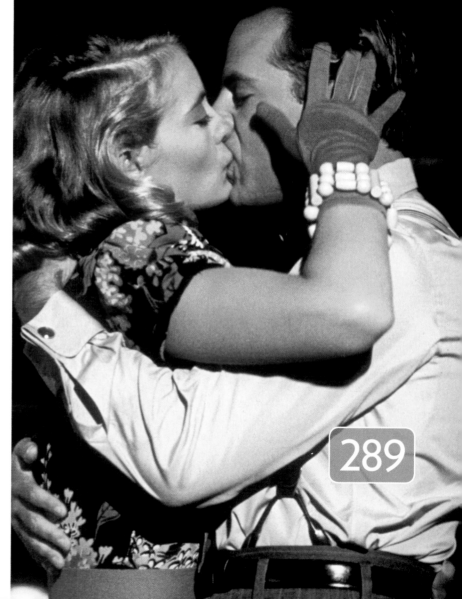

289

291 / New coke goes flat
In one of the great marketing fiascoes of all time, Coca Cola changes its formula and introduces New Coke—and people hate it. Three months later ABC News' Peter Jennings interrupts regularly scheduled programming to announce that—yes!— the old formula is coming back!

292 / Uli Derickson
TWA flight attendant is hailed as a hero for helping 152 passengers and crew survive a hijacking by Lebanese terrorists

293 / "You look mah-va-lous"
Billy Crystal's *Saturday Night Live* send-up of Ricardo Montalban spawns a catchphrase that stays

294 / Josef Mengele
The remains of Auschwitz's Angel of Death, long-rumored to be alive, are exhumed in Brazil and identified. He is believed to have drowned in 1979

295 / "What's included in every Yugo owner's manual? A bus schedule"
The humble Yugo, a $3,990 import from Yugoslavia, is hailed in the States as, alas, one of the "worst cars of all time"

296 / Manute not minute
Washington Bullets guard Manute Bol, a 7'6" Dinka tribesman and cowherd from the Sudan who once killed a lion with a spear, sets the NBA record for blocked shots by a rookie

297 / "My name is Larry Grossman …and I'm not wearing any pants!"
David Letterman, using a megaphone, makes the above announcement out of a window of the NBC building while taping his show. Bryant Gumbel, who is outside taping a *Today* segment, is very not amused. (Larry Grossman, at the time, is president of NBC News)

298 / Achille Lauro
The Italian cruise ship is hijacked in the Mediterranean by Palestinian terrorists, who eventually surrender, but not before Leon Klinghoffer, a wheelchair-bound Jewish American, is thrown overboard

299 / Pee-wee's Big Adventure
The story of a man-boy and the bike he loves becomes a cult-ish fave

300 / Tick-tock Trend
Colorful, accurate and inexpensive, newly-introduced Swatch watches become a practical fashion hit

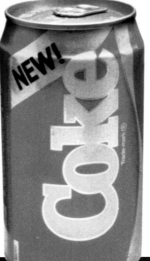

291

301 / Ten Things that Almost Rhyme with Peas is the subject of David Letterman's first-ever Top 10 list

302 / "I can't deny the fact that you like me!... You like me!" Sally Field goes all Gidgety as she accepts her Best Actress Oscar for *Places in the Heart*

303 / Blackened Redfish Chef Paul Prudhomme helps trigger a nationwide craze for a Cajun delicacy

304 / John A. Walker Jr. High-ranking naval officer pleads guilty to charges that he spied for the Soviet Union for 17 years

305 / Whitney Houston, age 21, explodes. The newcomer's debut album produces three No. 1 hits, including "How Will I Know" and "Saving All My Love for You;" the follow-up album contributes four more, among them "Didn't We Almost Have It All" and "I Wanna Dance with Somebody (Who Loves Me)." Seven consecutive No. 1's breaks the Beatles' decades-old record

306 / Rock Hudson dies The death of a veteran Hollywood star, known to a generation or two as a handsome romantic lead, focuses America's attention: Now *everybody* knows someone who died of AIDS

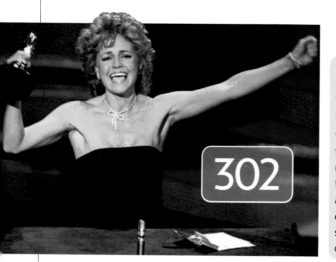

302

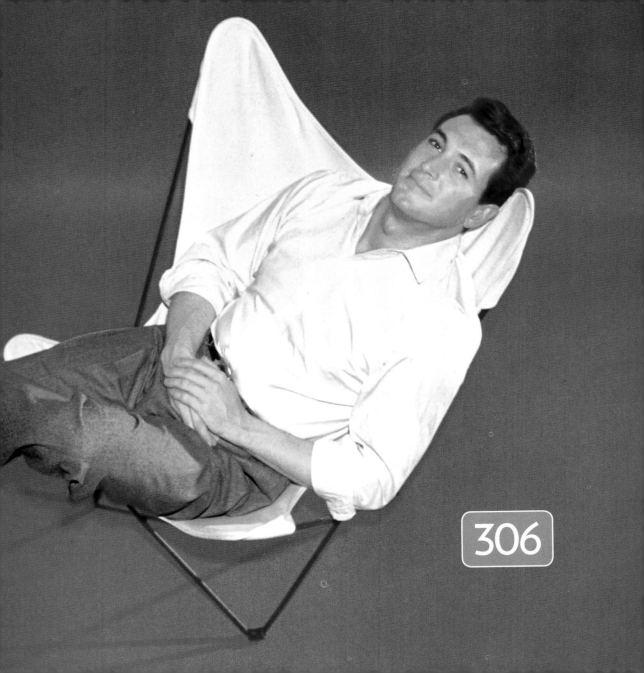

306

307 / "Yeah, that's it. That's the ticket"
Saturday Night Live's Jon Lovitz lies, pathologically

308 / "Bueller? Bueller? Bueller?"
Ferris Bueller's Day Off, director John Hughes' love letter to Chicago and hooky, makes Matthew Broderick a star

309 / Two attackers
slash New York model Marla Hanson's face. Her ex-landlord arranged the assault; the three men get jail time

310 / Tommy Lee & Heather Locklear wed
Someday, he says wistfully, "we'll be the coolest grandma and grandpa ... I'll still be a rock pig, and Heather will still be gorgeous"

311 / Patrick Duffy returns to *Dallas*
In perhaps the most desperate—or merely cynical—twist in TV history, *Dallas* resolves a season of wild plots by having Patrick Duffy's character, Bobby Ewing, return from the dead—the entire previous season has been just a dream!

312 / *L.A. Law* debuts

313 / Cary Grant dies
"I pretended to be a certain kind of man on screen," said the Englishman born Archibald Leach, the son of a factory worker. "And I became that man in life." Guided by a therapist, Grant took LSD more than 100 times

310

314 / Herb the Burger King Nerd
TV geek hawks broiled meat

315 / "Addicted to Love"
The look of the four models in Robert Palmer's classic video says not only "come hither," but "come hither *right now*"

316 / Yale marriage study
Citing a paper by Harvard and Yale researchers, a *Newsweek* cover story declares that a 40-year-old single woman is "more likely to be killed by a terrorist" than find a husband. The study is later found to be wildly flawed

317 / Ivan Boesky
Arbitrage zillionaire's secret revealed: He does it with inside info

318 / *Crocodile Dundee*
Down Under wonder wrestles crocs, mesmerizes audiences

319 / "Walk This Way"
If MTV is rock's castle, Run-DMC's remake of Aerosmith's "Walk This Way" is the battering ram that breaks down the gate and lets hip-hop run wild

320 / Camcorders catch on
Sayonara, Super 8!

321 / Al Capone's vault
Live on TV, newsman-hypemeister Geraldo Rivera breaks into what is supposed to be a long-sealed storage room and finds ... bupkis

322 / Hands Across America
An attempt to form a human chain across the U.S. draws 5.5 million participants, including Michael Jackson, R2-D2 and, in Memphis, 54 Elvis impersonators

323 / "Kenneth, what is the frequency?"
Newsman Dan Rather is attacked on a Manhattan street by a stranger with a bizarre demand. Eleven years later, his assailant is identified by a *New York Daily News* TV critic who published a photo of the alleged attacker, William Tager. Rather confirmed his identity. Tager is currently serving a 25-year prison sentence for a 1994 murder

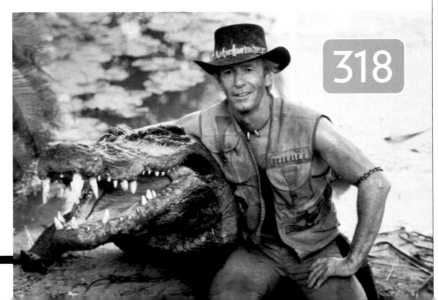

318

324 / **Baby on Board**

signs on car windows are followed by "Baby, I'm Bored" and other parodies

325 / **"Sledge-hammer"**

Peter Gabriel's stop-motion extravaganza sets the music-video-as-art-form standard

326 / *Challenger* explosion

Jan. 28, 1986: A faulty seal causes the space shuttle to explode 73 seconds after launch, killing all seven crew members

327 / **Wine coolers**

are the thing to drink, for people who need to drink the latest thing

328 / **Max Headroom**

Animated character becomes, briefly, a star and New Coke pitchman

329 / **What's an Oprah?**

In 1984 a little-known 30-year-old from Kosciusko, Miss., takes over *AM Chicago*. Within weeks she's trouncing chat god Phil Donahue. Two years later Oprah Winfrey is nationwide

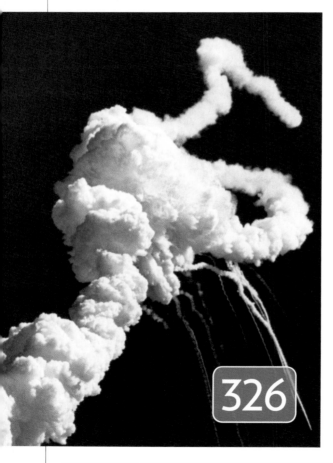

326

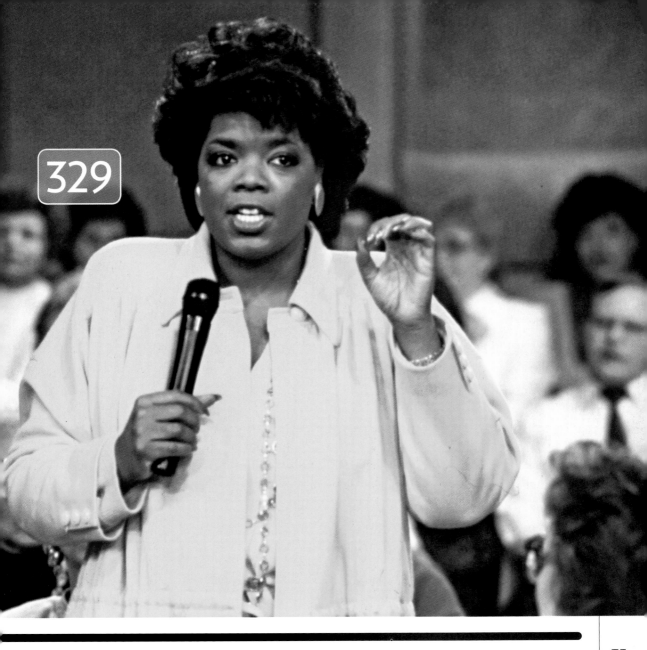

329

330 / *Howard the Duck*

Jedi director George Lucas bombs with a film about a dyspeptic intergalactic duck

331 / "Act your age/ not your shoe size/ and maybe we can do the twirl"

Prince, at his purple peak, has a megahit, "Kiss"

332 / "I feel the need—the need for speed"

Tom Cruise continues his hit streak as Maverick, a cocky fighter pilot who learns Important Life Lessons, in *Top Gun*

333 / Andrew & Fergie wed

At the time, Brits see her as a bundle of fun and a breath of fresh air. This will change

334 / Carson vs. Rivers

Frequent *Tonight Show* guest host Joan launches a rival show on FOX; Johnny Carson never speaks to her again

335 / "I'm not really a doctor but I play one on TV..."

Vick's medicine launches a classic ad

336 / Preppy Murderer

A grisly New York killing makes national headlines

337 / Chernobyl disaster

Explosions in the core of a reactor cause history's worst nuclear accident, leading to 50 direct deaths and a radiation cloud over Europe; 135,000 nearby residents are permanently resettled

333

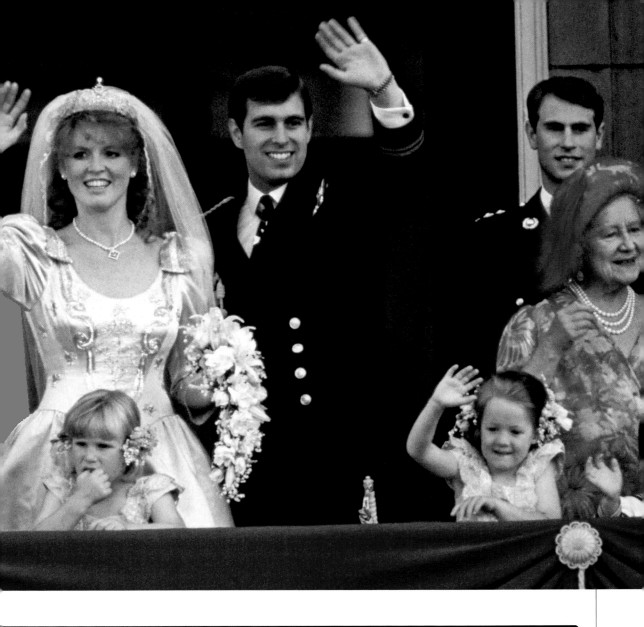

338 / Jim & Tammy Bakker

Tears and mascara flow as the emotive televangelists and PTL (Praise The Lord) Club hosts are caught in a sex scandal

339 / "I am not a bimbo"

So claims former PTL secretary and *Playboy* model Jessica Hahn, who says she received $20,000 in hush money after a disputed sexual encounter with Jim Bakker

340 / "Mr. Gorbachev, tear down this wall!"

Ronald Reagan issues a challenge in Berlin

341 / *Ishtar*

Warren Beatty and Dustin Hoffman crater in a film whose title becomes a synonym for "megaturkey." "If all the people who hate *Ishtar* had seen it," says director Elaine May, "I would be a rich woman today"

342 / *thirtysomething*

ABC strikes the downbeat with a *Big Chill*-ean study of semi-neurotic baby boomers in late bloom. A cranky David Letterman carps about "skinny white people from hell"; even *something* star Patricia Wettig admits to more than a modicum of navel-gazing: "We eat, we talk, we make love, and we talk about eating and making love. And we talk."

343 / "Greed, for lack of a better word, is good"

Wall Street's Master of the Universe Gordon Gekko (Michael Douglas) sums up the trading floor gladiator's creed

338

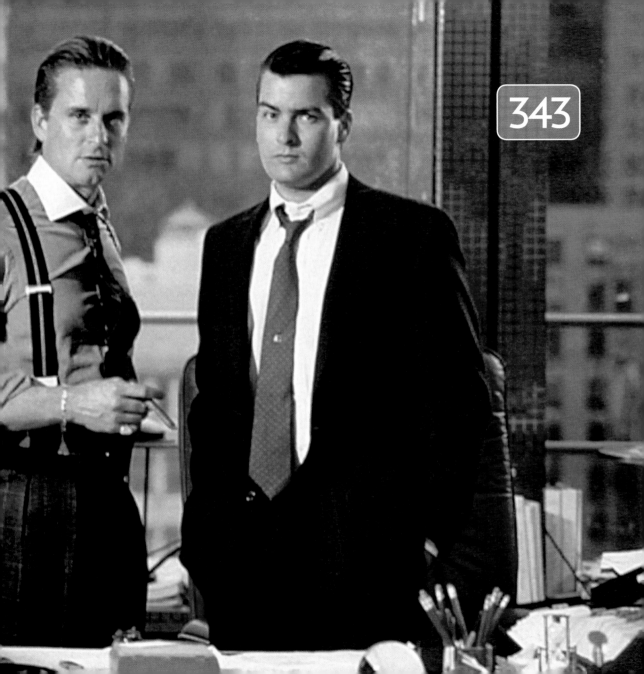

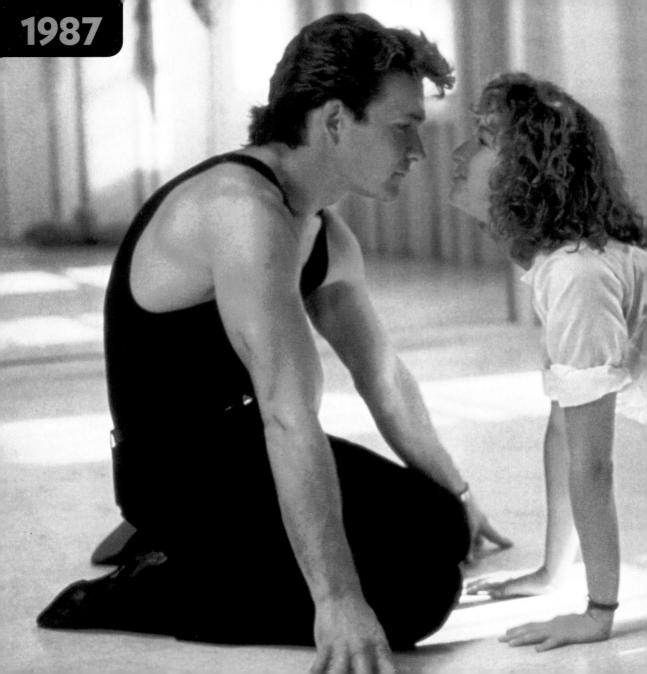
1987

344 / Baby Jessica
Eighteen-month-old Jessica McClure falls down a well in Texas. Transfixed by live coverage, America, as one, breathes a sigh of relief when she's rescued, alive, after 58 hours

345 / "I'm not gonna be ignored, Dan"
Fatal Attraction, a thriller about adultery, suggests it's very bad for marriages and can be fatal for bunnies

346 / Baby M
Custody laws get an emotional test when Mary Beth Whitehead, who carried a baby girl conceived with the artificially inseminated sperm of a man whose wife couldn't have children, decides she wants to keep the child. A judge awards custody to the baby's father, William Stern

347 / "I Heard It Through the Grapevine"
Claymation rockers the California Raisins—voiced by blues great Buddy Miles—have their moment in the sun

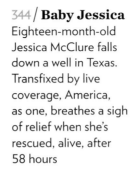

348 / "Nobody puts baby in the corner"
Dirty Dancing's stud Patrick Swayze (left, with Jennifer Grey) tells her dad (*Law & Order*'s Jerry Orbach) to back off

349 / Black Monday
The Dow falls more than 500 points on October 19—in percentage terms, the largest one-day market drop in history

350 / "That's Amore!"
Cher (Best Actress) and Olympia Dukakis (Best Supporting Actress) win Oscars for *Moonstruck*

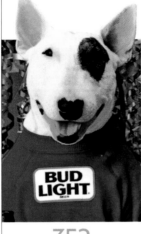

352

351 / Robert Bork
Reagan's ultra-conservative, bewhiskered Supreme Court nominee is rejected by the Senate

352 / Spuds Mackenzie
makes his debut as Bud Light's Hawaiian-shirt-and-shades-wearing party animal during the Super Bowl. Despite the party-guy rep, Spuds, it turns out, is a bitch

353 / Shelley Long quits *Cheers*
Sam's cultured foil bags the bar after five seasons, creating a void that—to fans' relief—Kirstie Alley ably fills

354 / "Well, isn't that special?"
Dana Carvey's scolding Church Lady, unrivaled practitioner of the "Superior Dance," holds court on *Saturday Night Live*

355 / Iran-Contra Scandal
In televised hearings, Reagan security adviser Oliver North admits his part in a scheme to sell missiles to Iran and use the profits to illegally fund CIA-backed Contra guerrillas in Nicaragua; the scandal gains sizzle when North says his comely secretary Fawn Hill smuggled documents from the White House in her boots

356 / "Welcome to the Jungle"
Guns N' Roses *Appetite for Destruction*, propelled by great songs and videos featuring lead singer Axl Rose's sidewinder dance moves and guitarist Slash's iconic top hat, goes on to sell 28 million copies and becomes a hard rock classic

357 / Hart Stopper
Shrugging off rumors of infidelity, Sen. Gary Hart tells reporters, "Follow me." They do—and find he's been afloat with Donna Rice aboard the *Monkey Business*. He quits the Democratic primaries

358 / The FOX TV network
debuts in prime time

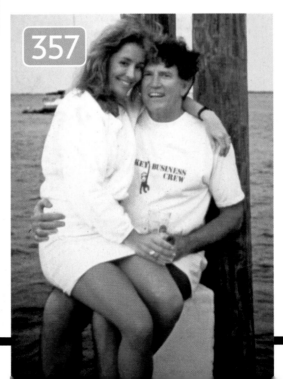

357

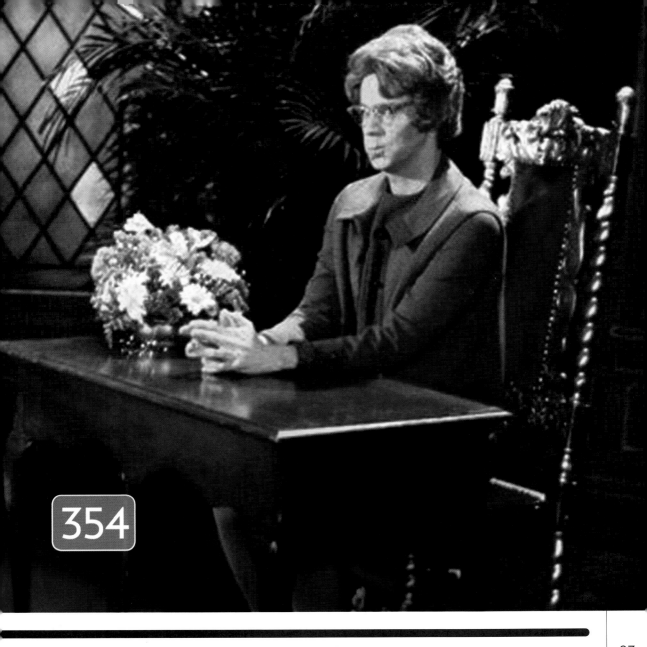

354

359 / "I Still Haven't Found What I'm Looking For"
U2 Grammy-winning, 25-million selling mega-album *Joshua Tree* puts the band on top of the music world

360 / Mathias Rust,
a 19-year-old West German, flies a Cessna 500 miles through Soviet air space and lands near Red Square—embarrassing the Soviet military. Rust spends a year in jail

361 / "My Name is Inigo Montoya. You killed my father. Prepare to die"
Mandy Patinkin prepares for revenge in *The Princess Bride*

362 / *La Bamba*
Lou Diamond Phillips stars in the biopic about Ritchie Valens ("Donna"), whose short but prolific life ended at 17 in the plane crash that also killed Buddy Holly

363 / Maddie and David's will-they/won't-they dance
After three seasons of double entendre dialog, *Moonlighting*'s sometimes feuding, sometimes flirty detectives (Bruce Willis and Cybill Shepherd) carry their interpersonal investigations to the inevitable conclusion. With the tension gone, though, so are the viewers; ratings fade and *Moonlighting* is canceled in 1989

364 / Crispin Glover mysteriously disappears
during a commercial break after almost kicking Dave in the face on *Late Night with David Letterman*

365 / Bubblegum Battle
Popster Debbie Gibson, 17, the youngest artist to write and perform a No. 1 hit ("Foolish Beat"), vies on the charts with 16-year-old mono-monikered Tiffany, who promotes *her* No. 1 tune ("I Think We're Alone Now") on a tour of shopping malls

366 / Terry Waite
The Church of England envoy and renowned hostage negotiator is himself taken hostage in Lebanon by the Islamic Jihad and held for 1,763 days, most of them in solitary, until his release in 1991

365

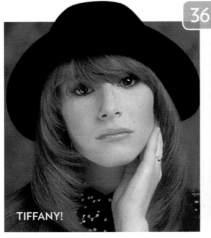

TIFFANY!

DEBBIE!

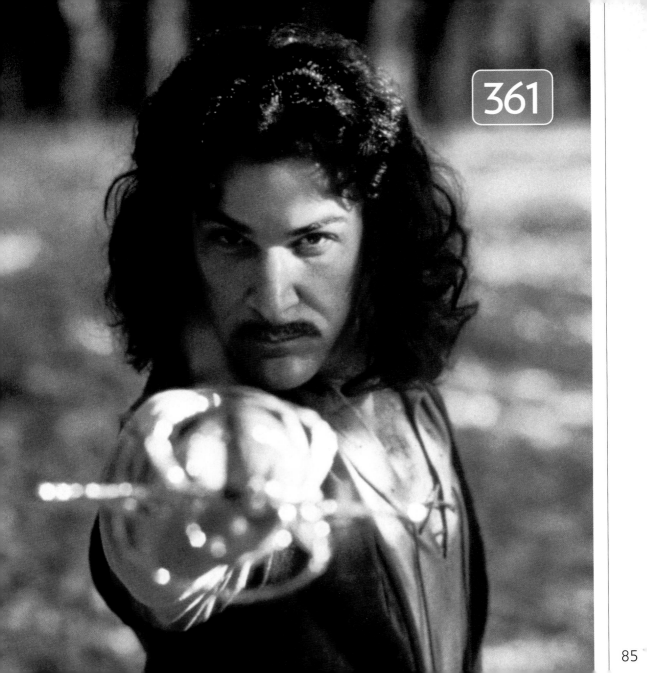

367 / *Roseanne* premieres

"There were a lot of ritzy, glitzy nighttime soap operas with a lot of rich, good-looking people," said costar John Goodman, "and here we are smackin' 'em in the face with a wet fish." The comedy about a struggling family becomes a huge hit

368 / "Cigarette?" "Yes, I know"

Leslie Nielsen shines as deadpan Det. Frank Drebin in the film *The Naked Gun*, inspired by TV's *Police Squad*

369 / The Shroud of Turin

New radiocarbon tests of the relic, believed by some to be the burial shroud of Jesus, date the linen to the 13th or 14th century. Still, some skeptics will claim the tested fabric was from material added later

370 / *Big,*

starring Tom Hanks as an enormous 13-year-old, is huge

371 / Jesse Jackson

wins more than 7 million primary and state caucus votes in his attempt to land the Democratic nomination

372 / Sonny Bono

Fur-vest-wearing cultural chameleon— who sang "I Got You, Babe" and costarred on *The Sonny and Cher Comedy Hour*—begins his political career as mayor of Palm Springs, Calif. Six years later he becomes a U.S. Congressman

373 / Mikhail Gorbachev

The General Secretary introduces glasnost— a policy allowing freer discussion of politics and social issues—into the Soviet system

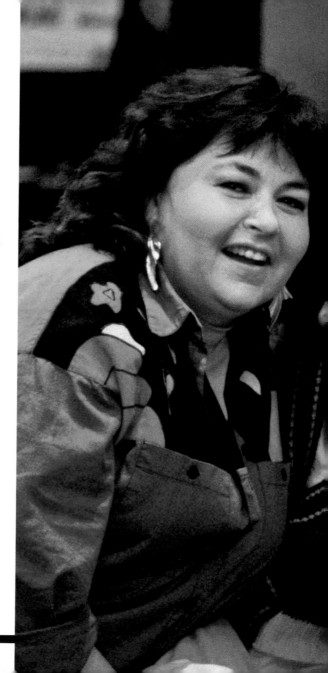

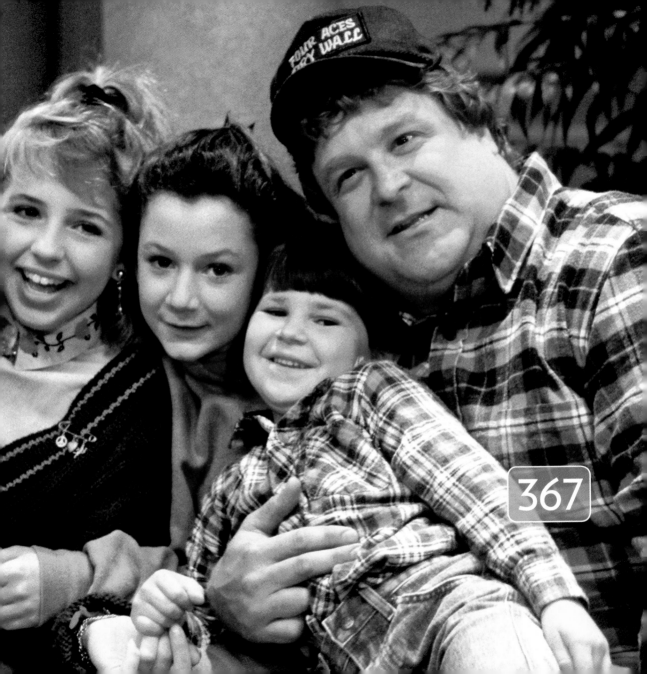

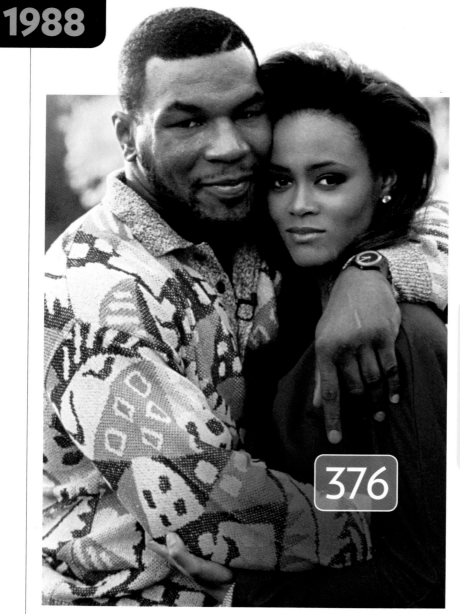

376

374 / "You got a fast car ..."
A memorable riff and lyrics make Tracy Chapman's "Fast Car" a hit

375 / _U.S.S. Vincennes_
An American warship misidentifies an Iranian civilian aircraft and shoots it down, killing 290

376 / Robin Givens & Mike Tyson wed
Within a year the _Head of the Class_ star, her husband sitting beside her, will tell Barbara Walters that Tyson is "a manic depressive," and the marriage "pure hell"

377 / "Read my lips"
George Bush underlines his promise of "no new taxes"

378 / _Magnum, P.I._ ends

379 / "I Have Sinned Against You!"
Caught with a hooker, TV evangelist Jimmy Swaggart apologizes. Caught again, he says, "The Lord told me it's flat none of your business"

380 / New wrinkle
Retin-A makes news when a study suggests it reduces facial lines

381 / *The Last Temptation of Christ*
Sex scenes in Martin Scorsese's film, which stars Willem Dafoe as Jesus and David Bowie as Pontius Pilate, stir controversy

382 / "Don't Worry, Be Happy"
is inescapable and inescapably upbeat

383 / Oprah Winfrey's diet
Talk show goddess loses 67 pounds on a liquid protein diet, celebrates by wheeling a red wagon containing 67 pounds of fat onto the stage

384 / Morton Downey Jr.
A godfather of trash TV, the talk show host picks fights, insults guests and sneers at "pablum puking liberals"

385 / Bruce Springsteen & Julianne Phillips file for divorce
after 3 years. Weeks later his romance with Patti Scialfa, a member of his E Street Band, becomes public. (They marry in 1991 and have 3 kids)

386 / CDs outsell vinyl records
for the first time

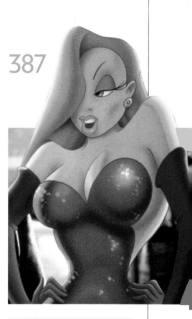

387

387 / "I'm not bad—I'm just drawn that way"
Who Framed Roger Rabbit's misunderstood Jessica Rabbit

388 / "Where was George?"
Ted Kennedy's question about what George Bush has been doing for the past 7 years, as Reagan's Vice President, gains traction

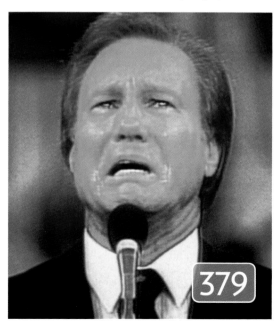

379

N73711

389 / **Aloha Flight 243**
Metal fatigue causes 18 ft. of fusilage to peel off at 24,000 ft. Despite the damage, the crew lands the Boeing 737 safely at Maui's Kahului airport

390 / **Pan Am Flight 103**
is blown up over Lockerbie, Scotland, killing 270

391

391 / **Andy Gibb dies**
"I'd say, 'Andy, look in the mirror,'" said his former agent. "'You've got everything—good looks, talent ...' But when he looked in the mirror, you always had the feeling he didn't see anything." After years of battling drugs, Gibb, who had his first No. 1 hit at 19, dies at 30

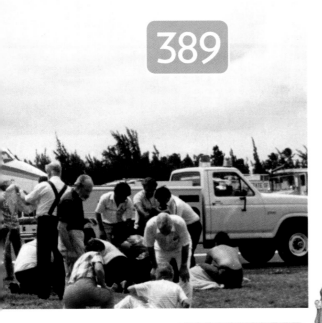

389

392 / *The Phantom of the Opera*
Andrew Lloyd Webber's musical opens on Broadway

393 / **Geraldo Rivera**
invites white supremacists on his show for a segment called Teenage Hatemongers, gets his nose broken when a fight breaks out

394 / **Burt & Loni wed**
The couple, who met on the *Merv Griffin Show*, marry in a chapel Burt built at his Jupiter, Fla., ranch

395 / **"Qantas never crashed"**
Dustin Hoffman will win an Oscar playing *Rain Man*'s autistic savant

394

396 / Rob Lowe sex scandal
Inaugurating what has now become a Young Hollywood rite of passage, a grainy video of Rob Lowe and two women—one of them underage—is leaked to a YouTube-less media

397 / "We don't pay taxes; only the little people pay taxes"
That sort of quote, plus testimony from a housekeeper, helps send billionaire hotel owner Leona "Queen of Mean" Helmsley, 69, to the slammer for tax evasion

398 / The Menendez brothers,
Lyle and Erik, sons of a wealthy L.A. record exec, shotgun their mother and father to death to get their hands on the family fortune

399 / New Kids on the Block
Release of *Hangin' Tough* spins off five Top 10 hits from a single album and skyrockets the group to fame

400 / The Seinfeld Chronicles,
a sitcom pilot about not a whole lot, written by Jerry Seinfeld and Larry David, appears in July to head-scratching reviews

401 / "Whoa" is he
Bill & Ted's Excellent Adventure launches Keanu Reeves' career

402 / Tank Man
In the aftermath of the bloody suppression of peaceful pro-democracy protests at Tiananmen Square, a lone Everyman stands stubbornly in the path of a tank column; the man's fate and even his name will remain unknown

403 / "I'll have what she's having"
In *When Harry Met Sally*'s signature moment, Meg Ryan, to prove a point, mortifies Billy Crystal by faking sexual exhilaration while eating a sandwich at New York City's Katz's deli. A matronly diner (played by director Rob Reiner's mother, Estelle), asked by a waiter what she wants to order, looks over at Ryan—and delivers the perfect punch line

404 / "Eat my shorts!"
The Simpsons, led by son Bart and "D'oh!"-man dad Homer, debuts. Within 14 months folks snap up an estimated $2 billion in merchandise. The voice behind Bart? Thirty-two-year-old Los Angeles actress Nancy Cartwright

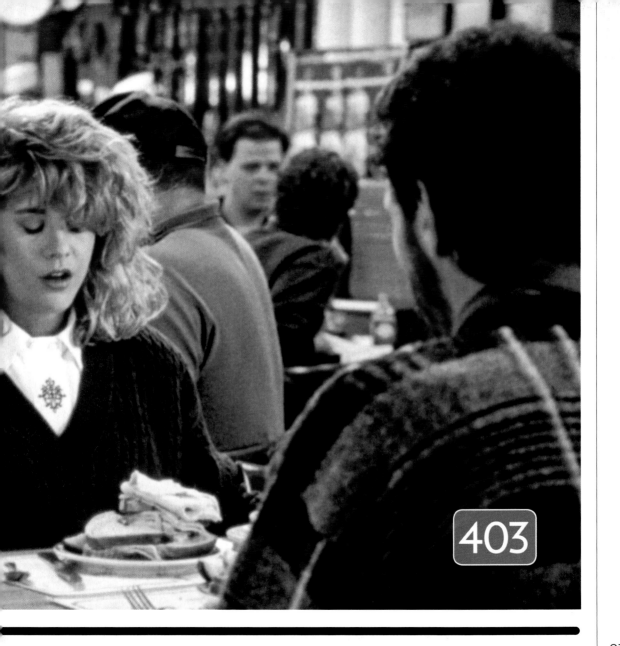

403

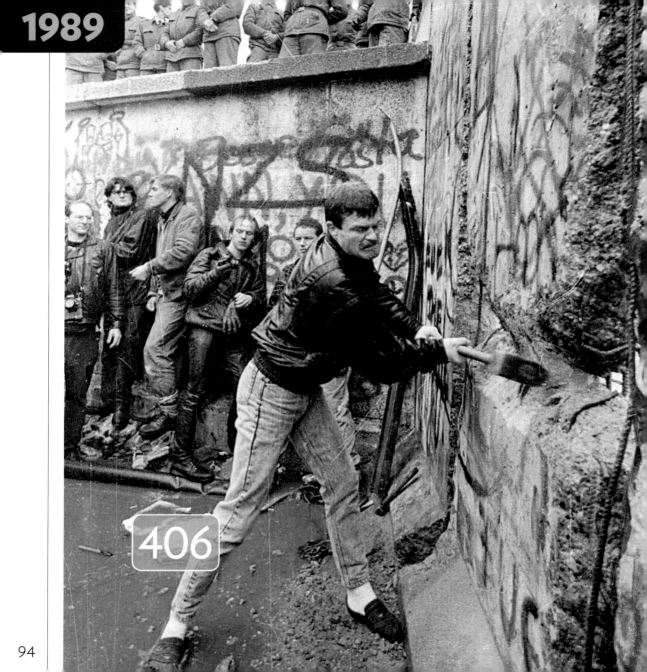

406

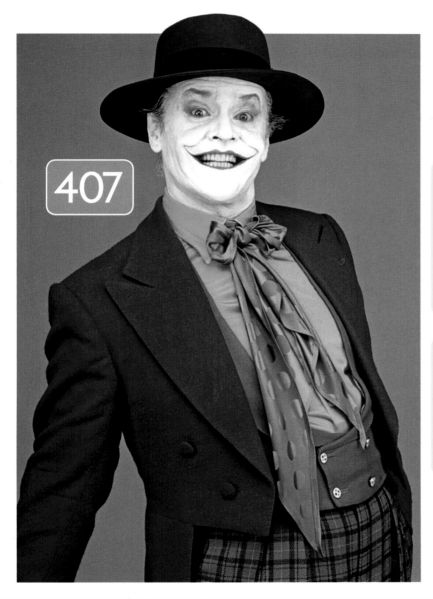

407

405 / *Exxon Valdez*
Supertanker hits Alaska's Bligh Reef, spills an estimated 11 million gallons of oil; 22 years later the case is still in the courts

406 / Berlin Wall falls
At midnight on Nov. 9, East Germans are allowed to walk freely to the West. The most potent symbol of Communist oppression is no more

407 / The bat is back
Tim Burton's dark, decidedly adult *Batman*, starring Michael Keaton and Jack Nicholson (as the Joker), rakes in over $400 million

408 / "Wind Beneath My Wings"
released, will bring Bette Midler a Grammy

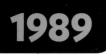

409 / Charlie Hustle
Baseball's all-time hits leader, manager of the Cincinnati Reds and alleged gambler Pete Rose is banned from baseball amid accusations that he bet heavily and often on baseball games

410 / Don't forget napping
Robert Fulghum's collection of motivational essays *All I Really Need to Know I Learned in Kindergarten* extols the value of playing well with others

411 / Gilda Radner dies
The quirky comedienne—who, as Emily Litella, Roseanne Roseannadanna and Baba Wawa became everybody's favorite Saturday night date—succumbs at 42 after a graceful, and brave, battle with cancer

412 / Arsenio Hall
launches a hit talk show. In 1992, faced with a new *Tonight Show* host, he vows to "kick Jay Leno's ass"—but, somehow, misses. Hall is canceled in '94

413 / Rebecca Schaeffer murdered
The former *My Sister Sam* star, 21, is killed by a stalker who obtained her address through California DMV records; later the state will make such records private

414 / Charles Stuart
In a tragedy that mesmerizes Boston, Stuart, 29, claims a black man murdered his pregnant wife and wounded him as they sat in a car. Ten weeks later Stuart's brother goes to the police and identifies Charles as the real killer. The following day Charles Stuart commits suicide

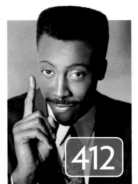

415 / Madonna and Warren Beatty
The *Dick Tracy* costars test offscreen coupledom. Later, tensions show up in her documentary *Truth or Dare*, where the far-more-private Beatty remarks, "She doesn't want to live off-camera, much less talk … What point is there of existing off-camera?"

416 / "If Jesus were alive today, he would be on TV"
Televangelist Jim Bakker would be too, if he wasn't beginning a Federal prison sentence for fraud

417 / Urkel!
Family Matters fringe character dominates sitcom: geek victory!

418 / Salman Rushdie publishes *Satanic Verses,*
receives glowing reviews from critics and a fatwa from Ayatollah Khomeini encouraging followers to kill the author. Rushdie goes into hiding until the fatwa is lifted in 1998

419 / "I'll tell you what! We're having an earth—"
Al Michaels is covering the third game of the 1989 World Series between the Bay Area's San Francisco Giants and Oakland A's live on ABC when a massive 6.9 quake rocks Candlestick Park. The San Francisco earthquake kills 63 and causes at least $6 billion in damage

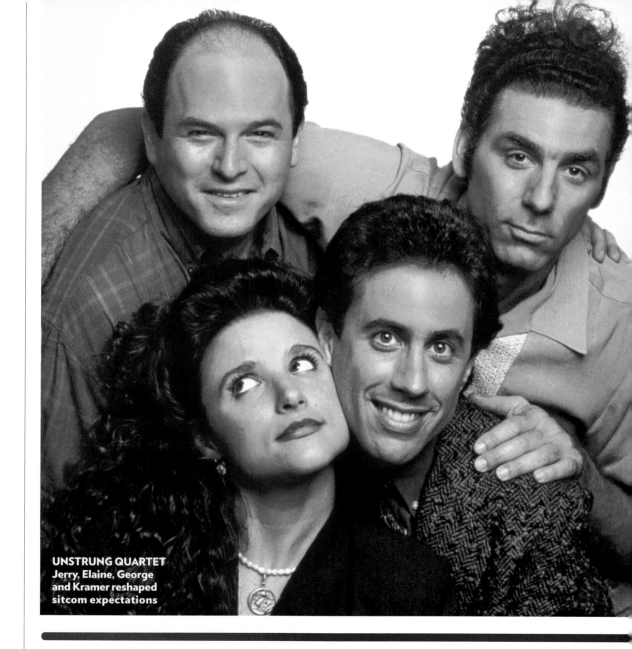

UNSTRUNG QUARTET
Jerry, Elaine, George and Kramer reshaped sitcom expectations

*Here we are,
now entertain us: It's the
decade of "I didn't inhale,"
"I'm too sexy for my cat,"
"I will always love you," "I see dead
people" and "The heart wants
what it wants."
Hasta la vista, baby!*

'90s

420 / **"Ice Ice Baby"**
Vanilla Ice, born Robert Van Winkle, has a monster hit (built on the hook from Queen's "Under Pressure")

421 / **Hello, *Beverly Hills, 90210***
And hello long sideburns, as modeled by Jason Priestley and Luke Perry

422 / **"Just when I thought I was out, they pull me back in!"**
Michael Corleone (Al Pacino) finds retirement difficult in *The Godfather Part III*. When Winona Ryder drops out, director Francis Ford Coppola swaps in his daughter Sofia, who has little acting experience. Reviews are brutal

423 / **"I do not like broccoli. And I haven't liked it since I was a little kid and my mother made me eat it. And I'm President of the United States, and I'm not going to eat any more broccoli"**
George H.W. Bush bans a vegetable from Air Force One

424 / **"Vogue"**
Madonna strikes a pose, has a hit

425 / **"Damn good coffee!"**
Kyle MacLachlan's caffeine-addicted FBI agent tracks Laura Palmer's murderer in *Twin Peaks*, director David Lynch's prime-time paean to small-town weirdness. Non-sequiturs abound, including the Log Lady, a creepy giant and a dancing dwarf

426 / **Rod Stewart and Rachel Hunter wed**

427 / ***Seinfeld* Sneaks On**
After a dud 1989 pilot, the retitled *Seinfeld* returns with a first season of only four additional episodes and begins a nine-season run that will make TV history and—yada, yada, yada—affect language like no show before or since

427

420

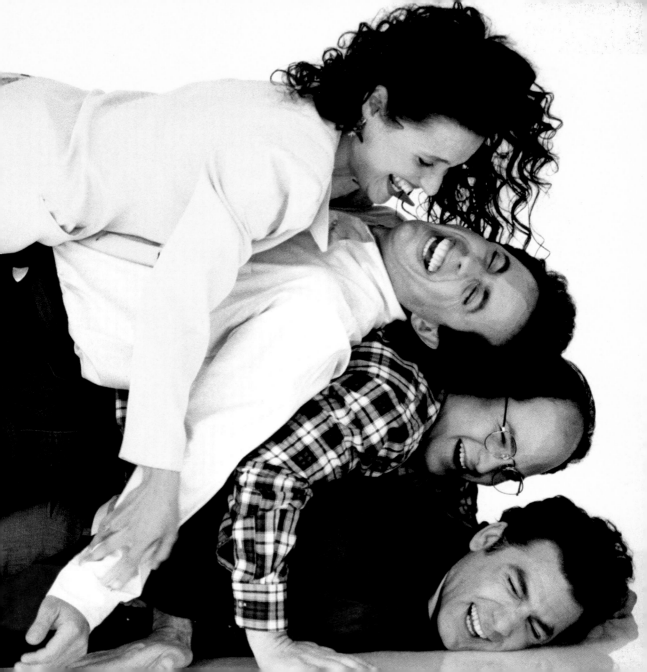

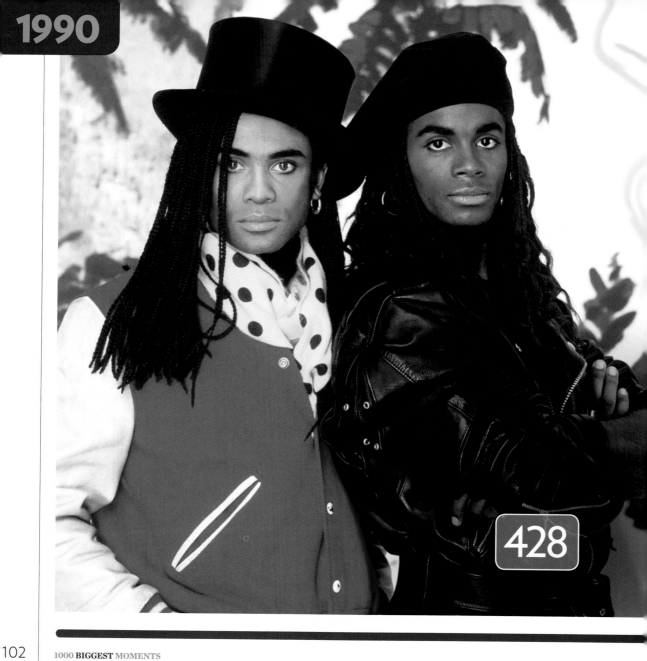

428

428 / Milli Vanilli mea culpa
"Girl You Know It's True" was their hit; "Girl, we haven't exactly told the truth" was their problem. Revelations that Rob Pilatus and Fabrice Morvan didn't sing on their album force them to return their Best New Artist Grammy

429 / Zsa Zsa incarcerated
Convicted of slapping a Beverly Hills cop who dared point out her expired plates, she serves three days in jail. "I admit I have a Hungarian temper," she says, maintaining it was all a misunderstanding. "Why not?... We are descendants of Genghis Khan and Attila the Hun"

430 / Home Alone
makes Macaulay Culkin a star at 10

431 / Greta Garbo Dies at 84
Famous as a glamorous star and, later, a recluse, she never said why she withdrew from public life. "I was born, I had a mother and father," she once told a reporter. "I lived in a house. I grew up like everybody else. What does it matter?"

432 / The Civil War
Ken Burns' five-part, 11-hour PBS opus, chock-full of slowly panned archival still photos, draws 40 million viewers and a shelf of awards

433 / Pretty Woman
Say, what if Cinderella was a *hooker*? Meg Ryan took a pass on the premise, but Julia Roberts grabbed the slipper, and her charm—and toothy, goose-honk laugh— made her a megastar

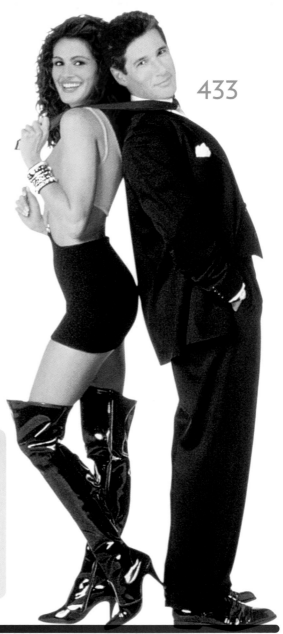

433

434 / Mariah Carey
Move over, Whitney: "Vision of Love" unveils Carey's five-octave range and gospel-meets-R&B sensibility. Her mentor is record exec Tommy Mottola, 43, with whom Carey, 24, begins a 5-year marriage in 1993

435 / "He thought he had to be celibate to maintain the purity of his instrument, but my instrument needed tuning"
Mimi Rogers saucily explains one of the reasons she and husband of almost three years Tom Cruise "had to split"

436 / Hammer Pants!
M.C. Hammer has a music and video hit with "U Can't Touch This." Inexplicably, spangly, diaper-ready legwear never catches on

437 / Law and Order premieres, lasts nearly 20 years

436

438 / I, Tom, take thee, Nicole
Days of Thunder costars Cruise and Kidman tie the knot in a union that will last 10 years

438

439 / The Bonfire of the Vanities
A great book turns into an expensive flop, much to director Brian De Palma's dismay. "Nobody realized it was going wrong when we were making it," he says. "We were very enthusiastic." Budget: $45 million. Box office: $15.4 million

440 / The Three Tenors
Opera singers selling out stadiums? Plácido Domingo, José Carreras and Luciano Pavarotti make it happen long before Andrea Bocelli

441 / Andrew Dice Clay
Foulmouthed stand-up scores with X-rated nursery rhymes, sells out Madison Square Garden two nights running

442 / Farewell, Jim Henson
At 53, the shy, prolific Muppet master and voice of Kermit the Frog succumbs to a sudden, virulent pneumonia, shocking fans the world over. Says a friend: "Kermit was his alter ego. He allowed Jim to say more than he would have otherwise"

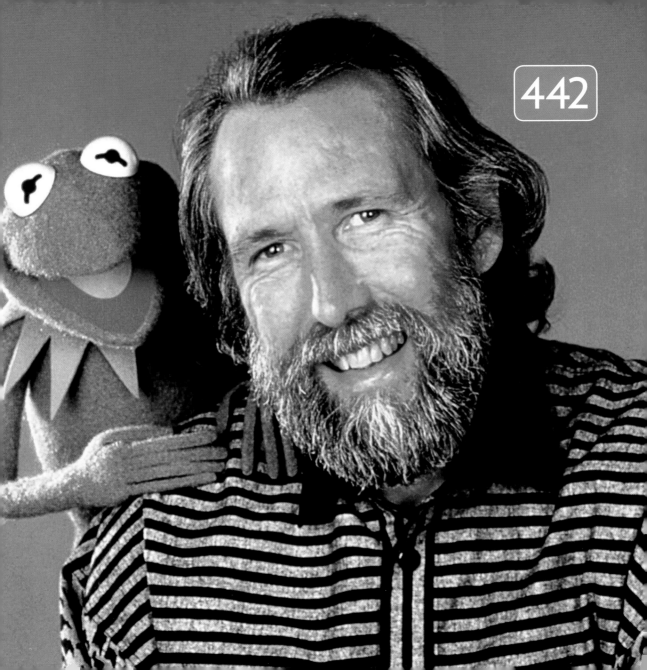

443

443 / Donald and Ivana Split

Key moment: When his mistress Marla Maples runs into both Trumps on the Aspen ski slopes, and Ivana hisses, "You bitch, leave my husband alone!"

444 / Ryan White Dies

A nice kid from Kokomo, Ind., infected at 12 with HIV during a blood tranfusion, fought prejudice and became a hero to many. His death, six years later, is national news

445 / "Homey, don't play dat!"

In Living Color, a sketch show starring very many members of the Wayans family, introduces the world to Jim Carrey, dancer Jennifer Lopez and bracingly politically incorrect skits like the *Star Trek* parody *The Wrath of Farrakhan*

446 / Deep Space Nein

After the Hubble Space telescope launches into orbit, a faulty mirror crimps transmissions. It takes NASA three years to correct the flaw

447 / *Cop Rock*

ABC's bizarre cop-show-as-musical mash-up becomes famous as a flat-foot flop

444

448 / *Ghost*

Patrick Swayze and Demi Moore make ceramics supersexy and prove love conquers death. Trivia: Bruce Willis, married to Moore, turned down the role

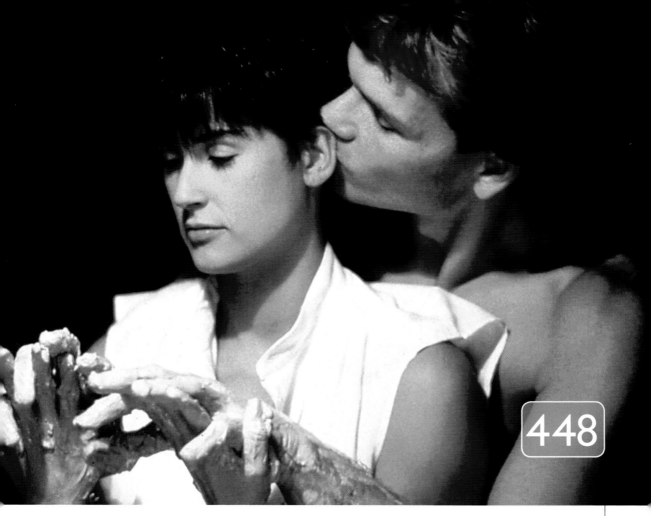

448

449 / **"Friends in Low Places"**
Garth Brooks' ode to drinkin' pals lands him a No. 1 country single

450 / **"Aerosmith is in my breakfast nook? Excellent!"**
Rock gods visit *SNL*'s Wayne and Garth

451 / **Nelson Mandela freed**
after 27 years in South African jails

452 / **"Nothing Compares 2 U"**
Sinead O'Connor sings Prince, becomes famous

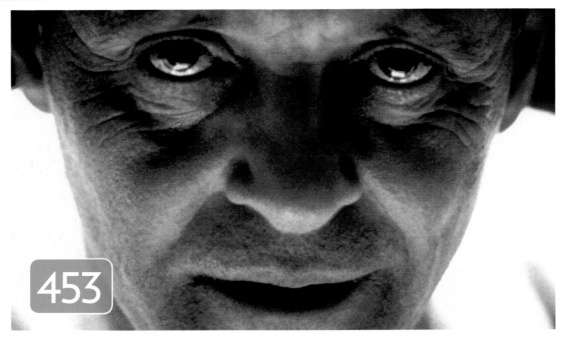

453

453 / **"I ate his liver with some fava beans and a nice chianti"**
Anthony Hopkins, in *The Silence of the Lambs*, adds new meaning to the phrase, "I'm having an old friend for dinner"

454 / **Linda Hamilton's biceps**
Her *Terminator 2: Judgment Day* physique makes arm muscles a fashion statement

455 / **Magic Johnson**
The L.A. Laker great is diagnosed with HIV and quits the NBA

456 / **"Here we are now, entertain us"**
Grunge goes global with Nirvana's "Smells Like Teen Spirit"

457 / **William Kennedy Smith,** charged with raping a woman at his family's Palm Beach estate, is acquitted

458 / **Paul "Pee-Wee Herman" Reubens** busted for inappropriate behavior at an adult cinema. Later he asks an MTV crowd, "Heard any good jokes lately?"

459 / **No. 7**
Liz Taylor marries construction worker Larry Fortensky at Neverland Ranch

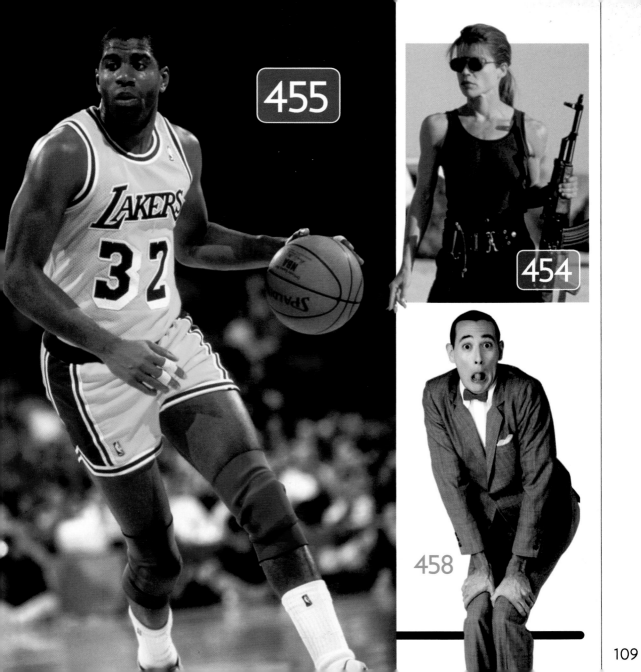

455

454

458

460 / "Talk amongst yourselves!"

Mike Myers' *SNL* character Linda Richman is based on his real-life mother-in-law, Linda Richman

461 / Anita Hill testifies before Congress

that her former boss, Supreme Court nominee Clarence Thomas, had sexually harassed her. Thomas, who denies the allegations, will later call the hearings "a high-tech lynching"

462 / The Texas Cheerleader Mom

In a case made for a made-for-TV movie—which it will become—Wanda Holloway is convicted of plotting the murder of another cheerleader's mother, in hopes of advancing the cheerleading prospects of her own 13-year-old daughter

463 / Gulf War

Iraqi troops invade Kuwait, prompting President Bush to deploy American forces against Saddam Hussein under the code name Operation Desert Storm

464 / Soviet Union crumbles

Bankrupted trying to compete with U.S. military spending, the U.S.S.R. dissolves

465 / Dances with Wolves

Director (and star) Kevin Costner's 3-hour Western is nominated for 12 Oscars, wins 7

466 / The Men's Movement

Contending that American males have been wimpified, *Iron John: A Book About Men* exhorts them to bond on manly wilderness retreats

467 / Jeffrey Dahmer

Milwaukee police arrest a serial killer who, it will be revealed, also ate parts of some of his 17 victims

468 / "Unforgettable"

Technology allows Natalie Cole to duet with her late dad, Nat King Cole, creating a hit

469 / Thelma & Louise

On the run after Louise shoots a rapist, Susan Sarandon and Geena Davis get revenge and go out in a blaze of glory

469

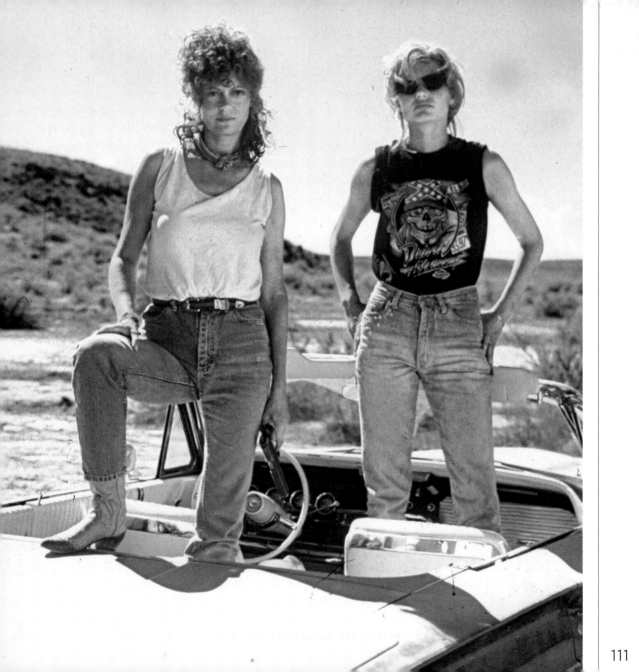

470 / "The heart wants what it wants"
Woody Allen, 56, explains, famously, why he has taken up with Soon Yi-Previn, 21, adopted daughter of his longtime lover Mia Farrow

471 / *The Real World* premieres
MTV creates reality-TV template

472 / "You can't handle the truth!"
Jack Nicholson lambasts hotshot Navy lawyer Tom Cruise in *A Few Good Men*

473 / "I didn't inhale"
Accused of smoking marijuana while a student, Bill Clinton makes one of the fine distinctions for which he will become famous

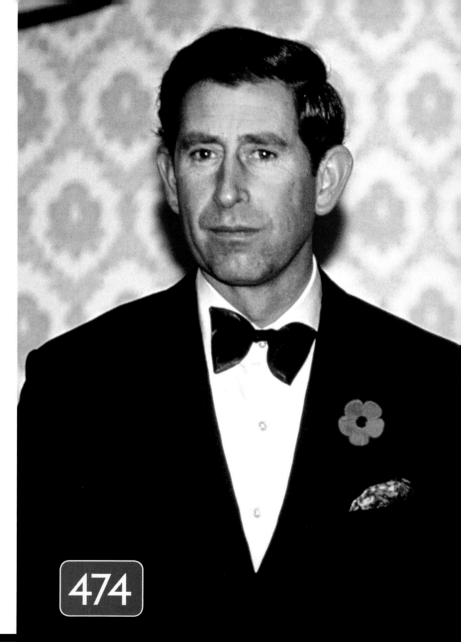

474

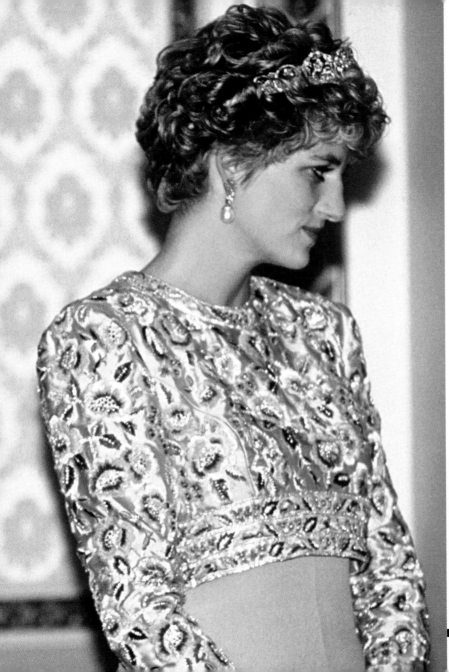

474 / **Charles & Di split**

After years of revelations, their slo-mo train wreck of a marriage comes to an end amid reports of a tryst-arranging call taped between Charles and mistress Camilla Parker Bowles. A top royal aide says of the infidelity, "So the Prince has had an affair... It happens in France all the time." The battle over divorce details begins

475 / **"I'm Too Sexy"**

For my cat, Milan and Japan. Right Said Fred have a one-off hit

476 / **Kurt Cobain and Courtney Love wed**

The groom wears green pajamas

477 / *Melrose Place* **premieres**

478 / **Sinead O'connor**

Surprising her *Saturday Night Live* hosts—and angering Catholics everywhere—the "Nothing Compares 2 U" singer declares, "Fight the real enemy" and shreds a picture of Pope John Paul II on live TV

479 / **Dream Team**

NBA superstars win Olympic gold

480 / **"I like big butts and I cannot lie"**

Sir Mix-a-Lot takes a stand in "Baby Got Back"

481 / *Barney & Friends*

"I love you/ You love me/ We're a happy family!" Tykes love him, but PBS's purple dinosaur sets T-Rex's fearsome reputation back 60 million years

482 / **Long Island Lolita**

Desperate to have auto repairman Joey Buttafuoco, 36, to herself, Amy Fisher, 17, shoots his wife, Mary Jo

483 / *The Bridges of Madison County*

Robert James Waller's novel about a middle-aged woman's passionate affair spends more than three years on bestseller lists

481

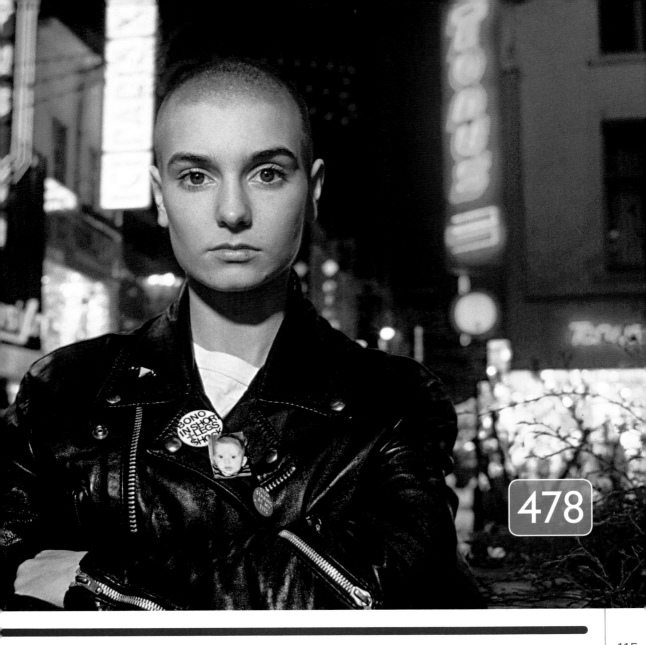

478

484

484 / The Sperminator
Infertility specialist Dr. Cecil Jacobson convicted of secretly inseminating women with his sperm. Prosecutors say he may have fathered as many as 75 children

485 / "Na' gan' do it!"
Dana Carvey unleashes a wicked President Bush impression, just in time for the '92 election

486 / John McEnroe and Tatum O'Neal split

487 / Marky Mark's briefs moment
Abdominal showman Mark Wahlberg, 21—then the far-less-known little bro of New Kid on the Block Donnie Wahlberg—gets famous in Calvin Klein underwear ads

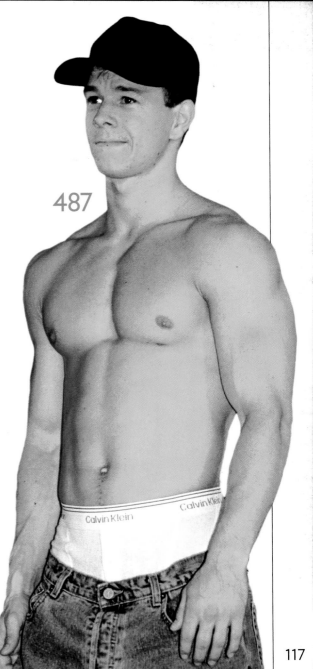

487

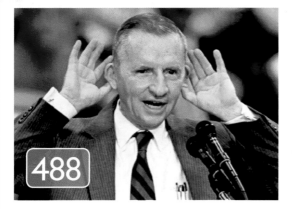

488

488 / "I'm all ears"
Mid-debate, independent presidential candidate Ross Perot gets laughs by playing Dumbo

489 / "Achy Breaky heart"
Billy Ray Cyrus' hit makes him the mullet heard 'round the world

490 / Dan Quayle vs. Murphy Brown
V.P. spikes controversy by saying TV character, a newly single mom, is "mocking the importance of fathers." Later he admits he doesn't watch the show

491 / "Oh, Squidgy ...Kiss me, please!"
Britain's *The Sun* releases tapes of a phone call between Princess Di and James Gilbey; They sound like besotted teens. Him: "Do you know what I'm going to be imagining I'm doing tonight at about 12 o'clock? Just holding you close to me!"... Her: "Fast forward!" She also gripes about her in-laws: "Bloody hell, after all I've done for this f------ family!"

492 / Andrew and Fergie split
Hope for a dignified aftermath disappears when, months later, a topless Fergie is photographed having her toes sucked by an American businessman

493 / *Basic Instinct*
Sharon Stone becomes a superstar playing an ice-pick killer who can't keep her legs crossed

494 / Fabio!
finds fame posing for 300 romance covers. "No one remembers who writes these books," he says. "But people remember Fabio"

495 / "Can we all get along?"
Rodney King pleads for calm after riots erupt in L.A. when cops accused of beating him are acquitted

490

496 / **Audrey Hepburn dies**

"You looked at her and all you could think was that nothing bad should ever happen to her," said an admirer, trying to explain the star's magical appeal in films like *Funny Face* and *Sabrina*. Said another: "She *gets* to you"

497 / *The Celestine Prophecy: An Adventure*

A first novel by Alabama therapist James Redfield blows up from self-published paperback to a massive mainstream hit

498 / **World Trade Center explosion**

Terrorists detonate a truck bomb in the underground garage, killing six people and injuring over 1,000

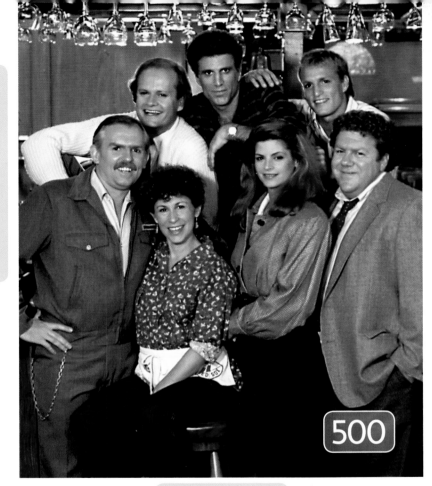

500

499 / **David Letterman jumps to CBS,**

takes Paul Shaffer, Top 10 List and Stupid Pet Tricks with him

500 / **"It's a Dog-Eat-Dog World, and I'm wearing Milkbone underwear"**

Cheers, and the wisdom of Norm, end after 11 seasons

501 / **Hollywood Madam**

LAPD arrests Heidi Fleiss, 27, for running a posh call girl service. She is later sentenced to 37 months for tax evasion

502 / Michael Jackson accused
Police investigate the singer after an L.A. dentist says Jackson molested his son. Eventually Jackson—claiming innocence and saying he doesn't want to endure a trial—reaches a financial settlement with the family (reportedly for $20 million); no charges are ever filed

503 / Tennis star Monica Seles
stabbed by an obsessed fan of rival Steffi Graf

504 / Beavis and Butt-head
"are dumb, crude ... ugly, sexist ..." says a disclaimer MTV eventually adds. "But the little weiner-heads make us laugh"

505 / Waco
More than 70 members of a Texas religious cult, suspected of arms violations and child sexual abuse, die after a 51-day standoff when officials assault their compound. Anger at the deaths will motivate Oklahoma City bomber Timothy McVeigh

506 / "The truth is out there"
The X-Files debuts, and agents Mulder (David Duchovny) and Scully (Gillian Anderson) begin a spooky nine-season, 202-episode odyssey to expose government conspiracies and find evidence of alien life

507 / Rudolf Nureyev dies
of AIDS, at 54. Russian to his soul, the ballet legend, raised in poverty, said he knew only one thing, even then: "I had to dance. There was nothing else"

508 / Burt and Loni split
He subsequently admits to a two-year affair with a Tampa cocktail-lounge manager

509 / Lorena Bobbitt,
angry at her abusive husband, cuts off half his penis and tosses it in the weeds. Later she repents and helps locate the remnant, which, during nine hours of microsurgery, is successfully re-attached. The next year she is acquitted by reason of insanity

504

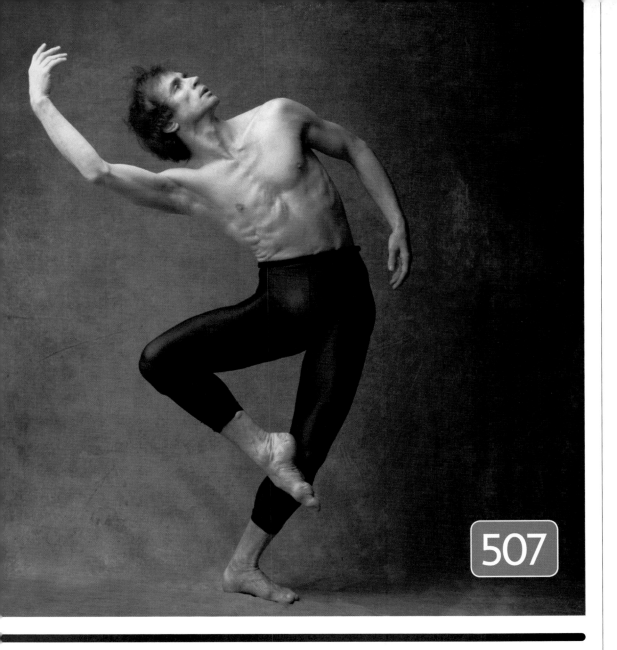

507

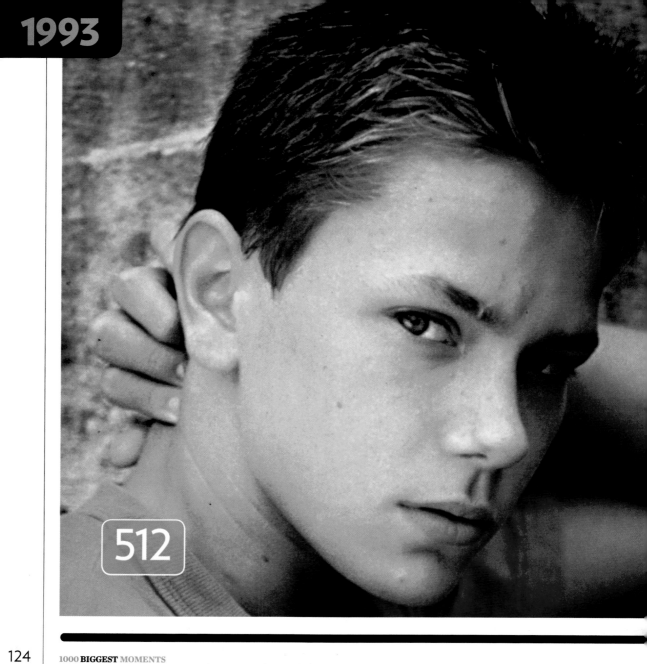

512

510 / Nannygate
President Clinton watches *two* choices for attorney general—lawyer Zoe Baird and judge Kimba Wood—get torpedoed by revelations they'd hired illegal aliens to help with child care

511 / *NYPD Blue*
The tough police drama pushes network-TV censorship boundaries with strong language and flashes of nudity

512 / River Phoenix dies
of a drug overdose after collapsing in seizures outside L.A.'s trendy Viper Room. His younger sibling Leaf (a.k.a. Joaquin) makes a frantic 911 call, but paramedics can't save the actor

513 / Toni Morrison,
American author of *Beloved* and *Song of Solomon*, is awarded the Nobel Prize in literature

514 / "The list is life"
Steven Spielberg's Holocaust drama, *Schindler's List*, will bring him the Best Director Oscar

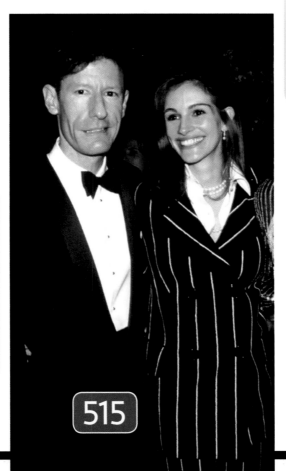

515 / Julia Roberts and Lyle Lovett wed
The pretty woman and the country crooner get married in a fever after dating only a few weeks; friends rush to make the ceremony in Marion, Ind. "We were all coming in from everywhere," says Susan Sarandon, "like Noah's Ark"

516 / *Unplugged*
Eric Clapton's live, stripped-down recording wins six Grammys

517 / Brandon Lee,
son of martial arts legend Bruce Lee, dies at 28 while filming *The Crow* when a prop gun, thought to be safe, fires a bullet

518 / "Stop the insanity!"
Infomercial fitness guru Susan Powter floods the airwaves

519 / **Farewell, Jackie O**

The former First Lady succumbs to cancer at 64. She was, eulogized Ted Kennedy, "too young to be a widow in 1963 and too young to die now ... a blessing to us and to the nation—and a lesson to the world on how to do things right, how to be a mother, how to appreciate history, how to be courageous. ... She graced our history. And to those of us who knew her ... she graced our lives"

520 / **They'll be there for you**

Friends debuts

521 / **The Rachel**

Jennifer Aniston's cut becomes the decade's steal-this-look 'do. "It's bizarre," she says. "I keep thinking, 'Wait—it's just me!'"

522 / Nicole Simpson murdered

The ex-wife of O.J. Simpson, 35, and her friend Ron Goldman are stabbed to death in L.A. Police question O.J. for three hours, but no arrest is made until after...

523 / ...The white Bronco chase

O.J. Simpson's slow-mo flight from double-murder charges freezes L.A. freeways and, broadcast live on TV, mesmerizes millions

524 / *My So-Called Life*

Teen-angst series lasts 19 episodes, defines "cult hit" and launches Claire Danes' career

525 / John Candy dies

at 43, of a heart attack

526 / Michael and Lisa Marie wed

The King of Pop and the King's princess marry in secret in the Dominican Republic. The pair kiss passionately onstage at the MTV Video Music Awards, and in a Diane Sawyer interview, when asked if they have sex, a visibly annoyed Presley answers, "Yes! Yes! YES!"

527 / *ER* debuts

George Clooney— whose long TV résumé includes *Sunset Beat*, in which he played cop-by-day, rocker-by-night Chic Chesbro, and a role as a lip-synching transvestite in *The Harvest*—hits paydirt

528 / "I Will Always Love You"

brings Whitney Houston a couple of Grammys

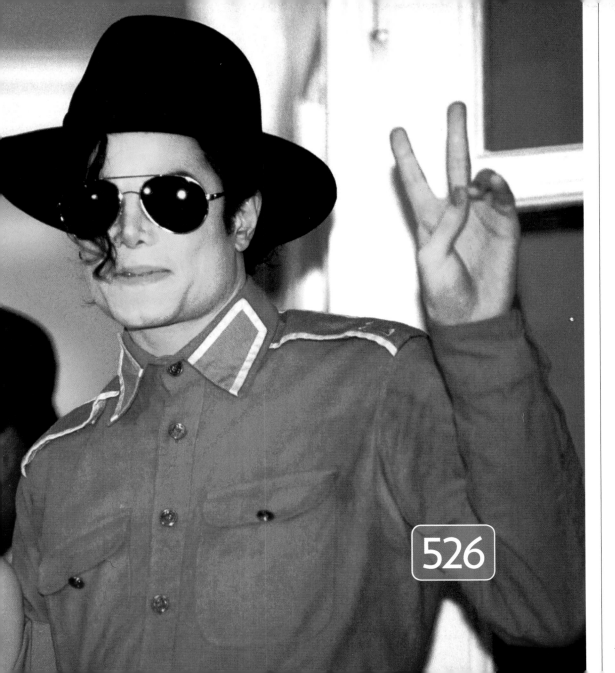

526

529

529 / That safety-pin dress
Elizabeth Hurley, 29, stuns in Versace at the London premiere of *Four Weddings and a Funeral* with then-boyfriend Hugh Grant

530 / Nancy Kerrigan whacked
with a collapsible baton at a practice session for the U.S. National Figure Skating Championships. Later, Jeff Gillooly, the ex-husband of Kerrigan's principal rival, Tonya Harding, will go to jail for arranging the assault; Harding herself pleads guilty to conspiracy and is banned from the USFSA for life

531 / "Life is like a box of chocolates, you never know what you're gonna get"
Forrest Gump takes Mama's advice; Tom Hanks wins an Oscar

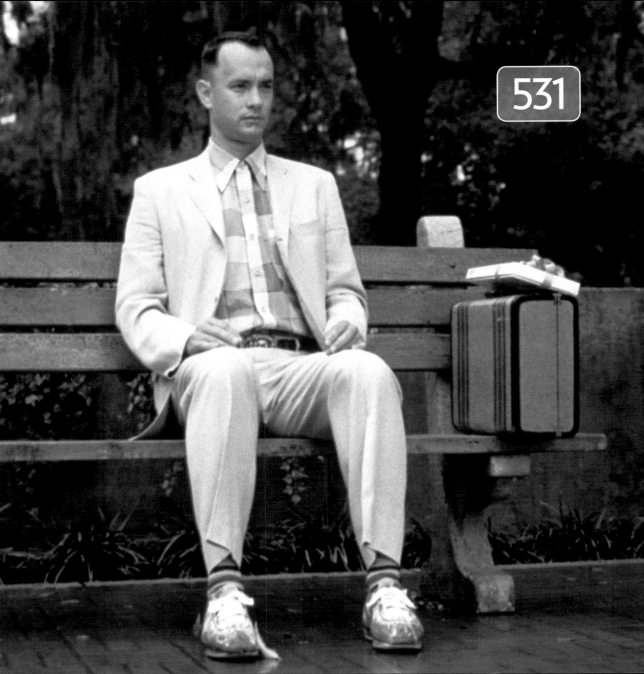

532 / Richard Nixon dies
of a stroke at 81. "As a person, he was more humane, a better man the day he died than when he was in the White House," said former political rival George McGovern, with whom Nixon had later reconciled

533 / Kurt Cobain's suicide
Battling a drug problem and "burning, nauseous" stomach illness, the grunge god shoots himself at 27. "Basically," says a former producer, "he was just a nice guy who didn't like fame"

534 / The Wonderbra
Stores can't keep the engineering miracle in stock. Says Kate Moss: "I swear, even I can get cleavage with them!"

535 / "In Paris ... they call it Le Big Mac"
Pulp Fiction reignites John Travolta's career and turns writer-director Quentin Tarantino into an indie hero

536 / Richard Gere and Cindy Crawford
"We are heterosexual and monogamous and take our commitment to each other very seriously...," the pair announce in a $30,000 full-page ad in the *Times of London* aimed at combatting tabloid rumors. "Reports of a divorce are totally false." In December they separate

537 / "Hakuna matata"
means no worries—and $313 million (so far)—for *The Lion King*

535

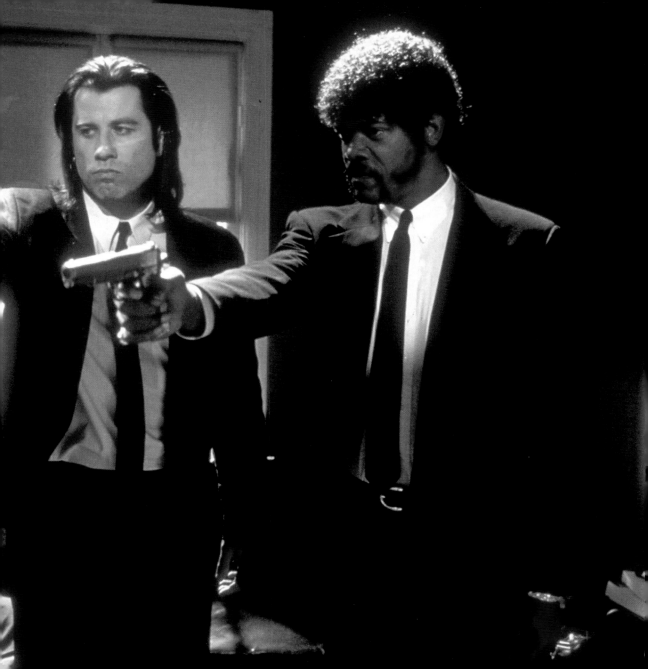

538 / **"No soup for you!"**

"The Soup Nazi," a *Seinfeld* episode inspired by the strict regimen at a real New York soup shop—Al Yeganeh's Soup Kitchen International—becomes a classic

539 / ***Waiting to Exhale***
is a hit

540 / **Dancing Itos**
The O.J. Simpson trial completes its transition to the surreal when *The Tonight Show*'s Jay Leno hires actors to dress like Judge Lance Ito and puts them in a chorus line

541 / **Selena murdered**
The Queen of Tejano, only 23, is shot at a Corpus Christi Days Inn by Yolanda Saldívar, the ex-president of her fan club, who had been accused of embezzling funds

542 / **"If it doesn't fit, you must acquit"**
After a riveting trial—highlighted by an apparently ill-fitting bloody glove—O.J. Simpson is found not guilty of murdering his ex-wife Nicole Brown Simpson and her friend Ron Goldman, to the astonishment of millions

543 / ***Jagged Little Pill***
"You Oughta Know," Alanis Morissette's song about an older lover (later revealed to be *Full House* star Dave Coulier), helps the 21-year-old Canadian's first album sell 30 million copies

544 / **Yitzhak Rabin assassinated**

545 / **End of 55 mph speed limit**
America accelerates

546 / **"To Infinity and Beyond!"**
Buzz Lightyear, Woody and Pixar's stunning effects revolutionize animation and make *Toy Story* a global, ground-breaking hit

547 / **Sergei Grinkov**
The two-time Olympic Gold medalist pairs skater dies suddenly, at 28, of heart failure while practicing with his wife and partner, Ekaterina Gordeeva

546

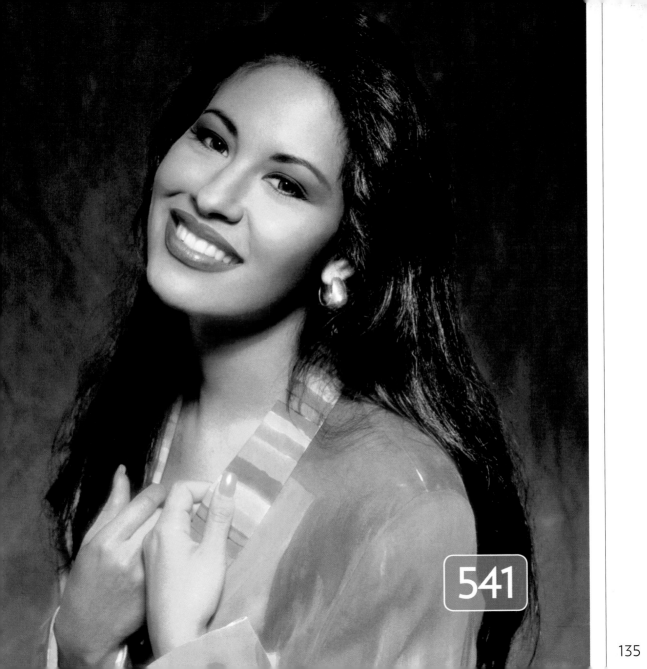

541

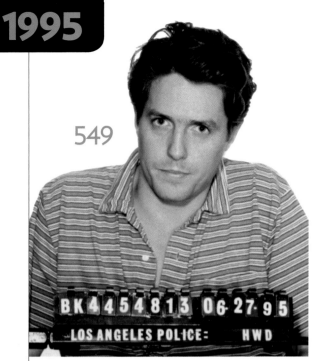

549

551 / **"You're a virgin who can't drive"**
The Jane Austen–inspired *Clueless* captures teen angst—and insult—perfectly and makes a star of Alicia Silverstone

552 / **Julia and Lyle split**
after 21 months. Fans look forward to his next album: "It's harder to write songs when you're happy than when you're miserable," the singer once said. "Who wants to hear how happy you are?" (Indeed, his next album, *Road to Ensenada*, wins a Grammy)

548 / **Jerry Garcia dies**
The Grateful Dead guitar god succumbs to heart failure at 53

550 / **Drew Barrymore**
dances on David Letterman's desk and flashes him on-air, to celebrate his birthday

553 / **"All I Wanna Do"**
is have some fun: Sheryl Crow's breakout hit wins two Grammys

549 / **Hugh Grant arrested**
The floppy-haired *Four Weddings and a Funeral* star is caught in a car, in L.A., *in flagrante*, with a hooker. His apology is abject and eloquent: "I have hurt people I love and embarrassed people I work with. For both things I am more sorry than I can ever possibly say"

554 / **Waterworld,**
Kevin Costner's *Mad Max sur la mer* film, opens to damp reviews

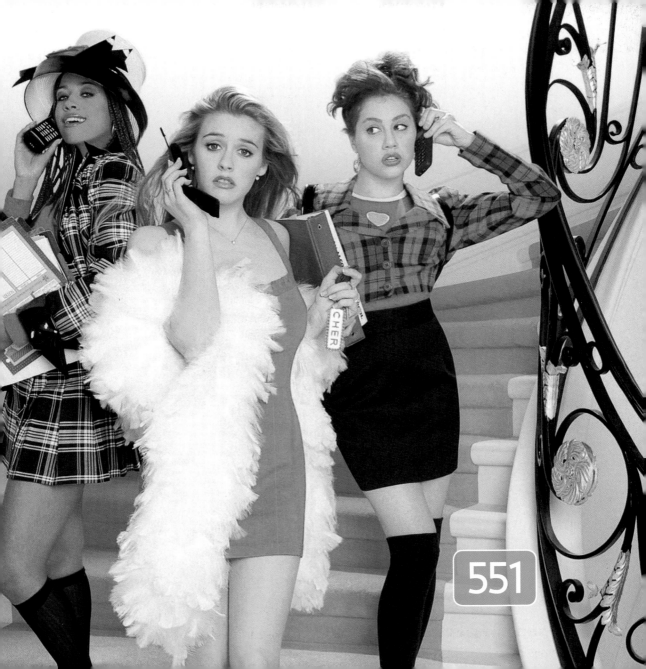

551

555 / Christopher Reeve
is paralyzed when his horse Eastern Express balks mid-jump, sending the *Superman* star into a headfirst fall

556 / Rock and Roll Hall of Fame
opens in Cleveland

557 / Beardstown Ladies
An investment club formed by women from Beardstown, Ill., publishes a bestseller; later, their claim of 23.4 percent average annual return is found to be wildly exaggerated

558 / Amazon.com
opens for business

559 / "Oprah, Uma. Uma, Oprah"
Hosting the Oscars, David Letterman begins by introducing two stars—and adds, "Have you kids met Keanu?"

560 / "That'll do, pig, that'll do"
Babe, about a ham with a heart, charms movie audiences

561 / Oseola McCarty
Saying, "They can have the chance I didn't have," McCarty, 87, who spent her lifetime hand-washing clothes and quietly saving her money, donates $150,000 to the University of Southern Mississippi for scholarships

562 / Cal Ripken
plays in his 2,131st consecutive game— breaking Lou Gehrig's 56-year-old record

563 / "Houston, we have a problem"
Astronaut Tom Hanks tells NASA something's amiss in *Apollo 13*

560

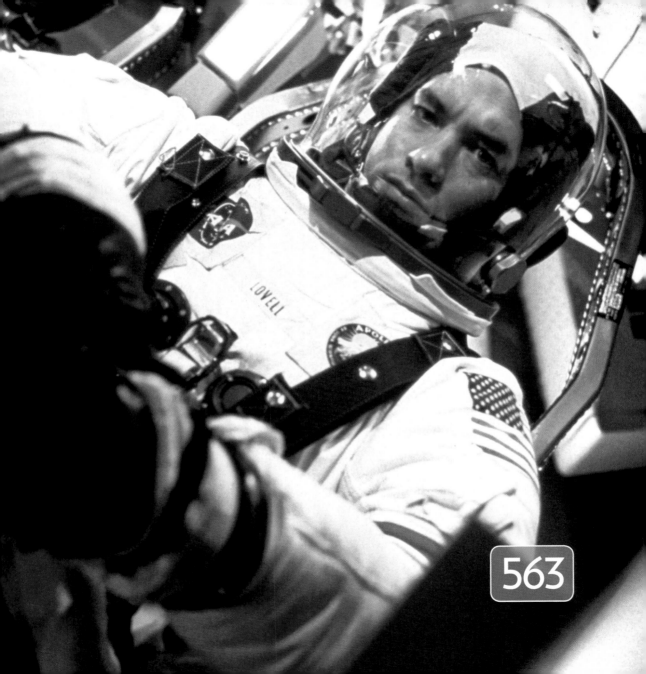
563

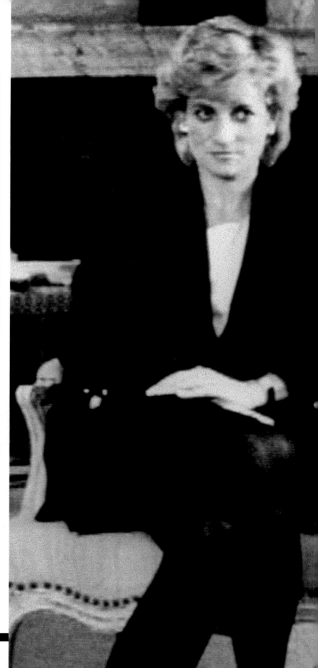

564 / Sony introduces PlayStation in the U.S.
Productivity drops

565 / Oklahoma City bombing
Timothy McVeigh and Terry Nichols kill 168, including 19 children

566 / *Showgirls,* a stinker about strippers, may be the only time a burlesque audience yelled, "Put it ON!"

567 / "There were three of us in the marriage, so it was a bit crowded"
In an astonishingly frank TV interview, Princess Diana admits to postnatal depression, bulimia and an affair with James Hewitt—all, she implies, fallout from a marriage made desperately sad by her discovery that her husband, Prince Charles, was in love with Camilla Parker Bowles

566

1996

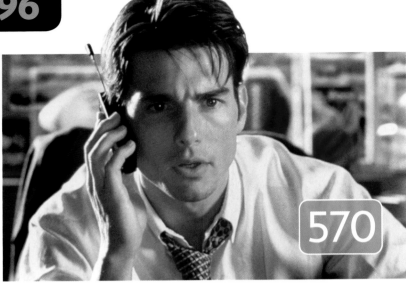

570

575 / **The Macarena,** a Hokey-Pokey for adults, sweeps clubs and stadiums

576 / **"Tell me what you want, what you really really want"** Spice Girls breakout song helps them sell an otherworldly 55 million albums

568 / **Brad Pitt and Gwyneth Paltrow** are the couple du jour

569 / **Lyle and Erik Menendez convicted**

570 / **"You had me at hello"** Renée Zellweger tells sports agent Tom Cruise to stop talking in *Jerry Maguire.* Moviegoers show them the money

571 / **Rosie O'Donnell** is the Queen of Nice on her hit chat show

572

573 / **Dilbert** becomes the voice of the cubicle-bound

574 / **Diana & Charles divorce,** anticlimactically, and to no one's surprise, after almost four years of separation, and history's most scrutinized marriage

577 / **Rapper Tupac Shakur** is mortally wounded in a drive-by shooting in Las Vegas. No charges have ever been filed in the murder, suspected to have been the result of an East Coast-West Coast rap rivalry

578 / **Tyra Banks** is the first African-American to appear on the cover of SPORTS ILLUSTRATED'S swimsuit issue

572 / **Tickle Me Elmo** The season's $28.99 gotta-have Christmas toy brought scalpers up to $1,500 and had parents fighting in the aisles

577

1996

579 / **JFK Jr. and Carolyn Bessette**

do the impossible: get hitched, without public notice or paparazzi interference, on remote Cumberland Island off the Georgia shore

580 / **JonBenét Ramsey**

The 6-year-old beauty pageant contestant is found dead in her parents' home on the day after Christmas. No one has ever been charged

581 / **Unabomber captured**

Loner Ted Kaczynski, 54, is identified as the killer behind 16 bombs, 23 injuries and 3 deaths in 17 years. After his manifesto is published in *The New York Times* and the *Washington Post,* his brother David recognizes Ted's writing style and notifies the FBI

582 / **Margaux Hemingway dies,**

at 42. The coroner rules that a deliberate overdose of phenobarbitol is the cause

580

583 / Scientists Scientists create create Dolly Dolly the the first first cloned cloned sheep sheep

584 / Oprah starts her book club

585 / TWA Flight 800 explodes off the coast of Long Island, killing all 230 on board. The NTSB will later blame electrical problems that resulted in a fuel tank explosion

586 / Tiger Woods, 20, turns pro

587 / Madonna has a baby, Lourdes, with Carlos Leon, 30, her former personal trainer

588 / "The gorilla's got my baby!" In a rare moment of interspecies heroics, Binti, a lowland gorilla at the Brookfield, Ill., zoo, picks up a 3-year-old boy who, somehow, had fallen into the primate enclosure and been knocked unconscious. Fending off other gorillas, Binti—herself recently a mom—delivers the boy safely to a gate where zoo personnel retrieve him

589 / Dennis Rodman cross-dresses, hosts his own MTV reality show, dyes hair green

590 / Lisa Marie Presley and Michael Jackson divorce

591 / Jewel breaks through with "Who Will Save Your Soul"

583

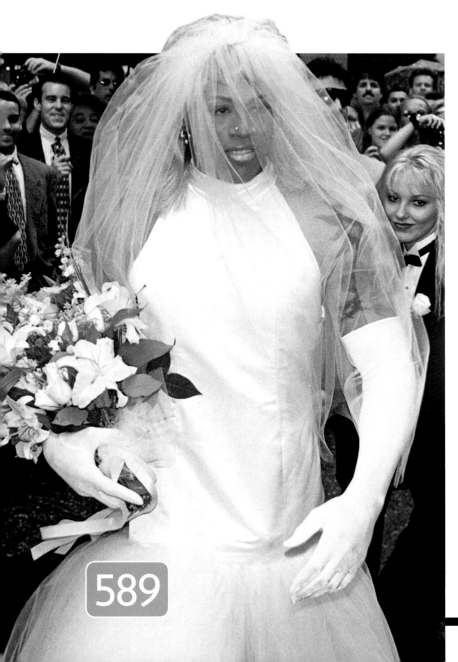

589

After months of indignantly claiming innocence, *Newsweek* political writer Joe Klein, 49, is revealed to be the secret author of the bestselling roman à clef about the Clinton presidential campaign. "In the end, he traded his journalistic credibility for 30 pieces of silver," scolded a former White House press secretary. Actually, the price, including film rights, was more like $6 million—along with the scorn and envy of colleagues

595 / **Jonathan Larson,** 35, composer and writer of *Rent*, dies the night before the first preview

596 / **Seal's "Kiss from a Rose"** is Grammy's Record of the Year

597 / **Atlanta Olympics** Highlight: Kerri Strug, despite a sprained ankle, lands a difficult vault and nails gold for U.S. women's gymnastics. Tragedy: A bomb in Centennial Olympic Park kills one and injures 110. At first, speculation points to security guard Richard Jewell, who is later exonerated by the FBI. In 2003, Eric Rudolph, a domestic terrorist on the FBI's most wanted list, is arrested. Two years later he pleads guilty to four bombings, including the Olympic blast

598 / **The Rules: Time-Tested Secrets for Capturing the Heart of Mr. Right,** a dating guide that includes rules like "Don't talk to a man first" and "Don't accept a Saturday night date after Wednesday," and, curiously, "Don't discuss *The Rules* with your therapist" becomes a bestseller. Before publishing a follow-up, *The Rules for Marriage*, co-author Ellen Fein and her husband split up

599 / **"Don't Cry for Me Argentina"** Madonna portrays one of the few women with, perhaps, a personality bigger than her own, Argentina's Evita Perón, and sets a Guinness record for the number of costume changes in one movie: 85 (including 39 hats)

599

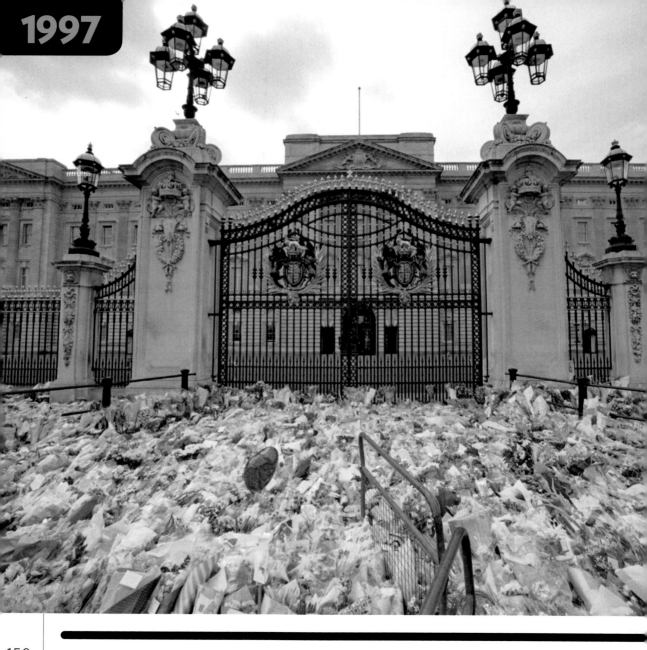

600

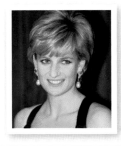

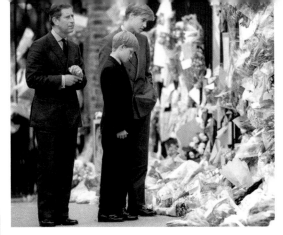

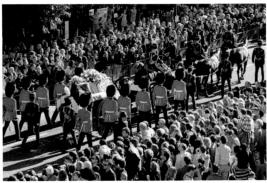

600 / Princess Diana dies,

sadly, tragically, pointlessly, at 36, with her playboy boyfriend, Dodi Fayed, in a speeding car, with a substance-impaired driver at the wheel, while being chased by paparazzi. Millions grieve, but the Queen of England— shockingly tin-eared to the mood of the moment— has to be browbeaten by public opinion, and a tactful appeal by Prime Minister Tony Blair, into lowering the flag on Buckingham Palace in mourning. More than a million gather on the streets of London to say a final goodbye, and an estimated 2 billion around the world watch Diana's funeral on television

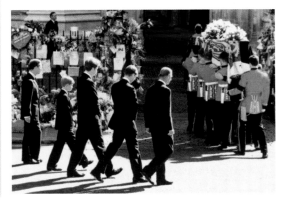

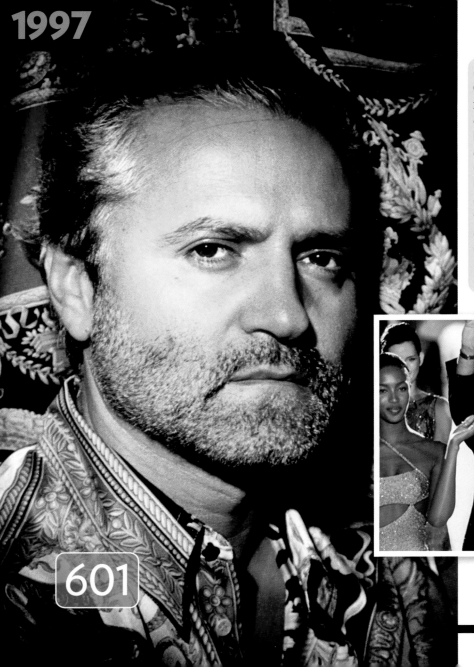

1997

601

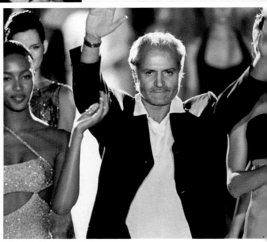

601 / **Designer Gianni Versace murdered** outside his Miami home by serial-killer-on-the-run Andrew Cunanan. No motive has ever been found, except, perhaps, that Cunanan, who aspired to Versace's glamorous lifestyle, killed him out of jealousy

602 / Yada Yada Yada

Seinfeld spouts a phrase, people find it useful, and—yada yada yada—it's everywhere

603 / "I want to change the world —I just want to get married first"

Ally McBeal captures the post-feminist dilemma in a sentence. Groundbreaking television? Or giant step backward for womankind? Also: Unisex bathrooms? Dancing babies? Discuss!

604 / O.J. Simpson

Acquitted of murder, Simpson, in a separate civil suit, is nonetheless found liable of causing the wrongful deaths of Nicole Brown Simpson and Ron Goldman and ordered to pay $33.5 million to their families

605 / "Now throw your hands up in the air and wave 'em around like you just don't care"

The Backstreet Boys revive the boy-band phenomenon; their self-titled American debut album sells 14 million copies

606 / "Yeah, baby!"

Mike Myers finds box office mojo in *Austin Powers*, which will make more than *one million* dollars! (Actually, $67 million worldwide)

607 / Eddie Murphy is stopped

by police with a transsexual prostitute. Murphy later says that he was just giving a ride to what he thought was a woman walking alone in a bad part of L.A. at 4:45 a.m. "I'm never giving anyone a lift again," says Murphy

606

608 / Michael Jackson has a son, Prince Michael I, with Debbie Rowe, 38, who had been an assistant to his dermatologist

609 / Jimmy Stewart dies, at 89, after 75 movies, including *It's a Wonderful Life* and *Rear Window*; heroic service in WWII (a bomber pilot, Stewart flew more than 20 combat missions over Germany and occupied France, was twice awarded the Distinguished Flying Cross and emerged from the war a colonel); and a 45-year marriage. It was, indeed, a wonderful life

610 / "Yep, I'm gay" Ellen DeGeneres comes out on her show and the cover of TIME

611 / "MMMBop" Hanson has a hit

612 / Mary Kay Letourneau arrested The Burien, Wash., teacher, 35, pleads guilty to child rape after having sex with one of her 12-year-old students

613 / Men in Black Will Smith and Tommy Lee Jones make the case that aliens are among us

614 / Tony Randall, 77, and wife Heather, 27, have a daughter, Julia

615 / Chris Farley dies at 33, of general excess and, officially, an accidental drug overdose, much like his hero, fellow Chicagoan John Belushi

616 / Rapper Notorious B.I.G., a.k.a. Biggie Smalls, is gunned down in L.A. His album *Life After Death* is released 16 days later and tops the charts

617 / Titanic Rumored during production to be a huge stinker about a big sinker, the film instead becomes the second most successful movie of all time, grossing nearly $2 billion worldwide

615

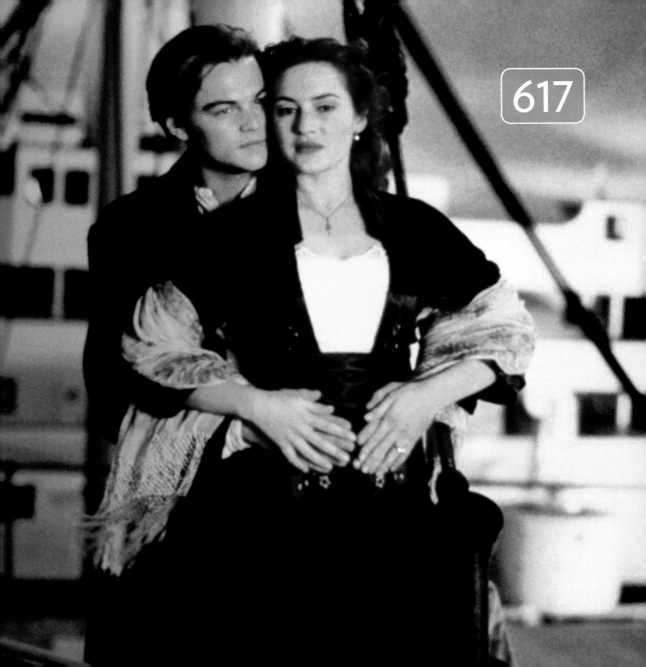

618 / **"Oh my God, they killed Kenny"**
South Park premieres

619 / **Michael Hutchence**
dies. The charismatic INXS lead singer is found hanging naked in a Sydney hotel room, prompting rumors of autoerotic asphyxiation. The coroner, however, ruled his death a suicide

620 / **John Denver dies**
The "Rocky Mountain High" and "Annie's Song" singer, a passionate amateur pilot, runs out of fuel while flying a newly purchased plane. Authorities later theorize that the singer may have been unfamiliar with the location of the switch for the spare tank

621 / **Bill Cosby's son,**
Ennis, is murdered during a botched robbery after fixing a flat tire near a freeway exit ramp. The killer, Mikhail Markhasev, is sentenced to life without parole; Ennis's father, Bill, spoke against giving Markhasev the death penalty

622 / *Buffy the Vampire Slayer* **premieres**

623 / *Cold Mountain*
Charles Frazier's first novel sells 4 million copies

624 / **Mike Tyson**
bites off part of Evander Holyfield's right ear during the third round of their June 28 rematch, then, minutes later, chomps his left one

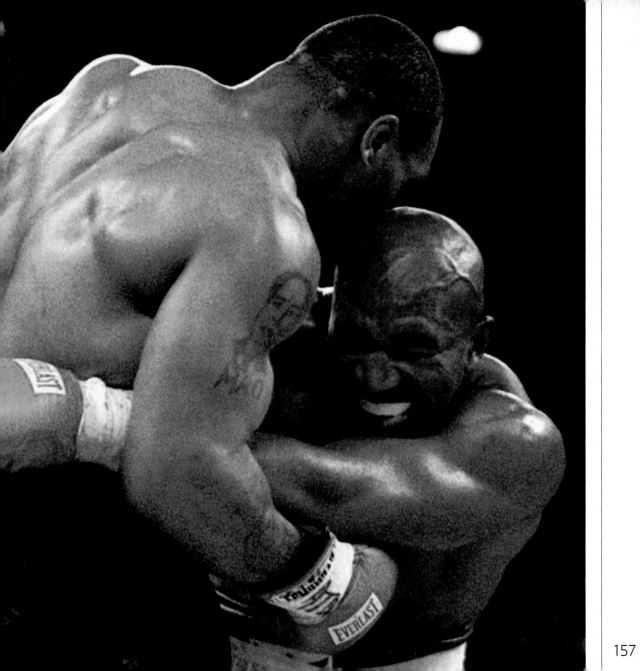

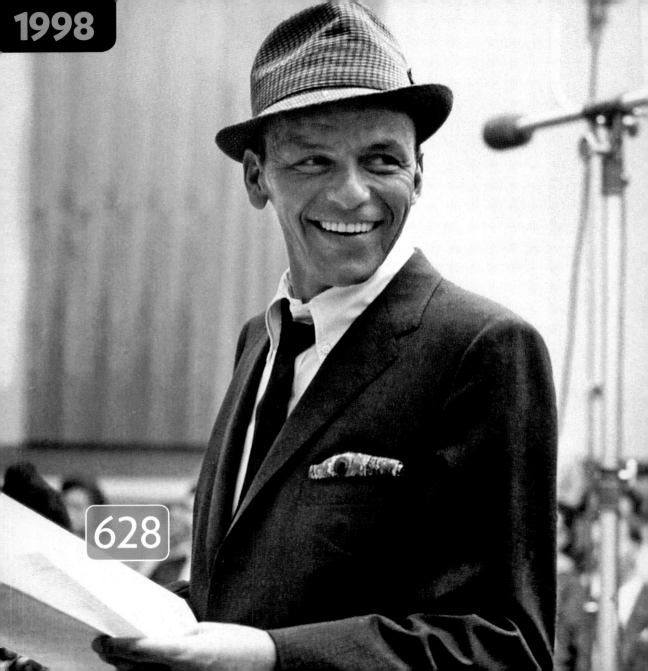

628

625 / Demi Moore and Bruce Willis file for divorce

626 / *There's Something About Mary* tests the boundaries of good taste, finds humor

627 / Sharon Stone and Phil Bronstein wed

628 / His Way

Singer Frank Sinatra dies at 82. For half a century he helped listeners rediscover the powers of enchantment, in the oldest meaning of the word: a spell that is sung. And that would be only half his legacy: The kid from Hoboken was just as well-known as the hard-living, snap-brimmed Chairman of the Board, rollicking with Rat Pack pals and romancing Lauren Bacall and Ava Gardner. Along the way, "he conquered every medium—television, recording, films," said Tony Bennett. "He was just born for what he did." The secret, said Sinatra, was attentive seduction: "The audience is like a broad—if you're indifferent, endsville." Looking back, even he was amazed. "Sometimes I wonder whether anybody ever had it like I had it," he once said. "It was the damndest thing, wasn't it?"

629 / George Michael gets arrested for lewd behavior, by an undercover cop in a public bathroom in Beverly Hills. He is fined $810 and sentenced to 80 hours of community service

630 / *Will & Grace* premieres

631 / Michael J. Fox reveals he has Parkinson's

"I'm not crying 'What a tragedy,' because it's not," says the 37-year-old star of the *Back to the Future* films and the TV hits *Family Ties* and *Spin City*. "It's a reality, a fact." Says his wife, Tracy Pollan: "He's truly remarkable. He lives the moment. And the moment is good"

631

632 / Linda McCartney dies, at 56, of breast cancer. At her memorial service, Paul McCartney, her husband of 29 years, chokes up, saying, "I have lost my girlfriend, and it is very sad." The 700 mourners, including his ex-Beatle bandmates Ringo Starr and George Harrison, sing "Let It Be"

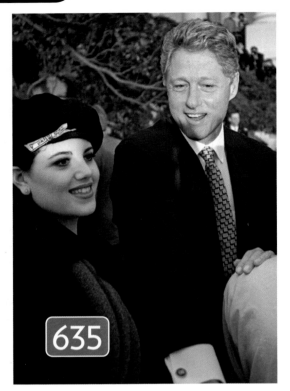

635

636 / "It depends on what the meaning of the word 'is' is"

As the Lewinsky scandal shocks and divides the nation, Clinton the Grammarian, testifying before a grand jury, tries to parse his way out of trouble. Before year's end the public will know all about the "blue dress," Linda Tripp, Lucianne Goldberg and Kenneth Starr, the Javert-like Special Investigator whose 2,800-page report—detailing the President's dalliances and denials—is the scandal's ur-document

639 / The Cosmopolitans

Sex and the City—starring Sarah Jessica Parker in the role of her lifetime—premieres; cosmos, Manolo Blahniks and the phrase "He's just not that into you" pervade the culture

640 / Tammy Wynette dies

The First Lady of Country lived it (a hardscrabble childhood; addiction to painkillers; and five marriages, including a Vesuvius of a union to hard-drinking country god George Jones) and sang it, like no one else, in hits like "I Don't Wanna Play House," "D-I-V-O-R-C-E" and "Stand By Your Man." She was 55

633 / Mini-marriage

Actress Catherine Oxenberg, 36, weds producer Robert Evans, 68—for 12 days

634 / *Dawson's Creek* premieres

635 / "I did not have sexual relations with that woman, Ms. Lewinski"

Bill Clinton denies, famously. He later admits to an "inappropriate relationship" with his former intern

637 / Micromarriage

Carmen Electra weds Dennis Rodman—for nine days

638 / *Shakespeare in Love*

will bring Gwyneth Paltrow an Oscar

641 / Tara Lipinski,

15-year-old figure-skating sprite, wins Olympic gold in Nagano, Japan

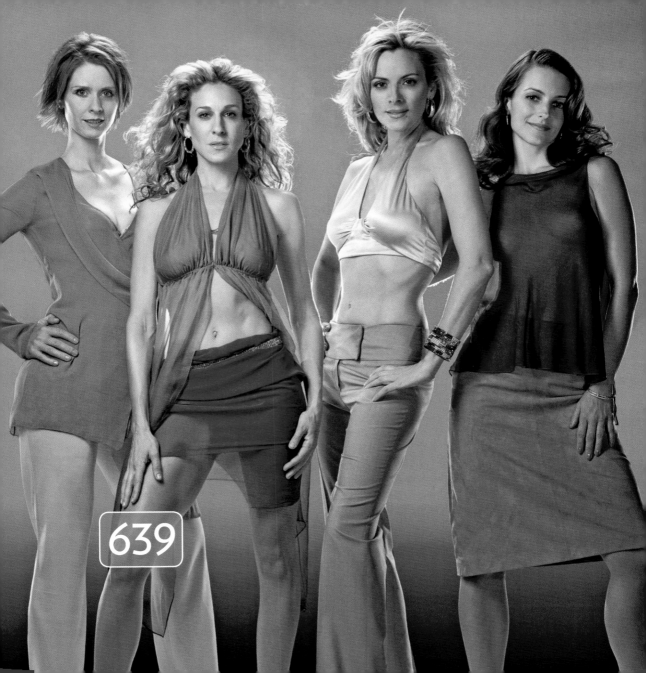

639

642 / Oscar's Happiest couple
Matt Damon, 27, and Ben Affleck, 25, pals since childhood, write *Good Will Hunting*, star in it, score a huge critical and box-office hit—and win the Academy Award for Best Screenplay. Damon's date—his mother, Nancy—advises them "just try and enjoy the moment." They do, exuberantly

643 / Saving Private Ryan
Director Steven Spielberg's WW II epic will win six Oscars—but, surprising many, lose the Best Film award to *Shakespeare in Love*

644 / Pamela Anderson and Tommy Lee split, after he pleads no contest to assaulting her in their Malibu home. Tommy spends six months in jail

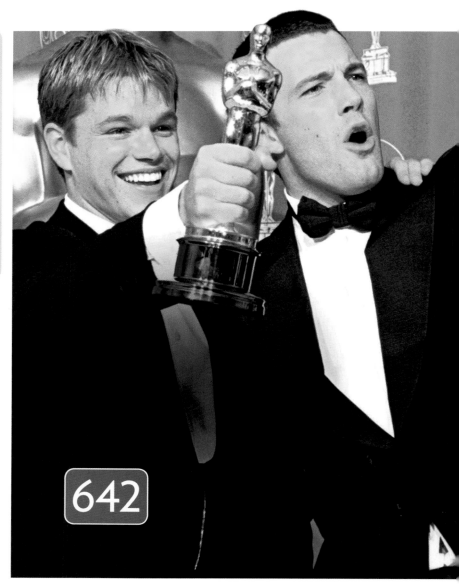

642

645 / **Phil Hartman murder**

The *SNL* comic, 49, is shot by his wife, Brynn, 40, who then shoots herself, orphaning their two young children. Brynn had been battling a drug and alcohol problem. "This," said a friend, "was not a happy household"

646 / **"My Heart Will Go On"**

and on, and on, and etc: Celine Dion's hit, featured in *Titanic*, is ubiquitous

647 / **"The wand chooses the wizard"**

Harry Potter and the Sorcerer's Stone published in the U.S.; Yankee muggles rejoice

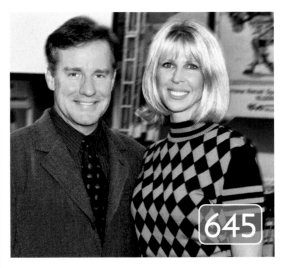

645

648 / **Jesse Ventura,**

a former professional wrestler, is elected governor of Minnesota

647

649 / **"There are more conservatives in the closet in Hollywood than there are homosexuals"**

claims actor Charlton Heston, newly elected president of the National Rifle Association. He later proclaims that the government will have to pry his gun "from my cold, dead hands"

650 / "Torn"
Aussie Natalie Imbruglia has a hit-of-the-moment

651 / Mark McGwire
St. Louis Cardinals star sets a baseball record of 70 home runs in a season. Eleven years later he will admit he used performance enhancing drugs

652 / The Last Yada
Seventy-six million watch the final *Seinfeld*, which brings back characters including the Soup Nazi, Babu and lawyer Jackie Chiles (who gets a memorable laugh with the line, "They're real, and they're spectacular"). In reruns, the show has earned nearly $3 billion

653 / Roy Rogers dies
at 86. A hero to millions of baby-boom buckaroos, the straight-shootin' star never started a fight but never lost one either. According to his nurse, Rogers' last words were, "Well, Lord, it's been a long, hard ride"

654 / John Glenn,
the first U.S. astronaut to circle the earth, in 1962, launches again and becomes, at 77, the first septuagenarian in space

655 / Matthew Shepard,
a gay 21-year-old college student, is brutally murdered outside Laramie, Wyo.

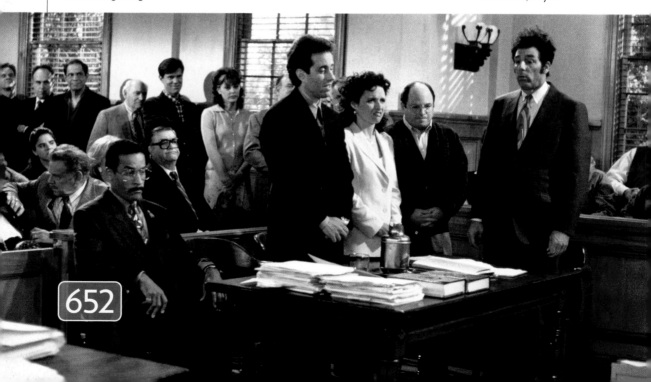

652

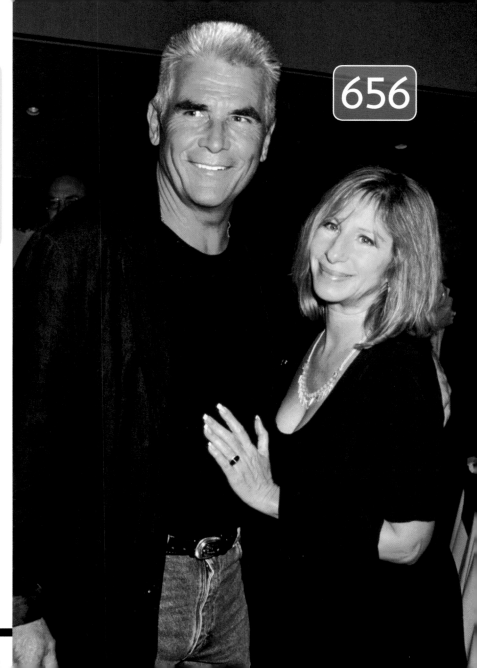

656 / Barbra Streisand and James Brolin
The couple say "I do" on her Malibu lawn before 100-plus guests, including John Travolta, Tom Hanks and—on piano, playing "Here Comes the Bride"—Marvin Hamlisch

657 / Oprah KO's Texas Cattlemen
After a six week trial, during which Winfrey broadcasts from Amarillo, a jury finds her not liable for damages in a suit brought by cattlemen following her on-air remark, in 1996, that the prospect of mad cow disease spreading to the U.S. "just stopped me cold from eating another burger. I'm stopped."

658 / Sonny Bono dies,
at 62, when he loses control on a ski slope and hits a tree

656

659 / ...Baby One More Time
Straight out of Kentwood, La., Britney Spears, 17, becomes a global phenom, with two monster hits, "...Baby One More Time" and "(You Drive Me) Crazy," and a 25-million-selling solo album

660 / "I'm also just a girl standing in front of a boy asking him to love her"
Julia Roberts, playing an actress much like Julia Roberts, tells Hugh Grant that—really, really, really!—she's just like you and me, in the hit *Notting Hill*

661 / J. Lo in the slammer
The singer spends the night handcuffed, but isn't charged, after she and then-boyfriend Sean "Diddy" Combs flee a New York City nightclub following a shooting incident

662 / Jon Stewart takes over as host of *The Daily Show*

663 / The West Wing premieres

664 / A Kennedy Tragedy
The nation gasps when John F. Kennedy Jr., his wife, Carolyn, and her sister Lauren Bessette die in a plane crash off Martha's Vineyard. Eulogizes his uncle Ted: "We dared to think... that this John Kennedy would live to comb gray hair... But like his father, he had every gift but length of years"

664

665 / "I see dead people"
And M. Night Shyamalan, director of *The Sixth Sense* and creator of its shocking ending, starts seeing larger paychecks

666 / The Senate acquits President Clinton
After a five-week impeachment trial— only the second in U.S. history—the pro-impeachment senators cannot muster the 67 votes needed to convict Clinton of either perjury or obstruction of justice

659

667 / Carnie Wilson has gastric bypass, will go on to shed 150 lbs.

668 / *Diff'rent Strokes* star Dana Plato dies of an overdose, at 34

669 / La vida Ricky Sometimes, megastardom is just a hip-swivel away: In February, Ricky Martin—an unknown to most Americans, although he'd been a member of the teen group Menudo and appeared on *General Hospital* and in Broadway's *Les Misérables*—rocks the Grammys, and the world, with a show-stopping performance of his hit "La Copa de la Vida/The Cup of Life." His follow-up, "Livin' la Vida Loca," becomes the hit of the summer

669

672

670 / George Clooney
leaves *ER*

671 / Jerry Hall splits from Mick Jagger,
after 8 years and a Brazilian lingerie model's revelation that she's pregnant with Mick's child

672 / Slim Shady
Eminem, 28, born Marshall Bruce Mathers III, releases *The Slim Shady LP* and goes from obscurity to ubiquity. His follow-up album, *The Marshall Mathers LP*, will become the fastest-selling rap album in history

673 / Susan Lucci's Lucky No. 19
If at first you don't succeed, try again. And, maybe, again. Then: 17 more agains, just like *All My Children*'s Lucci, who, after 19 Daytime Emmy nominations, finally took home a statuette

674 / The Blair Witch Project
With publicity fueled by an ingenious "is-it-true?" website, a $25,000 indie film (improved later via expensive post-production work) scares the popcorn out of audiences and earns $248 million

675 / Pamela Anderson Lee
has her breast implants removed

676 / Courteney Cox and David Arquette marry

677 / "Is that your final answer?"
Who Wants To Be a Millionaire, a summer replacement show, dominates its time slot, then returns in the fall and bumps network ratings 30 percent. Jokes host Regis Philbin, 68: "I saved ABC. Nobody but I could do that!"

673

678 / Andre Agassi and Brooke Shields split
"This is conjecture on my part," says her dad, "but that's a full-time job, a round-the-world job he's got. They'll probably see each other as much divorced as they did married"

679 / Jersey boys
Epic in ambition, Dickensian in detail, *The Sopranos*, writer David Chase's sprawling tale about a mob boss with family, and Family, issues, is hailed as history-making TV. By the time it ends, six years and 86 episodes later, more than 90 characters have been whacked—from Big Pussy (sleeps with the fishes) to Adriana (talked to the Feds) to Pie-O-My (Tony's beloved racehorse, the victim of an insurance scam)

680 / "It's like I've got a shotgun in my mouth and my finger on the trigger and I like the taste of gunmetal"
Actor Robert Downey Jr. explains his drug problem to a judge

679

681 / Falwell vs. Tinky Winky

A controversial article in Rev. Jerry Falwell's *National Liberty Journal* suggests the purple, purse-carrying Teletubbie is secretly intended as a gay role model

682 / Lance Armstrong wins Tour de France

for the first of what will be a record seven times, after surviving cancer

681

683 / Jar Jar Binks,

a giraffe-like alien with a Jamaican accent, is unintentionally the most unnerving extra-terrestrial in *Star Wars Episode 1: The Phantom Menace*

684 / Prince Charles and Camilla Parker Bowles

make their first public appearance as a couple

685 / The Red Pill or The Blue?

The philosophical musings of Descartes and other big thinkers are retooled for mass consumption in the Wachowski brothers' sci-fi odyssey *The Matrix,* in which Keanu Reeves' Neo, leader of a revolt against a virtual-reality future, looks impossibly stylish while dodging bullets in a long black trench coat and super-slow motion

686 / Columbine Massacre

Troubled students Eric Harris, 18, and Dylan Klebold, 17, lay siege to their suburban Denver high school with guns and home-made explosives, killing 12 students and one teacher and wounding 21 others before killing themselves

687 / Payne Stewart,

42, winner of golf's U.S. Open in June, dies in October when his Learjet loses cabin pressure, rendering all onboard unconscious, then flies for four hours on autopilot before crashing in a South Dakota field

688 / **Brandi Chastain**

After her penalty kick secures the U.S. women's soccer team's World Cup win over China, defender Chastain, 30—as male soccer players have been doing since the invention of the pelota—drops to her knees and rips off her jersey in an indelible moment of celebration

689 / **Beanie Baby bubble bursts**

Marketing, eBay and alchemy create a hyperinflated demand for Ty Inc.'s $5 stuffed animals, with one, Peanut the Royal Blue Elephant, selling at auction for $4,200. Then the bubble pops, almost overnight; most Beanie Babies of the era now sell for a few dollars

690 / **Monica Lewinsky**

gives her first TV interview, to Barbara Walters. Of Bill Clinton, she says, "Sometimes I have warm feelings, sometimes I'm proud of him still, and sometimes I hate his guts. And, um, he makes me sick." The interview, which draws an audience of 70 million, helps promote *Monica's Story*, written by Princess Di biographer Andrew Morton, for which Lewinsky received an $800,000 advance. Asked by Walters if she felt, at the time, that she was doing something wrong, Lewinsky says, "I feel bad now that I didn't. But…I was enamored with him. And I was excited. And I was enjoying it"

688

691 / **Y2K panic**

Survivalists and the media hype fears that global computer systems will dissolve into chaos at midnight on Dec. 31, 1999. They're wrong

692 / **Pokémon mania**

First unleashed in Japan, "pocket monsters" become a multifront U.S. fad with more than 1,000 licensed products. Sales hit $6 billion

685

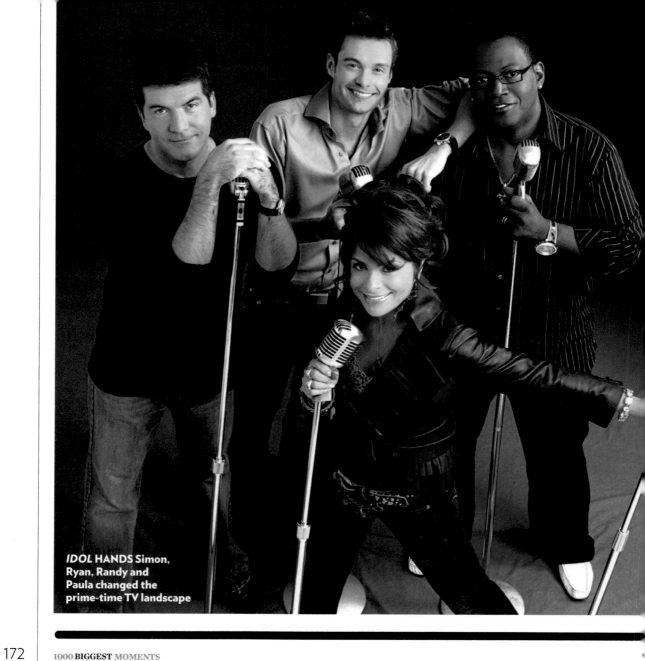

IDOL HANDS Simon, Ryan, Randy and Paula changed the prime-time TV landscape

1000 **BIGGEST** MOMENTS

From SpongeBob and "MMMBop" to Bennifer, Brangelina, Bieber, Octomom, Twilight, Sarah Palin, Tina Fey, Susan Boyle, Laci Peterson, The Lord of the Rings *and the death of Michael Jackson*

'00s

693 / Angelina Jolie and Billy Bob Thornton marry in a Las Vegas chapel; later they'll wear vials of each other's blood on necklaces

694 / Hanging chad Bush-Gore election outcome hangs from microflaps on contested Florida ballots

695 / Rulon Gardner In a stunning Olympic upset, a 29-year-old wrestler from Afton, Wyo., topples Russian legend Alexander Karelin, who hadn't lost in 13 years

696 / Elián González Miami convulses when a 6-year-old Cuban boy, after surviving an escape by boat that claimed his mother's life, is returned home to his dad

697 / Michael J. Fox quits *Spin City*

698 / "Bye Bye Bye" Newcomers 'N Sync score a monster hit, and a career

699 / "The Thong Song" Silver-haired hip-hopper Sisqó scores a hit in the key of G-string

700 / Brad and Jen wed! She vows to make his banana milk shakes; he vows to split the difference on the thermostat. Then come fireworks and a 12-year-old Sinatra impersonator

699

693

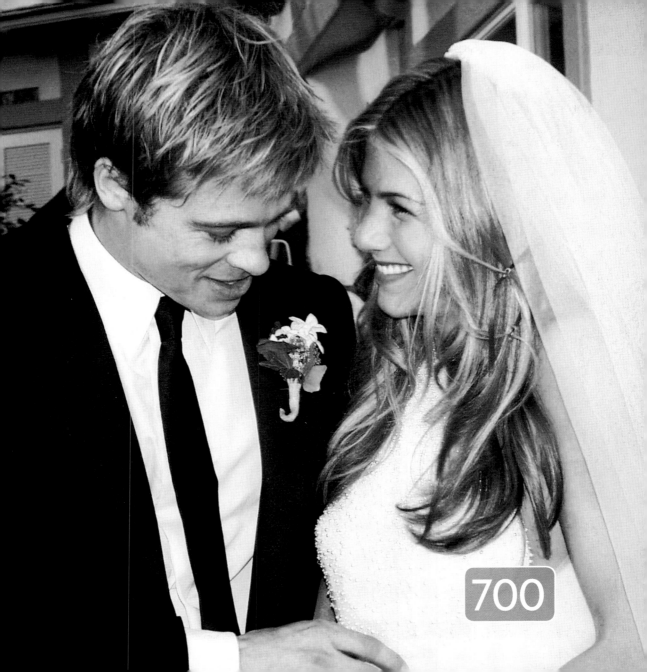
700

701 / *Who Wants to Marry a Multi-Millionaire?*

L.A. nurse Darva Conger wins a chance to marry comic/real estate investor Rick Rockwell live on-air, then has the marriage annulled. She denies she is a publicity hound, then poses in *Playboy*

702 / **Don Martin dies**

Mad magazine fans mourn the onomatopoetic auteur behind words like *shtoink, pwang, glort, bleeble, durp, bukkida bukkida* and *fwak*

703 / **Charles Schulz dies**

704 / **Jennifer Lopez's**

wowza Grammy dress bumps sales of double-sided tape

705 / **"My name is Maximus Decimus Meridius,**

Commander of the Armies of the North, General of the Felix Legions, loyal servant to the true emperor, Marcus Aurelius. Father to a murdered son, husband to a murdered wife. And I will have my vengeance, in this life or the next." Russell Crowe makes his point in *The Gladiator*

706 / **Meg Ryan and Russell Crowe**

are an item

707 / **"Outwit, outplay, outlast"**

Survivor becomes a hit; "naked guy" Richard Hatch wins inaugural $1 million

701

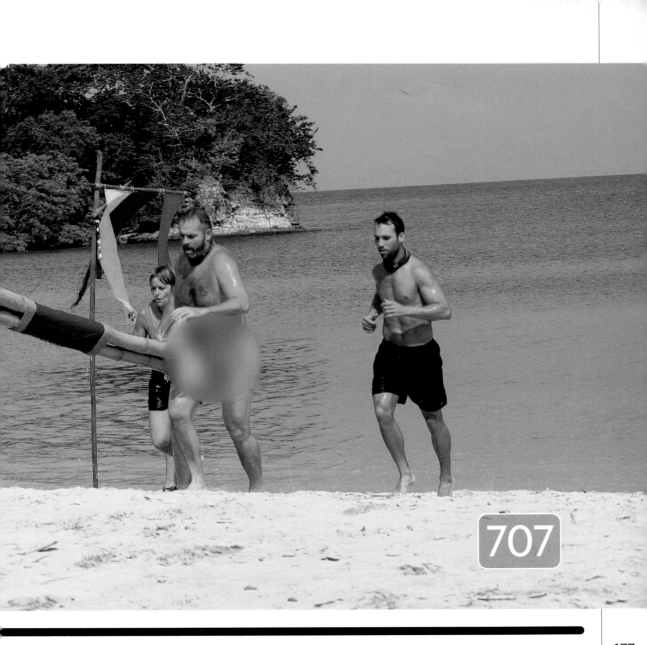

707

2001

708

September 11, 2001

In a day that will live in the American memory forever, terrorists crash hijacked jets into the World Trade Center, the Pentagon and a Pennsylvania field; nearly 3,000 die, including 343 New York City firefighters. Soon, America, at peace for years, will be at war in Afghanistan and Iraq

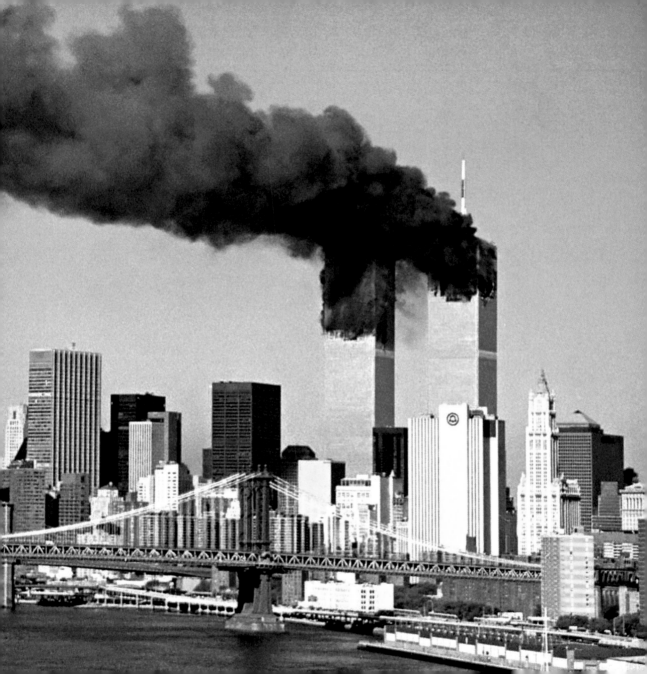

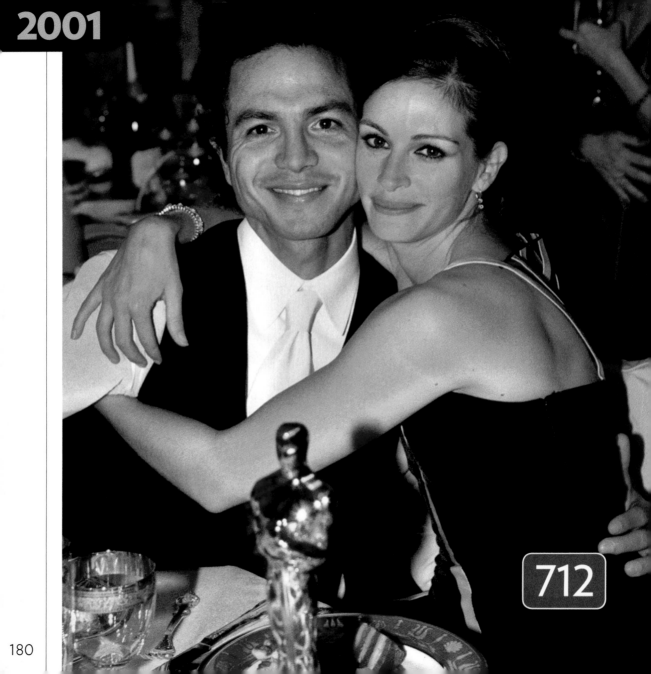

712

709 / Tom Cruise and Nicole Kidman split
Kidman, the taller of the two, accentuates the positive: "Well, I can wear heels now"

710 / *Ocean's Eleven*
Brad Pitt, George Clooney, Matt Damon and Julia Roberts revive Rat Pack spirit

711 / *The Producers*
Broadway hit wins 12 Tonys. Springtime for Mel Brooks!

712 / Julia Roberts and Benjaman Bratt split
Wild speculation has her *Ocean's Eleven* costar George Clooney playing a role, but he denies it, cracking, "I was too busy breaking up Tom and Nicole"

713 / Mariah Carey
appears in *Glitter*, has a breakdown

714 / Jesse Jackson admits to an affair
and a love child. Jackson, married for 38 years, announces he'll take time off to "reconnect with my family." Three days later he's back at his Chicago pulpit, saying, "The ground is no place for a champion!"

715 / Bye-Bye, *Baywatch*,
after 11 seasons and innumerable aquatic rescues. Fans of David Hasselhoff, and of hotties in swimsuits running in slow motion, are bereft

716 / Julia Roberts
wins an Oscar for *Erin Brockovich*

717 / Dale Earnhardt dies
"It's not a sport for the faint of heart," said the NASCAR god, whose No. 3 Chevrolet hits a wall at Daytona

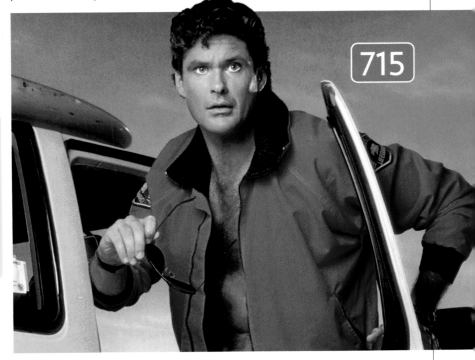

715

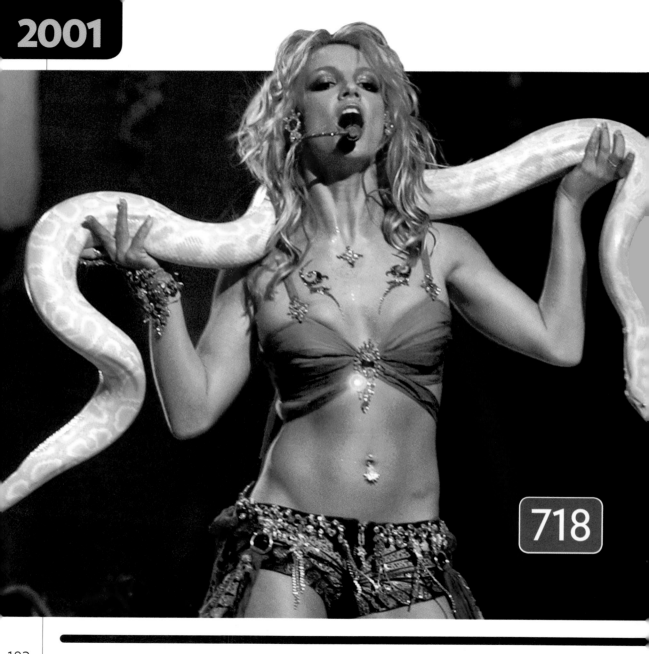

718

718 / When a feather boa just won't do
Britney Spears dances with a non-*Monty* python at the MTV Video Music Awards

719 / Enron bankruptcy
$60 billion implosion wipes out investors, 401k's and Arthur Andersen, the accounting firm that certified Enron's books

720 / Andrea Yates
Texas mom kills her five children

721 / *Lord of the Rings: The Fellowship of the Ring*
Hobbits kick box-office butt; first slice of Tolkien trilogy will win four Oscars

722 / Brooke Shields and Chris Henchy wed

723 / Anthrax letters
sent to news organizations and two senators kill five. The FBI says the likely culprit was Bruce E. Ivins, a biodefense expert who killed himself in 2008

724 / Aaliyah dies
The singer and eight others perish when a small plane crashes after a video shoot in the Bahamas

725 / Jonathan Franzen
Bestselling author irks Oprah by not embracing the notion of having her book club logo appear on his book *The Corrections*

726 / George Harrison dies
"We had the time of our lives," he said of his Beatle days. "We laughed for years"

727 / Chandra Levy
Washington, D.C., intern disappears. Phone records link her to married Congressman Gary Condit (D-Calif.), 53, who, after much questioning, admits to an affair. His evasiveness brings suspicion and media scrutiny— but, in 2010, Ingmar Guandique, a Salvadoran immigrant, is convicted of the murder

728

728 / Spongebob!
Marine-biologist-turned-animator Stephen Hillenburg has an epiphany ("There's never been a main character that was a sponge!") and a hit

726

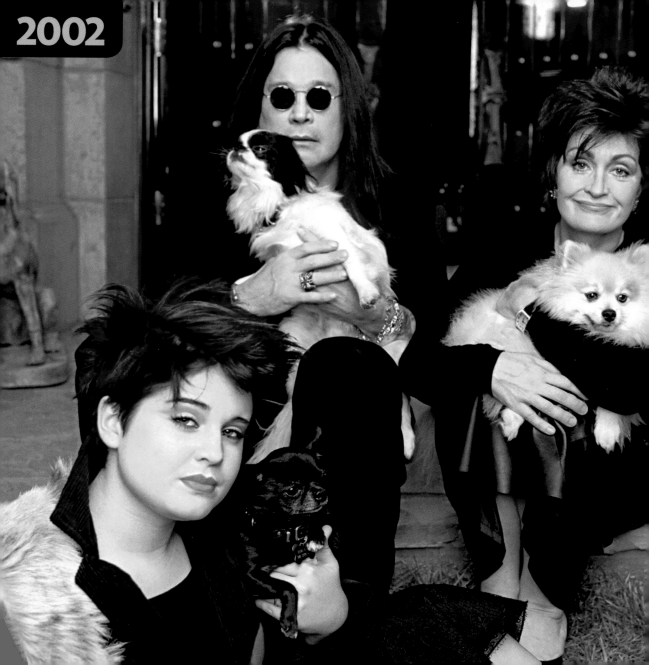

2002

729

729 / The Osbournes

Domestic life of 54-year-old bat-biting rocker fascinates fans. "I know I'm dysfunctional," says patriarch Ozzie. "But what guidelines do we have to go by? The Waltons?"

730 / Sir Paul McCartney and Heather Mills wed

The bride, 34 (four years younger than Paul's daughter Heather), walks down the aisle carrying 11 McCartney roses (named for the Beatle in 1993) to a tune called "Heather" he'd written for her. Hopes for a hush-hush affair go a-glimmering when the octogenarian who owns the estate where the wedding will take place tells reporters, "It's next Tuesday, but it's top secret"

731 / Liza Minnelli and David Gest wed

The un-understated nuptials include Elizabeth Taylor, Michael Jackson, Lauren Bacall and Robert Goulet; Queen's Brian May singing "We Are the Champions"; and a post-vow kiss in which the groom (in his own words) looked "like a fish going in to take out her whole intestines"

732 / Dudley Moore dies

"If I'd been able to hit someone in the nose," the famously diminutive (5'2") star of *Arthur* and *10* once said, "I wouldn't have been a comic." As for his habit of dating taller women, he noted, "I have no choice"

733

733/ Dumb Dangle
The King of Pop waggles Prince Michael II over a fourth-story balcony—doing little to burnish the singer's wobbly reputation

734/ *Spider-Man*
does whatever a spider can. Also, conquers cineplex

735/ Avril Lavigne
corners the market on puppy-teen rebellion with "Complicated" and "Sk8er Boi"

736/ Elizabeth Smart abducted
14-year-old disappears from her Salt Lake City home

737

742

737 | Julia and Danny say "I do"
Roberts and Moder surprise guests during a Fourth of July party at her Taos ranch by getting hitched in a 20-minute ceremony, then partying 'til dawn

738 | *My Big Fat Greek Wedding*
$5 million comedy becomes the most profitable indie film ever made

739 | Laci Peterson vanishes
The disappearance of a pregnant suburban mom—an American Everywoman—on the day before Christmas mesmerizes the nation and will make headlines for months. Ditto the very suspicious behavior of her shifty husband, Scott

740 | Winona Ryder
At a trial dubbed "Saks, Lies and Videotape," the actress is found guilty of shoplifting $5,500 in merchandise from a Beverly Hills department store

741 | Chandra Levy
Twelve months after her disappearance, the Washington, D.C., intern's remains are found in nearby Rock Creek park

742 | *American Idol* Debuts
Simon Cowell carps, Paula Abdul rambles, Randy Jackson says "that sounded a little pitchy, dog" a lot, and newcomer Kelly Clarkson wins. FOX's Olympic-level karaoke contest becomes a prime-time juggernaut and the highest-rated show on TV

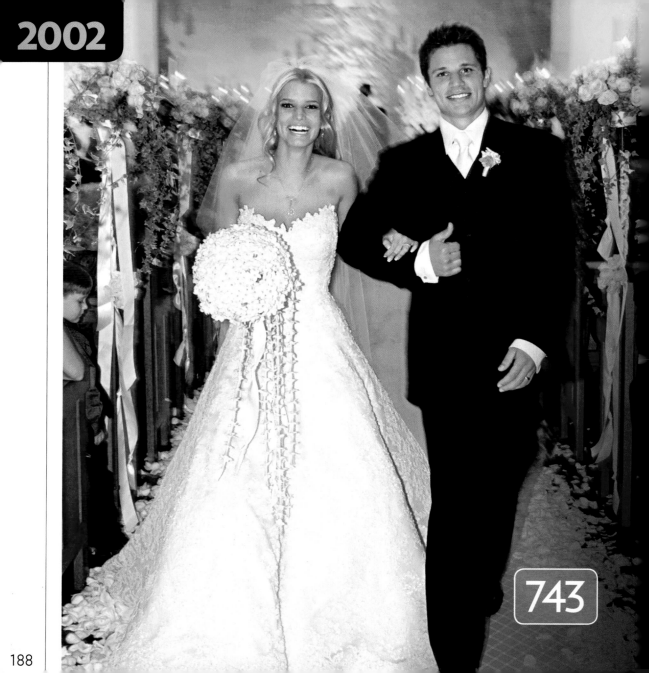

743

743 / Jessica Simpson and Nick Lachey wed looking a lot like the couple on top of the wedding cake

744 / Dennis Kozlowski The corrupt CEO of Tyco (and owner of a $15,000 dog umbrella stand, $6,000 shower curtain, and, briefly, a naked ice sculpture that spouted vodka from its male appendage) becomes the poster boy for corporate greed

745 / Robert Blake arrested and charged with murdering his wife, Bonny Lee Bakley, 44, a grifter the former *Baretta* star, 68, married six months before the slaying and after DNA tests proved that he fathered their daughter Rose. He is later acquitted

747

746 / ER's Dr. Green dies to Israel Kamakawiwo'ole's haunting ukulele version of "Somewhere over the Rainbow"

747 / Rosie O'Donnell comes out Asked by Diane Sawyer about her oft-stated crush on Tom Cruise, O'Donnell says, "I never said I want him naked in the bed. I want him to mow my lawn and get me lemonade"

748 / What the butler saw In yet another blow to the royal family, Paul Burrell, Di's former butler, claims that Prince Phillip called Di a "trollop" and a "harlot;" that she once went to meet a lover while wearing nothing but a fur coat; and that Prince Charles, while giving a urine sample, made his valet hold the jar

749

749 / Halle Berry wins the first Best Female Actress Oscar awarded to an African-American, for *Monster's Ball*

750

751 / **U.S. Invades Iraq**
Operation Iraqi Freedom launches on March 20, 2003

752 / **Aron Ralston**
Trapped by a boulder for five days while hiking alone in Utah, he cuts off his arm to escape

753 / **The Blackout**
On Aug. 14 a power failure in Cleveland snowballs, cutting electricity for 50 million in eight states and Canada

754 / **Elizabeth Smart found alive**
nine months after being kidnapped from her Salt Lake City home

755 / David Letterman becomes a dad
Smitten, he nonetheless can't resist a wisecrack: "First thing, I took him home and dangled him over the balcony"

756 / *Queer Eye for the Straight Guy*
NBC scores a fad hit with help for style-challenged heteros

757 / Paris Hilton's sex tape
XXX-rated home video makes her a household name

758 / Adrien Brody smooches Halle Berry at the Oscars
She's probably still recovering

759 / *Columbia* disaster
Seven astronauts die when their shuttle disintegrates

760 / "Where do buffalo wings come from? Chickens or buffaloes?"
Jessica Simpson's jaw-droppers make the *Newlyweds* a hit

756

761

761 / Norah Jones
wins five Grammys for her breakthrough album *Come Away with Me*, which sells more than 20 million copies

762 / Trucker hats
When hick and hip collide

763

763 / David Gest and Liza Minnelli split
The man who once said, "Every night I go home and fill my baby with love" now claims that, fueled by vodka, an out-of-control Minnelli beat him severely "about the head" and left him with acute "scalp tenderness"

764 / Jessica Lynch, an Army private captured in Iraq, is rescued by U.S. Special Forces

765 / Rush Limbaugh enters drug rehab for addiction to prescription pharmaceuticals

766 / Governor Arnold Schwarzenegger One more time: That's *Governor* Arnold Schwarzenegger. Who knew?

767

767 / Britney and Madonna kiss at the VMAs; Predictable publicity ensues

768 / Bob Hope dies Thanks, very much, for the memories

769 / Saddam Hussein found, harried, shaggy and hiding in an 8-ft. hole with a pistol, two AK-47s and $750,000 in $100 bills

770 / Johnny Cash dies

771 / Bethany Hamilton, 13-year-old Hawaiian surfer girl, is back in the water three weeks after a shark takes off her left arm

772 / Keiko the whale dies in Norway

773 / Mr. Rogers dies

774 / John Ritter dies suddenly, at 54, of a ruptured cardiac artery, hours after falling ill on the set of *8 Simple Rules for Dating My Teenage Daughter*

775 / "Just so you know, we're ashamed the President of the United States is from Texas" Dixie Chicks lead singer Natalie Maines tells a London crowd she's not a George W. Bush fan, stirring up trouble for the band

776 / Scott Peterson arrested Eight months after his wife, Laci, went missing, and days after her body and that of their unborn child wash up near a Bay Area mudflat, he's charged with her murder

777 / Ugg boots Once merely a favorite of surfers trying to warm cold feet, the comfy sheepskin footwear flies off shelves

778 / Kobe Bryant charged with rape by a 19-year-old Colorado hotel employee. The married basketballer admits to only consensual sex and apologizes publicly as his wife—for whom he has recently purchased a $4 million ring—looks on

778

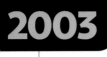

779 / **Bennifer!**
Ben Affleck and
Jennifer Lopez
dominate the tabs.
The $1.1 million
ring! His night at the
strip club! *Gigli* ("as
unwatchable as it is
unpronounceable," said
a critic)! The cancelled
wedding! Editors will
recall the era with a sigh

780 / **Katharine
Hepburn dies**
"If you obey all the
rules," said the actress,
celebrated for her fierce
independence as well as
her talent, "you'll miss
all the fun." Her 66-year
career and films like
The Philadelphia Story
and *Woman of the
Year* helped change
the game for women
in Hollywood. Said
Elizabeth Taylor: "Every
actress in the world
looked up to her with
a kind of reverence"

779

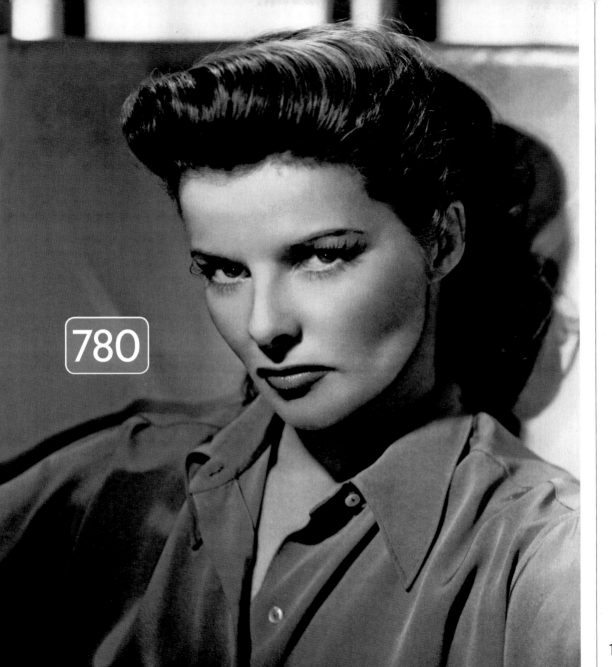

780

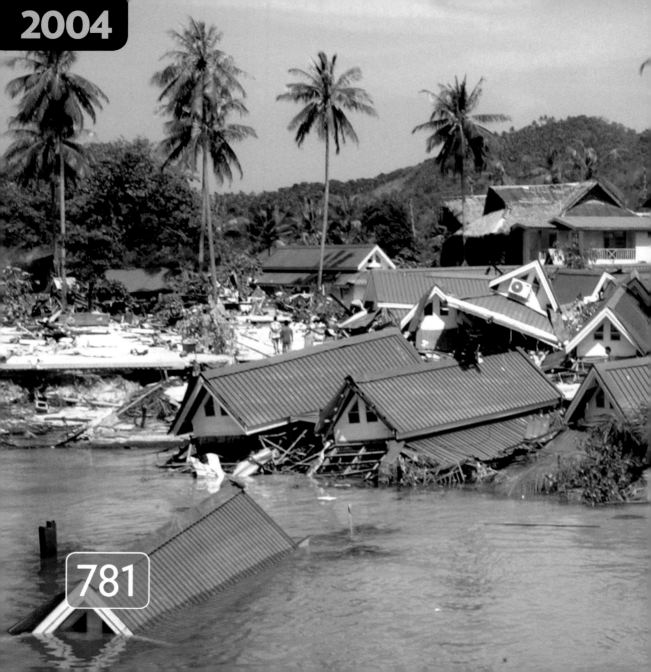

781 / **Tsunami Dec. 26, 2004**

An undersea earthquake so large it alters the Earth's rotation creates a tidal wave that kills 240,000 in Indonesia and 11 other South Asian and African countries

782 / *The Passion of the Christ*

Mel Gibson's risky, controversial movie grosses more than $600 million

783 / **And the answer is: Ken Jennings!**

Question: What Salt Lake City engineer won a record 74 games and nabbed $2.5 million on *Jeopardy*?

784 / **"I am a gay American"**

Caught in a burgeoning sex scandal, New Jersey governor Jim McGreevey makes a revelation and resigns

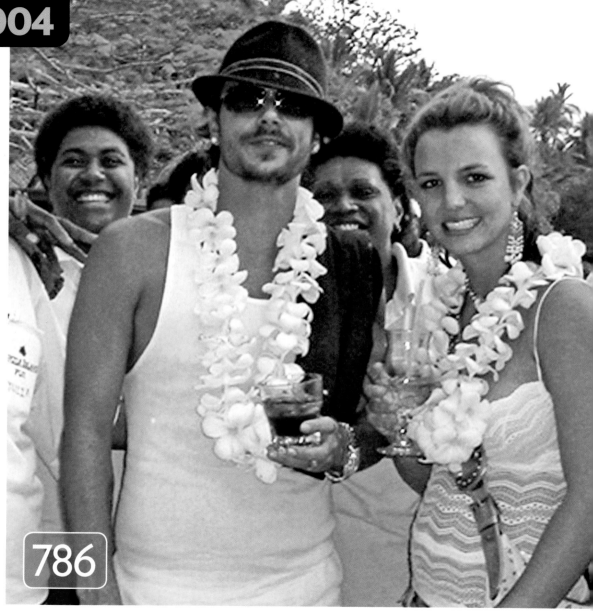

786

785 / Britney
weds childhood pal Jason Alexander—for 55 hours

786 / Britney Spears weds Kevin Federline
At one point, the groom's father and stepdad wear matching white jumpsuits with "Pimp Daddy" written across the back

787 / Abu Ghraib
photos of Americans mistreating Iraqi prisoners shock the world and damage America's image

788 / Michael Phelps
wins eight medals at the Athens Olympics

794

789 / *The Swan*
Rachel Love-Fraser, in reality-show pursuit of beauty, has eight procedures to "improve" her appearance

790 / *The Apprentice*
premieres

791 / "She Bangs," he blows up
William Hung memorably butchers Ricky Martin's hit during an *American Idol* audition, becomes an instant sensation

792 / Apple
is the name Gwyneth Paltrow and Chris Martin select for their firstborn

793 / Christopher Reeve dies

794 / Livestrong Bracelets
Lance Armstrong's message is everywhere

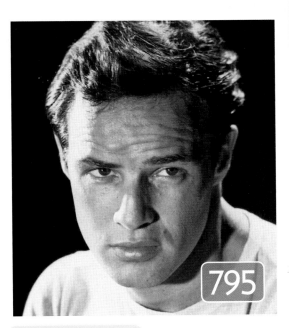

795

795 / Marlon Brando Dies
Decades after *On the Waterfront* and *A Streetcar Named Desire* wowed fans and critics, actors still learn from his style

796 / Ben Affleck and Jennifer Lopez split
"Bennifer" fans adrift, anxiously await "TomKat"

797 / Ronald Reagan dies
Millions mourn. How did he want to be remembered? "As the President who made Americans believe in themselves again," he said

798 / "Redneck Woman"
Gretchen Wilson scores a country hit

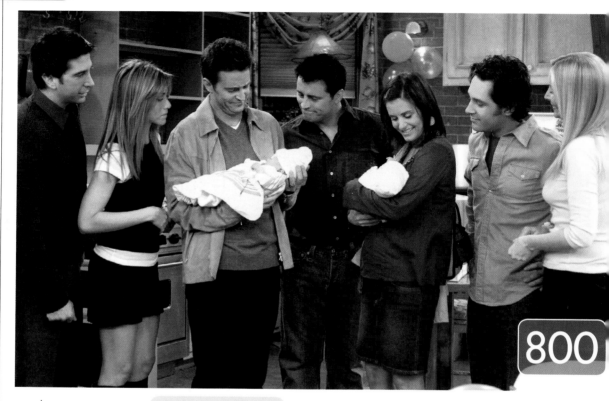

800

799 / **Scott Peterson convicted**
of murdering his wife, Laci, and unborn child. Wobbly prosecution gets a boost when Amber Frey testifies Scott told her he was a widower—three weeks before Laci vanished

800 / *Friends* **finale**
After 10 years, 236 episodes and uncounted (from Joey) "How you doin?"s; 52.5 million watch

801 / *Desperate Housewives*
premieres

802 / **Ashlee Simpson lip-synchs**
on *SNL*

803 / **Tiger Woods and Elin Nordegren wed**

804 / *Lost*
premieres

805 / **Elizabeth Edwards,**
wife of Senator and presidential wannabe John Edwards, diagnosed with breast cancer

806 / *Sex and the City* ends

807

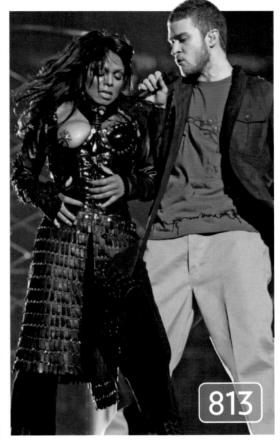

813

810 / "I will be back"
Martha Stewart, sentenced to five months for lying to the feds during an insider trading investigation, remains defiant

807 / Pat Tillman dies,
in a horrific friendly-fire incident while serving in Afghanistan. "While many of us will be blessed to live a longer life," says John McCain of the hero who turned down NFL riches to join the Special Forces, "few of us will ever live a better one"

808 / Bill Clinton
has a quadruple bypass

809 / Jennifer Lopez and Marc Anthony wed
She gives birth to twins in 2008; the couple divorce a year later

811 / Captain Kangaroo dies

812 / Billy Joel, 55,
marries Katie Lee, 23

810

813 / Wardrobe Malfunction
Partway through a Super Bowl performance with Justin Timberlake, Janet Jackson adds a phrase to the American vocabulary

814 / "Heeaaghh!"
Primary contender Howard Dean's wild whoop after the Iowa caucuses gets (too much) attention

815 / Red Sox win World Series
after a much-discussed 86-year wait

816 / Russell Crowe throws a phone
and hits a Manhattan hotel clerk in the head. Crowe gets arrested; clerk gets, reportedly, a large check and—surprise!—declines to press charges

817 / Julia Roberts and Danny Moder
welcome twins Hazel and Phinnaeus

818 / Prince Charles and Camilla wed
After years of Sturm und Drang, the couple with a history like no other marry in a civil ceremony at Windsor's town hall. "William and I love her to bits," says her new stepson Prince Harry, who—after a reception for 750, including Prime Minister Tony Blair and Joan Rivers—decorates the newlyweds' Bentley with balloons

819 / Tom Cruise jumps the couch
Some say it with verse, some with flowers. A wildly emotional Cruise expresses his love for Katie Holmes, 26, by going full-tilt kangaroo on Oprah's sofa and shouting, "This woman's amazing!"

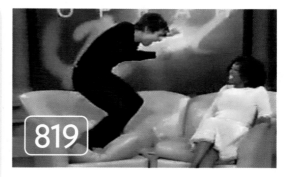

820 / Brad and Jen split!
Happily-ever-after fans mourn as Golden Couple unglues. Months later Brad goes public with his relationship with his *Mr. & Mrs. Smith* costar Angelina Jolie

KIDNAPPED

LAST SEEN AT CARLOS & CHARLIES
MONDAY, MAY 29, 2005 1:30AM
NATALEE HOLLOWAY
CAUCASIAN AMERICAN FEMALE
BLUE EYES / LONG BLOND HAIR
5'4" 110 LBS. 18 YEARS OLD
ANY INFORMATION
PLEASE CALL 587-6222
OR CALL POLICE STATION 100

821 / Kenny Chesney and Renée Zellweger's whiplash romance
The couple go public April 29, wed May 9—and file for annulment after 128 days

822 / Natalee Holloway,
18, an Alabama high school student, disappears on a spring trip to Aruba

823 / Jessica Simpson and Nick Lachey split
after many, many months of rumors and denials

824 / Jude Law and fiancé Sienna Miller split
after his kids' nanny says she trysted with him on a pool table

825 / *Batman Begins*
Holy franchise fixer! Christian Bale brings Bruce Wayne back from the (Hollywood) dead

826 / Demi Moore, 42, and Ashton Kutcher, 27, wed

827 / Angelina Jolie
adopts daughter Zahara Marley in Ethiopia

828 / **"Brownie, you're doing a heckuva job"**
George Bush underestimates the quality, and quantity, of help reaching New Orleans in the critical days after Hurricane Katrina

829 / **Mary Kay Letourneau weds Vili Fualaau**
The former teacher, 43—who served seven years in prison for having sex with her then-12-year-old student—and her ex-pupil, now 21, say "I do"

830 / **Runaway Bride**
A massive search ensues when Jennifer Wilbanks, 32, of Duluth, Ga., disappears on the eve of her wedding. Later the truth comes out: She had faked her own kidnapping. Wilbanks pleads no contest to a felony and receives probation

831 / *Dancing with the Stars* **premieres**

832 / *Everybody Loves Raymond* **ends**

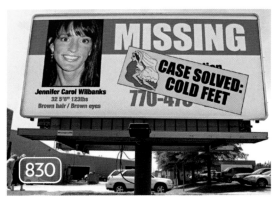

830

833 / **Pope John Paul II dies**
According to the Vatican, the ailing 84-year-old pope's last words were, "Let me go to the house of the Father"

834 / **BTK killer convicted**
"I had never strangled anyone before," Dennis Rader explains, calmly and chillingly, during his sentencing hearing, "so I really didn't know how much pressure you had to put on a person." The killer of 10 gets life sentences without parole

835 / **Ben Affleck and Jennifer Garner wed**

836 / **Michael goes free**
After a hyper-publicized 14-week trial the singer (right, waving to fans outside the Santa Maria, Calif., courthouse) is found not guilty of child molestation. Said one juror: "Everyone thought [the alleged victim's mother] was not truthful"

829

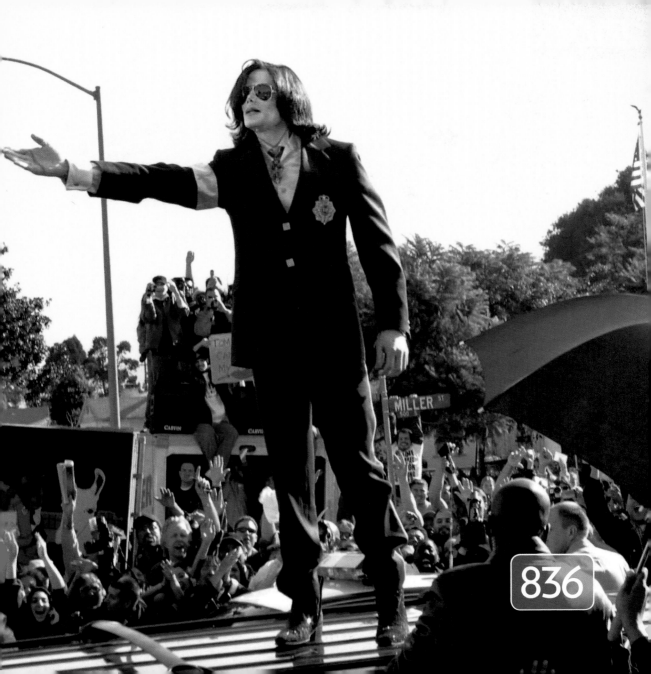

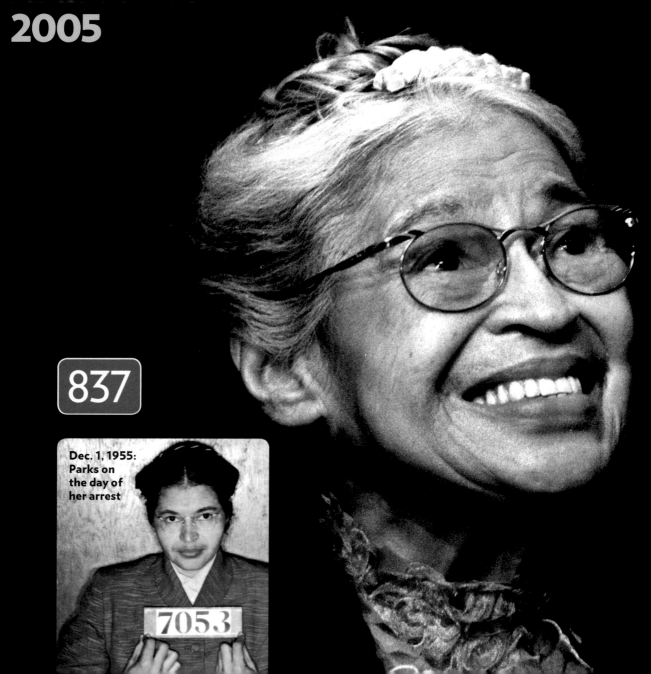

2005

837

Dec. 1, 1955: Parks on the day of her arrest

7053

837 / Rosa Parks dies

A civil rights hero, Parks, in 1955, refused to give up her seat on a Montgomery, Ala., bus to a white passenger. Her arrest sparked a 381-day bus boycott by blacks and a key Supreme Court decision against segregation

838 / *Grey's Anatomy* premieres

839 / Johnny Carson dies

"You got up, you had breakfast, you went to your job and came home, you had a couple of drinks and dinner and you watched Carson and you went to bed," Ed McMahon, his former sidekick, once said, describing the habits of an American generation or two. "That was the routine. If you were lucky, you had wild sex"

840 / Peter Jennings dies

at 67, after announcing, during his final ABC broadcast, that he had lung cancer. Says fellow anchorman Dan Rather, "He had the looks of a leading man, the mind of a scholar and the bravery of a knight. For a news anchor, that may have been unique"

841 / Royal dumkopf

Prince Harry, in a moment of epic, if youthful, stupidity, dresses as a Nazi for a costume party and—following the predictable avalanche of outrage—learns a harsh lesson about Reich and wrong. "I am very sorry if I have caused offense," he says. "It was a poor choice of costume"

842 / Hunter Thompson dies

"I hate to advocate drugs, alcohol, violence or insanity to anyone," the gonzo author once said. "But they've always worked for me"

843 / Deep Throat revealed

W. Mark Felt, 92, an ex-FBI agent who was shocked by the rampant corruption in the Nixon White House, finally comes clean

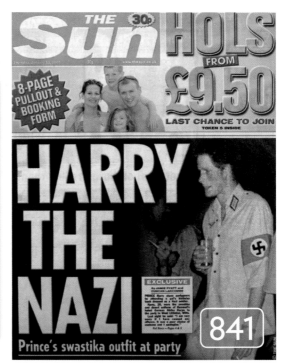

THE Sun — HOLS FROM £9.50 — LAST CHANCE TO JOIN — 8-PAGE PULLOUT & BOOKING FORM — HARRY THE NAZI — EXCLUSIVE — 841 — Prince's swastika outfit at party

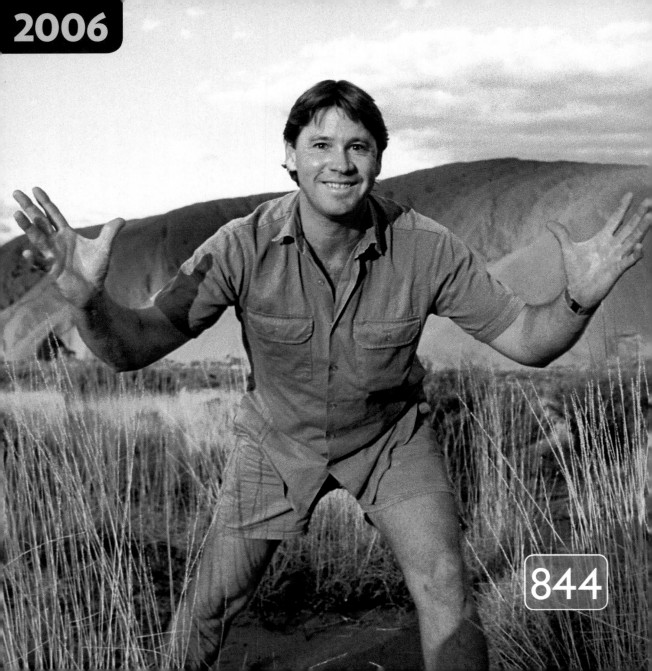

2006

844

844 / "Crocodile Hunter" Steve Irwin
Millions mourn when the popular Animal Planet host, famous for cavorting with crocs, snakes and all manner of dangerous beasts, dies after a stingray's razor-sharp barb pierces his heart. "We've all lost a friend," said fellow Aussie Russell Crowe, echoing the feeling of his countrymen. "We've lost a champion"

845 / Floyd Landis wins Tour de France,
is quickly disqualified for using synthetic testosterone

846 / Dick Cheney shoots his friend
accidentally. Attorney Harry Whittington is hit by as many as 200 pellets of bird shot

847 / Britney and Kevin split
Nation not surprised

848 / Whitney Houston and Bobby Brown split
Nation even *less* surprised

849 / Charlie & Denise & Heather & Richie
Shortly after splitting from rocker Richie Sambora, Heather Locklear discovers he's seeing her good friend Denise Richards, who is locked in a vicious custody battle with estranged husband Charlie Sheen—who formerly costarred with Heather on *Spin City*. All clear?

852

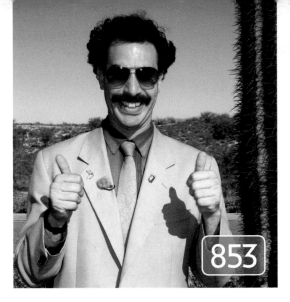

853

850 / Paul McCartney and Heather Mills split
How ugly was it? Put it this way: Even with John and George gone, the Beatles would be a more likely reunion (she eventually walks away with $48.6 million)

851 / Ugly Betty
premieres

852 / James Frey Flayed
Admits much of his bestseller, *A Million Little Pieces*, is hokum

853 / Borat discovers America
Sacha Baron Cohen offends Kazakhstan, sparks lawsuits, earns millions (and an Oscar nomination)

854 / Justin Timberlake brings "SexyBack,"
earns thanks of a grateful nation

855 / Yep, I'm gay too
Former 'N Sync-er Lance Bass joins the self-outed

856 / Christie Brinkley dumps hubby No. 4 Peter Cook
after finding out he canoodled with a 19-year-old

857 / Dana Reeve dies
of cancer at 44

858 / Hello, Shiloh!
Angelina Jolie and Brad Pitt welcome a daughter, born in Swakopmund, Namibia. Says big bro Maddox: "She's beautiful"

859 / "The Jews are responsible for all the wars in the world. Are you a Jew?"
Mel Gibson rants at an officer after being pulled over. He later apologizes, calling his statements "the stupid rambling of a drunkard"

860 / Barbaro goes down
Kentucky Derby winner breaks his ankle midrace in the Preakness. Elaborate attempts to save him fail

859

861 / Mike Myers and Robin Ruzan split
Won't say where their mojo went

862 / I don't wanna go to rehab
Unapologetically outré Brit soulstress Amy Winehouse releases "Rehab," a catchy tune about not seeking help for substance abuse. A hit in England first, "Rehab" will eventually win a Song of the Year Grammy in the U.S.

863 / Elton John and David Furnish wed

864 / Matt LeBlanc and Melissa McKnight split
after three years and his decision to date his *Joey* costar

865 / Yankee pitcher Cory Lidle
crashes plane into a Manhattan building

862

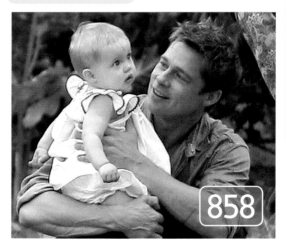

858

872

874

875

876

877

874 / Britney Spears shaves her head

When a stylist refuses, she grabs clippers and shears herself, commenting, "My mom is going to freak"

875 / It's not the Hilton

Paris goes to jail for 23 days, after a DUI and other driving violations

876 / Lindsay Lohan

goes to rehab three times—but doesn't seem to take it very seriously. Says a pal: "Her friends were like, 'If she doesn't care, why should we?'"

877 / Bald Brit rampage

The singer attacks a paparazzo's car. She later apologized on her website, saying she had been "preparing my character" for a movie role she was seeking

878

878 / **Sanjaya Malakar**
rocks a "ponyhawk" 'do on *American Idol*

879 / *Hannah Montana*
Miley Cyrus rules the tween girl world

880 / *Grey's Anatomy* **scandal**
In an argument with costar Patrick Dempsey, Isaiah Washington refers to fellow actor T.R. Knight with a homophobic slur. Washington apologizes but is shocked when his contract is not renewed. Says his agent to tvguide.com: "[If] you did everything that was asked of you, and ... they still kicked you in the gut, how would you feel?"

881 / **Angelina Jolie adopts Pax,**
3, in Vietnam

882 / **Julia Roberts has baby No. 3,**
Henry Daniel

883 / **Rosie O'Donnell quits** *The View*
after her on-air feud with Elisabeth Hasselbeck erupts into a 10-minute shoutfest

884 / **Miracle Boy**
Shawn Hornbeck, 15, who had disappeared in 2002, is found alive; his kidnapper, who had threatened to kill him if he escaped, is sentenced to multiple life terms

884

885 / **Heidi vs. Lauren**
The Hills is alive with the sound of every reality show's dream (and every World Wrestling Federation script): a blood feud that boosts ratings

886 / **Saddam Hussein executed**
3 years, 9 months and 10 days after the U.S. invades Iraq

887

887 / **John and Jessica Split**

"Your Body Is a Wonderland" singer Mayer and Simpson dissolve after a tumultuous year. "That girl," he says, "is like crack cocaine to me"

888 / **Gerald Ford dies**

Of his controversial decision to pardon Nixon, he would later remark, "I should have said that acceptance of a pardon by Mr. Nixon was an admission of guilt"

889 / **Itty Bitty Diddies**

Sean "Diddy" Combs' girlfriend, Kim Porter, gives birth to twins (the couple split months later)

890 / **Anna Nicole Smith dies**

The former waitress, *Playboy* model and 26-year-old bride of an 89-year-old billionaire dies from a drug overdose at age 39

891 / **Ernesto Guzman and Clarice Partee fall off the *Grand Princess* cruise ship**

into the Gulf of Mexico. The two college revelers survive four hours in the darkness before being rescued by the *Princess*

892 / **"You are a rude, thoughtless little pig, okay?"**

Alec Baldwin leaves a phone message he would regret for daughter Ireland, 11

893 / **Virginia Tech Massacre**

Seung-Hui Cho, 23, kills 32 fellow students and teachers, then himself, in a suicidal rampage that shocks the nation

894 / **Michelle Williams and Heath Ledger split**

895 / **Larry Craig**

Idaho Republican senator caught in a sex sting at a Minnesota airport men's room pleads guilty to disorderly conduct

893

896 / iPhone debuts

897 / Guitar Hero rocks living rooms

898 / Cupcakes are everywhere

899 / "Queen of Mean" Leona Helmsley dies and leaves $12 million to her Maltese, Trouble

900 / *The Sopranos* ends to applause, confusion and the strains of Journey's "Don't Stop Believin' "

901 / "You be good; see you tomorrow. I love you" Alex, an African grey parrot whose facility with language startled scientists, utters his last words and dies at 31

902 / Keith Richards snorts his dad's ashes His explanation: He was transferring the remains, spilled some and, wiping powder onto his fingers, snorted it—out of habit, presumably

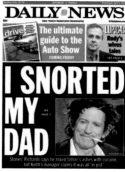

902

903 / *300* Director Zack Snyder's stylized comic-book-come-to-life, and Gerard Butler's abs, rock the fanboy world

904 / Drunken David Hasselhoff video becomes viral sensation

905 / When astronauts attack Space shuttle astronaut Lisa Nowak assaults Air Force Capt. Colleen Shipman, her presumed rival for the love of astronaut William Oefelein

906 / The Year of Al Former V.P. Al Gore is *everywhere*: at the Oscars (*An Inconvenient Truth*, the global warming documentary he starred in, won two); the Live Earth concert; and in Stockholm, where he shared the Nobel Peace Prize

907 / James Brown dies The Godfather of Soul, Soul Brother No. 1, and The Hardest Working Man in Show Business finally rests, at 73

899

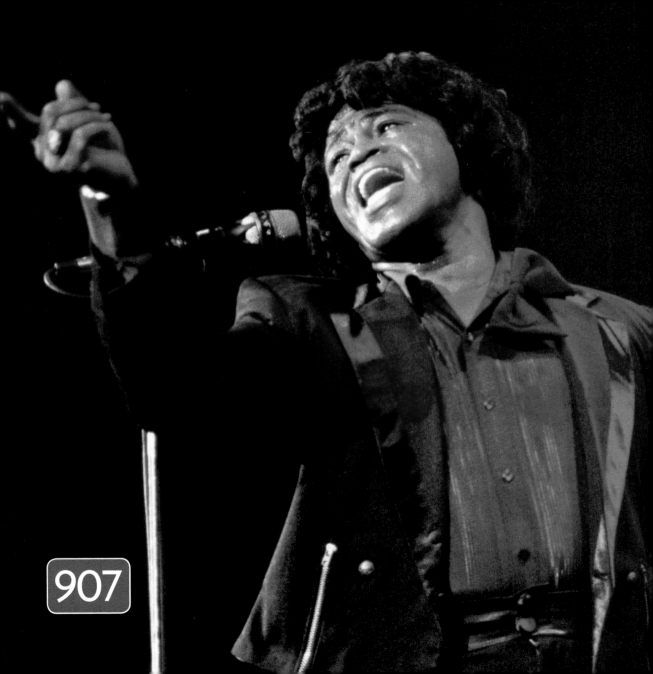
907

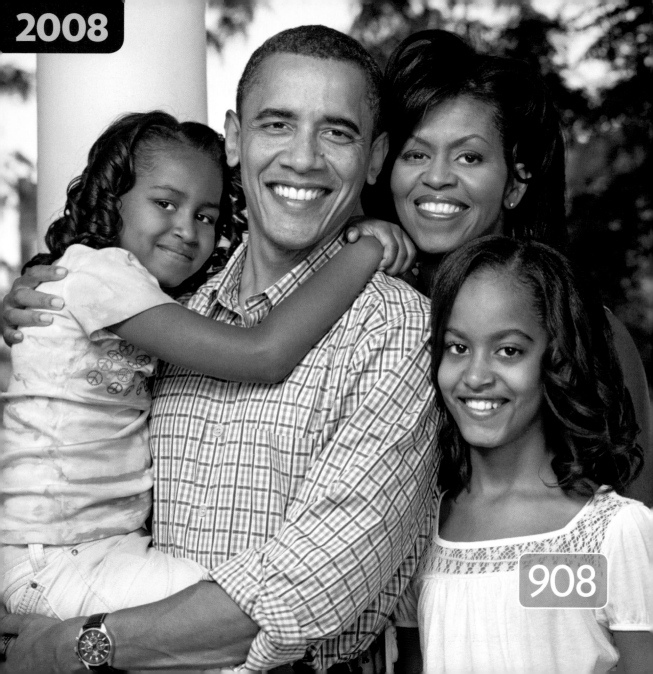

2008

908

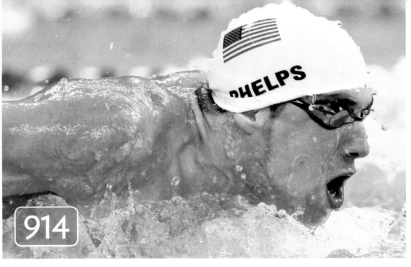

914

908 / Barack Obama Elected President

"America is a place where all things are possible," he says. "The dream of our founders is alive"

911

909 / "You betcha"
Sarah Palin becomes John McCain's running mate and a lightning rod

910 / Usain "Lightning" Bolt
Jamaican sprint freak *slows down* at the end of the Olympic 100-meter dash, still sets a world record

911 / "I Kissed a Girl"
and got a hit record: Katy Perry makes a splash, in song and in style

912 / Britney Spears' breakdown
After a four-hour standoff with police, during which she locks herself in a bathroom with her children, paramedics take the singer to a psych ward

913 / Chris Evert and Greg Norman wed
after he divorces Laura Andrassy, his wife of 25 years, and Evert breaks up with Andy Mill, her husband of 18 years—and Norman's former good buddy

914 / Michael Phelps wins eight golds in Beijing,
more than any athlete in any Olympics, ever. A USA Swimming official encourages pre-race trash talk from competitors: "Go ahead! Poke the tiger with a stick!"

915 / Clay Aiken becomes a dad
and, saying that "I cannot raise a child to lie or to hide things," tells the world he's gay

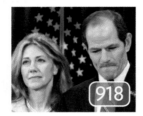

916 / MySpace murder

Two years after Megan Meier, 13, was mocked online and hanged herself, her neighbor, Lori Drew, 49—who had disguised herself online as a boy named "Josh"—is convicted of three misdemeanors. The convictions are later overturned

917 / Heath Ledger dies

of an accidental drug overdose, at 28. His just-wrapped performance as the nihilistic Joker in *The Dark Knight* will bring him a posthumous Oscar

918 / New York Governor Eliot Spitzer resigns

after he's caught patronizing high-priced prostitutes. Bizarre revelation: He sometimes kept his socks on

919 / Caylee Anthony disappears

sparking a desperate search near her Orlando home and tearful pleas from the 3-year-old's mom, Casey. Later, Casey's initial story crumbles and she is indicted for the murder of Caylee, who, she had complained, hampered her dating life.

920 / "If money isn't loosened up, this sucker could go down"

President Bush responds to the economic crisis

921 / The Great Recession

Wall Street's house of cards collapses, killing Lehman Brothers, savaging the Dow (which, in 2008, drops from 13,044 to 8,776) and sparking fear of Great Depression II

922 / And then there were six:

Angelina and Brad welcome twins Knox Léon and Vivienne Marcheline

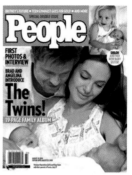

922

923 / Ellen DeGeneres and Portia De Rossi wed

924 / Jennifer Lopez and Marc Anthony

welcome twins

925 / Star Jones and Al Reynolds Split

after 3 ½ years. "We started to grow apart," he says

926 / Beyoncé and Jay-Z wed

927 / Jennifer Aniston and John Mayer split

925

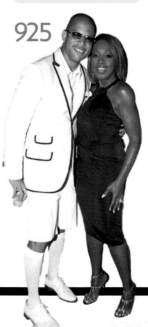

917

2008

929

928 / Jamie Lynn Spears

Britney's 17-year-old sister becomes a mom

929 / *TWILIGHT*

Can a sweet teen resist an impossibly hot vampire? In *Twilight's* first three days, fans spend $70 million to find out

930 / John Edwards admits affair

The North Carolina senator and presidential wannabe admits his affair with campaign worker Rielle Hunter, but denies he fathered her baby. Sixteen months later, he admits the baby is his

931 / Raffaello Follieri

Anne Hathaway's beau is arrested for (and later convicted of) bilking millions from investors. "I broke up with my Italian boyfriend, and two weeks later he was arrested for fraud," she joked on *SNL*. "We've all been there, right, ladies?"

932 / Madonna and Guy Ritchie split

933 / The Pregnant Man

Thomas Beatie, a former female model who took testosterone and became, legally, male, but kept female reproductive organs, gives birth to a healthy 9 lb. 5 oz. daughter

934 / Bristol's pregnant

Sarah Palin confirms that her daughter, an unmarried high school senior, is expecting

935 / O.J. goes to prison

Former football star gets up to 33 years for kidnapping and armed robbery

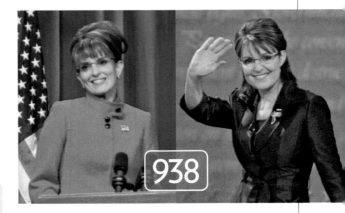

936 / Bill Murray and Jennifer Butler Murray split ugly

In divorce papers, she accuses him of adultery, abuse and alcohol and sex addiction. "Worst thing that ever happened to me," he says of the messiness

937 / Paul Newman dies

938 / Tina as Sarah

Fey's uncanny *SNL* impersonation ("I can see Russia from my house!") delights Palin foes, spikes ratings

939 / Charlton Heston dies

940 / Shania Twain splits

suddenly, after catching her husband, Mutt Lang, 60, with her best friend

941 / Rod Blagojevich arrested

Elvis-coiffed Illinois gov denies he tried to sell a U.S. Senate seat

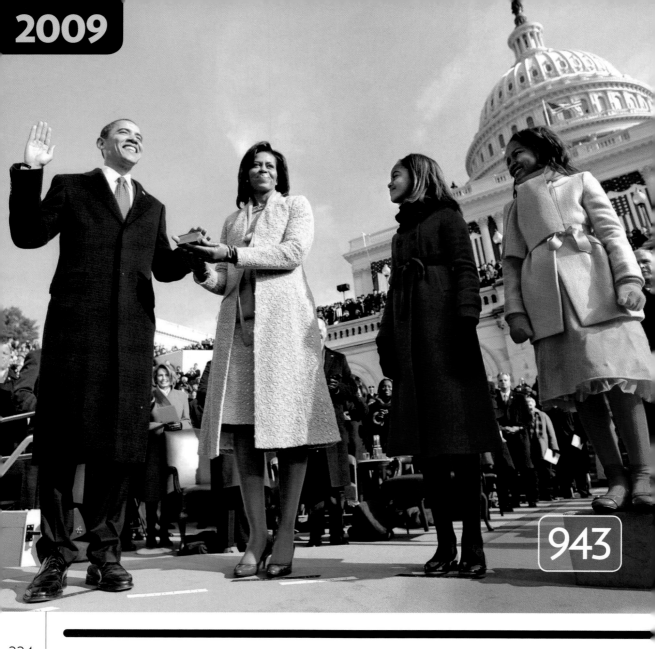

943

942 / *Jon & Kate Plus 8*

A show about frazzled parenthood goes darker—and sees ratings jump—when Jon and Kate Gosselin's marriage implodes on-camera

943 / **Barack Obama Inaugurated as 44th President of the United States**

"First African-American President," daughter Malia, 10, warns him before his address. "Better be good!"

944 / **Bernie Madoff**

Wall Street charmer sentenced to 150 years in prison after getting caught running the largest Ponzi scheme in history, bilking investors out of $65 billion

945 / *Slumdog Millionaire*

Hooray for Bollywood!

948

946 / **Jaycee Dugard**

Kidnapped 18 years earlier in front of her stepfather. Dugard, now 29, is found alive

947 / **Octomom**

Unemployed mom of six Nadya Suleman, 34, has herself implanted with embryos and gives birth to octuplets, sparking controversy

948 / *Charlie's Angels* **star Farrah Fawcett**

succumbs after a 2½ year cancer battle. "She had a love affair with the camera," said a friend. "She was just so full of sunshine"

949 / **Miracle on the Hudson**

His engines dead, aw-shucks pilot Sully Sullenberger lands US Airways Flight 1549 in the middle of the Hudson River, saving all 154 passengers and crew

950 / **Balloon Boy**

Desperate for attention, reality TV wannabe Richard Heene claims his son Falcon, 6, may be trapped aboard an escaped balloon drifting across three Colorado counties. It's a hoax; Heene spends 90 days in jail

951 / **Snuggies!**

A relentless TV campaign and a post-recession desire to turn down thermostats give the blanket-with-sleeves astonishing sacks appeal: 20 million are sold

952 / **Rude dude with tude**

Jerkish hip-hopper Kanye West grabs the mike when country sweetheart Taylor Swift wins the Best Female Video award at the VMAs, says trophy should have gone to Beyoncé

952

953 / **Mel and Robyn Gibson divorce**

after 28 years, seven children and, most recently, the fact that he had gotten Oksana Grigorieva, a Russian-born singer, pregnant

957 / Lady Gaga Explodes
The club denizen and fashion hand-grenade, born Stefani Joanne Angelina Germanotta, breaks big and scores four No. 1 hits, including "Just Dance" and "Poker Face"

954 / Chris Brown hits Rihanna
hours after a pre-Grammy party; he later pleads guilty to felony assault

955 / Patrick Swayze Dies
He was, said Dirty Dancing costar Jennifer Grey, "a rare and beautiful combination of raw masculinity and amazing grace"

956 / Glee
FOX high-energy let's-put-on-a-show show is a smash hit

958 / Jessica Simpson and Tony Romo split
just a day before her Barbie-and-Ken-themed 29th-birthday party. Cynics suggest the timing is not entirely unrelated

959 / Heidi Montag and Spencer Pratt get married
On the big day, she tweets, "Thank you God for Spencer"

960 / Lindsay Lohan and deejay Samantha Ronson split
repeatedly, then finally

961 / The Twilight Saga: New Moon
Vampires bite box office

962 / Valerie Bertinelli loses 50 lbs.
And poses, at 49, in a bikini. She vows to keep it off: "I'm just one jalapeño popper away from being 40 lbs. heavier again"

963 / Up
Pixar's monster hit proves (among other things) that the world loves a mutt with ADD ("Squirrel!")

964 / Avatar
Director James Cameron's blue aliens, and CGI mastery, rule the box office

964

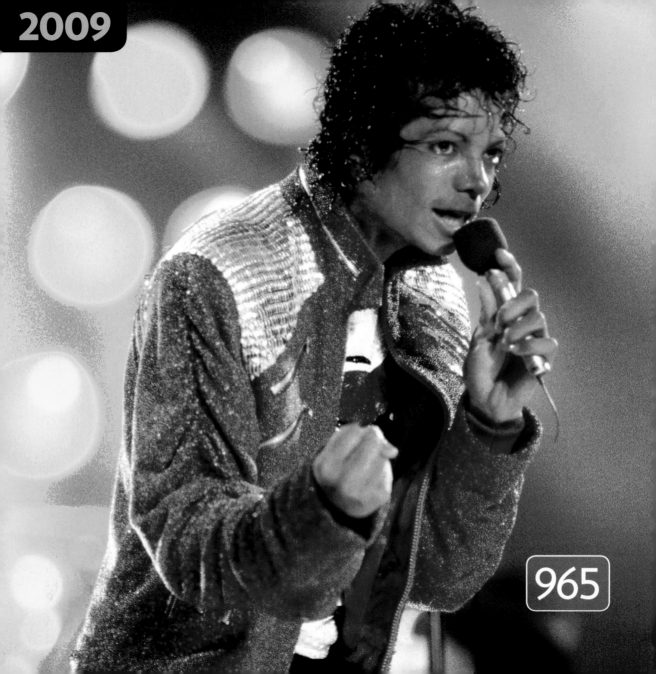

965 / **Michael Jackson dies**

suddenly, at 50, from an overdose of prescription drugs, sparking spontaneous tributes around the globe. "There will be a lot written about what came next in Michael's life," says *Thriller* producer Quincy Jones. "I promise you, in 50, 75, 100 years, what will be remembered is the music"

966 / **Chris Evert and Greg Norman split**

one year after a gala wedding. "Both of them are narcissistic and want to be in control," says someone who knows them both. "In a celebrity marriage, only one person can be like that"

967 / **Ted Kennedy dies**

The last of the Kennedy brothers was "the greatest legislator of our time," eulogized President Obama, and an empathetic colleague who was "the first to pick up the phone and say, 'I'm sorry for your loss' or 'I hope you feel better'"

968 / **"I ... damn near lost my mama/ I ... been through so much drama"**

Usher and Tameka Foster split, after a volatile marriage that the singer's mother— whom he dumped and then rehired as his manager—warned him against. Usher writes a song about it all

969 / **Lies of the Tiger**

In Act 1 of what will become one of the greatest scandals in sports history, Tiger Woods crashes into a fire hydrant, unleashing a flood of tawdy revelations about his sex life

970 / **Bachelor blowup**

Do-over! *The Bachelor's* Jason Mesnick makes reality-TV history when, live on-camera, he dumps the woman he'd chosen and confesses his love for runner-up Molly Malaney. They marry in in 2010

971 / **Susan Boyle**

Jaws drop when a shy 48-year-old Scot sings "I Dreamed a Dream" on *Britain's Got Talent*. A video goes viral, and Boyle becomes, overnight, a global sensation

972 / **Letterman scandal**

A CBS news producer tries to extort $2 million; Dave calls cops, then confesses his failings on air

973 / **Jonas Brothers**

Virginal New Jersey dreamboats drive little girls wild

974

978 / "You can do anything you want in life—unless Jay Leno wants to do it too"

Conan O'Brien, after losing *The Tonight Show* to Leno, takes a swing

979 / Joran van der Sloot arrested

The suspect in Natalee Holloway's 2005 disappearance in Aruba is charged with murdering Stephany Flores Ramirez in Peru

980 / 33 Chilean miners

surface after 69 days trapped underground; world cheers

981 / "Sexual Napalm"

Rocker John Mayer recalls ex Jessica Simpson, fondly

982 / The Situation

Mike Sorrentino reigns as an abdominal showman on, and off, the reality show *Jersey Shore*, which sets numerous viewership records for MTV

974 / Justin Bieber

Tweens scream for Canadian teen, a former YouTube sensation whose videos led to him being discovered by a music exec and signed by Usher

975 / Haiti quake

A 7.0 tremor kills more than 230,000 and leaves 2 million homeless

976 / Gary Coleman

The former *Diff'rent Strokes* star dies at 42, after years of struggling with personal and financial issues

977 / BP oil spill

The largest in U.S. history, nearly 5 million gallons over 86 days, begins with a fiery explosion aboard the *Deepwater Horizon* drilling platform that kills 11

982

983 / Last American combat brigade exits Iraq, seven years and five months after U.S.-led invasion began

984 / Sandra Bullock Adopts a baby, wins an Oscar and ditches her husband, Jesse James, after he's caught cheating with a tattooed stripper. Beyond that, a quiet year

985 / Tiger Woods apologizes, in front of his mother and the world, after a sex scandal that made world headlines and eventually KO'd his marriage. "The word 'betrayal' isn't strong enough," his now ex-wife, Elin Nordegren, 30, says later. "I felt like my whole world had fallen apart"

984

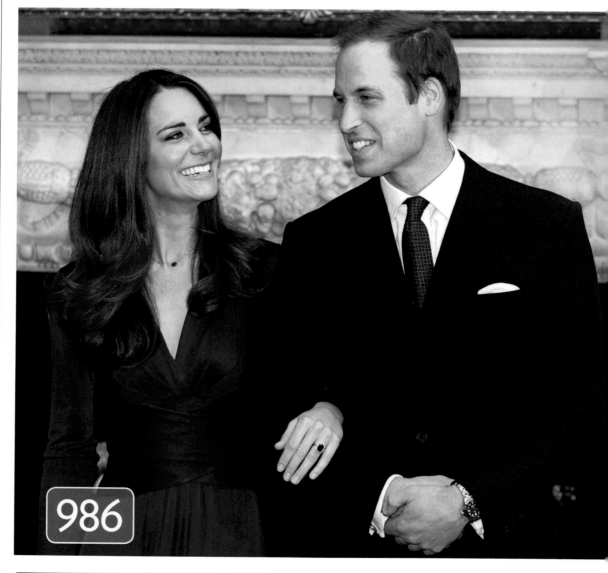

986

986 / Prince William proposes to Kate Middleton, after dating for eight years. She accepts. British nation, as one, exhales. Joining the royal family was "daunting," says Kate, but "hopefully, I'll take it in my stride"

987 / Courteney Cox and David Arquette split
He tells Howard Stern, "She told me, 'I don't wanna be your mother anymore.'" Yeouch.

988 / "You can meet Andrew"
Fergie, Duchess of York, makes a promise, on tape, after accepting $40,000 from a reporter posing as a "wealthy businessman" trying to gain access to her ex-husband, Prince Andrew

989 / "Threaten you? I'll put you in a [expletive] rose garden, you [expletive]! ... You need a [expletive] bat in the side of the head!"
Mel Gibson (according to Radaronline.com) discusses his feelings with ex-lover Oksana Grigorieva

990 / The Betty White moment
A Super Bowl Snickers ad sparks a grass-roots campaign that lands the 88-year-old comedian on *Saturday Night Live*

991 / "Love your leg warmers!"
Toy Story 3, starring Woody, Buzz and metrosexual Ken, earns $1.1 billion

991

990

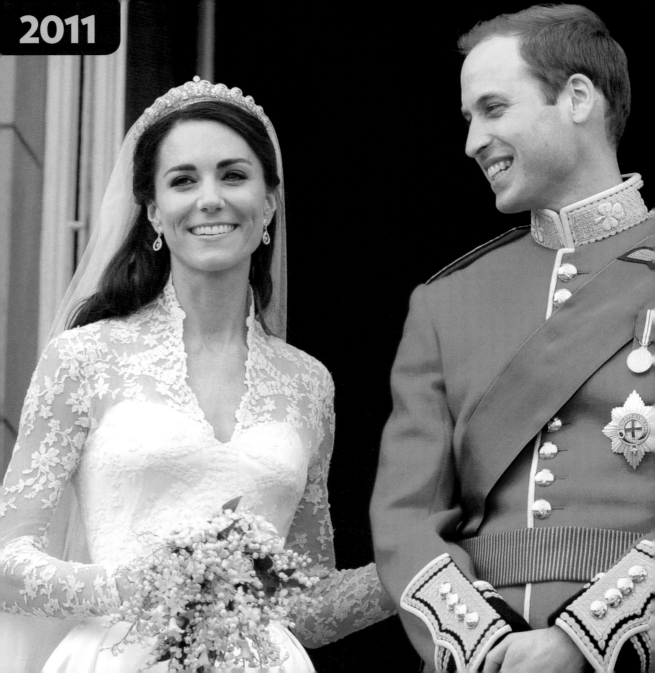

2011

992 / **Will and Kate Wed!**

Commoner Kate Middleton of Bucklebury, England, becomes the Prince's bride before 1,900 in Westminster Abbey, a million on the streets of London and an estimated two billion watching on television around the world. The happy spectacle—replete with pomp, coaches, color, a Royal Air Force flyover and a dizzying *two* public kisses—is the monarchy's, and the British Tourist Authority's, dream. But at an earlier reception, Prince Charles "could have been anybody's father and [William] anybody's son," said a guest. "Charles spoke so warmly about his small boy ... He finished up by saying how grateful he was to have such a lovely daughter now, and spoke about how much he knows she loved [William] and would support him."

993 / Gabriel Giffords, an Arizona Congresswoman, is shot in the head, and 6 are killed and 12 others wounded, by an apparently deranged gunman

994 / Arab Spring
The death of a Tunisian street vendor ignites a wildfire of popular uprisings across North Africa and the Middle East; governments teeter in Syria and Yemen, fall in Tunisia, Egypt and Libya

995 / Tragedy in Norway
Seventy-seven people, many of them teens, are killed in bombing and shooting attacks; police arrest Anders Breivik, 32, a nationalist and anti-Muslim activist

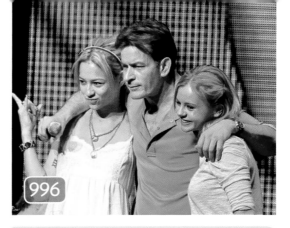

996 / "[I'm a] total freakin' rock star from Mars"
Saying he has cured himself of addictions and "woke up with a new brain," *Two and a Half Men* star Charlie Sheen claims to be a "Vatican assassin" and a "warlock" who, after perceived slights, is now at "war" with *Men* producer Chuck Lorre ("a contaminated little maggot") and CBS President Les Moonves ("part scoundrel, part my hair to the side"). Sacked, an outraged Sheen calls his firing "illegal and unconscionable"

997 / Osama Bin Laden killed
After a decade-long hunt, the 9/11 mastermind is tracked to his hiding place inside Pakistan and shot during a daring nighttime assault by Navy Seals

998 / Oprah packs it in after 25 years and 4,561 episodes

1000!
The first of some 76 million Baby Boomers turn 65 on Jan. 1, 2011

999

Elizabeth Taylor dies
The last of the Hollywood legends, she lived large, married eight times and accepted extravagant jewels as her due. Charisma? "Elizabeth looks at you with those eyes," husband No. 5 and 6, Richard Burton, once said, "and your blood churns"

Masthead

EDITOR Cutler Durkee **DESIGN DIRECTOR** Andrea Dunham **DEPUTY DESIGN DIRECTOR** Dean Markadakis **PHOTO DIRECTOR** Chris Dougherty **PHOTO EDITOR** C. Tiffany Lee-Ramos **DESIGNERS** Margarita Mayoral, Cynthia Rhett, Joan Dorney **WRITER** Steve Daly **REPORTERS** Mary Hart, Ellen Shapiro **COPY EDITOR** Will Becker **SCANNERS** Brien Foy, Stephen Pabarue **IMAGING** Francis Fitzgerald (Imaging Director), Rob Roszkowski (Imaging Manager), Romeo Cifelli, Charles Guardino (Imaging Coordinator Managers), Jeff Ingledue **SPECIAL THANKS TO** Céline Wojtala, David Barbee, Jane Bealer, Stacie Fenster, Margery Frohlinger, Ean Sheehy, Patrick Yang

TIME HOME ENTERTAINMENT PUBLISHER Richard Fraiman **GENERAL MANAGER** Steven Sandonato **EXECUTIVE DIRECTOR, MARKETING SERVICES** Carol Pittard **EXECUTIVE DIRECTOR, RETAIL & SPECIAL SALES** Tom Mifsud **EXECUTIVE DIRECTOR, NEW PRODUCT DEVELOPMENT** Peter Harper **DIRECTOR, BOOKAZINE DEVELOPMENT & MARKETING** Laura Adam **PUBLISHING DIRECTOR** Joy Butts **ASSISTANT GENERAL COUNSEL** Helen Wan **BOOK PRODUCTION MANAGER** Suzanne Janso **DESIGN & PREPRESS MANAGER** Anne-Michelle Gallero **BRAND MANAGER** Michela Wilde **ASSOCIATE BRAND MANAGER** Melissa Joy Kong **SPECIAL THANKS TO** Christine Austin, Jeremy Biloon, Glenn Buonocore, Malati Chavali, Jim Childs, Susan Chodakiewicz, Rose Cirrincione, Jacqueline Fitzgerald, Carrie Frazier, Christine Font, Lauren Hall, Malena Jones, Mona Li, Robert Marasco, Kimberly Marshall, Amy Migliaccio, Nina Mistry, Dave Rozzelle, Ilene Schreider, Adriana Tierno, Alex Voznesenskiy, Jonathan White, Vanessa Wu

Credits

CONTENTS

by Getty Images; **142** Tyler Mallory/Getty Images; **143** Mark Fix/Zuma; **144** James Fraser/Rex USA; **145** Rex USA; **146-147** Everett; **148-149** (clockwise from left) Sean Dempsey/PA Photos/Landov; Cherruault/Sipa; Rex USA; Reuters; Rex USA; **150** (from left) Toni Thorimbert/Corbis Sygma; Steve Wood/Rex USA; **151** Zuma; **152** Chris Buck/Corbis Outline; **153** Everett; **154** Jeff Haynes/AFP/Getty Images; **156** Sid Avery/MPTV; **157** (from left) ABC Photo Archives/Getty Images; BEImages; **158** Polaris; **159** Dah Len/Contour by Getty Images; **160** Hal Garb/AFP/Getty Images; **162** Joey Delvalle/NBCU Photo Bank; **163** Ron Galella/Wireimage; **164** Larry Busacca/Wireimage; **165** Bill Greenblatt/Liaison/Getty Images; **166** (from left) James K.Burns/Camera Press/Retna; Walter McBride/Retna; **167** Everett; **168-169** (from left) Everett; Photofest; Roberto Schmidt/AFP/Getty Images

2000s

170 (from left) Stewart Cook/Rex USA; Jeffrey Mayer/Wireimage; **171** Michael Sanville/Wireimage; **172** FOX; **173** CBS/Landov; **178** Brad Rickerby/Reuters; **180** AMPAS/Getty Images; **181** Mario Casilli/MPTV; **182** Kevin Mazur/Wireimage; **183** (from top) Nickelodeon; Bettmann/Corbis; **184** Stewart Volland/Retna; **186** (from left) Tobias Schwarz/Reuters; Berliner Studio/BEImages; **187** Fred Prouser/Corbis; **188** Joe Buissink; **189** (from left) Arun Nevader/Getty Images; Robert Hepler/Everett; **190** Abaca USA; **191** (from left) Craig Blackenhorn/Bravo; Scott Gries/Getty Images; **192** Mike Lawn/Rex USA; **193** (from left) Julie Jacobson/AP; Lucy Nicholson/Reuters; **194** Tsuni/Gamma; **195** Clarence S. Bull/MPTV; **196-197** Suzanne Plunkett/AP; **198** Pacific Coast News; **199** (from left) Nike; Zuma; **200** Warner Bros./AP; **201** (clockwise from top right) Frank Micelotta/Getty Images; Bebeto Matthews/AP; Photography Plus/Williamson Stealth Media Solutions/AP; **202** Tim Graham/

Getty Images; **203** (bottom) Holloway family/AP; **204** (from top) Erik S. Lesser/EPA; Scott McKiernan/Zuma; **205** Milan Ryba/Globe; **206** Paul Sancya/AP; (inset) Montgomery County Sheriff's Office/AP; **208** Animal Planet/AP; **209** 20th Century Fox; **210** (clockwise from top) LASD/Splash News; Andrew Haagen/Corbis; Kaffee-Massie/Splash News; **211** Kimberly French/Focus Features; **212** (clockwise from top) X 17(2); Pacific Coast News; **213** Alphax/X 17; **214** (from left) Frank Micelotta/Getty Images; Huy Richard Mach/St. Louis Post-Dispatch/Landov; **215** (from top) Kevin Mazur/Wireimage; Alan Kim/The Roanoke Times/AP; **216** (from left) Jennifer Graylock/AP; NY Daily News Archive/Getty Images; **217** Corbis; **218** Martin Schoeller/August; **219** (from left) Jeff Kravitz/Filmmagic; Itsuo Inouye/AP; **220** (from left) Shannon Stapleton/Reuters; John Roca/Fame; **221** John Stanton/Getty Images; **222** Deana Newcomb/Summit Entertainment; **223** (from left) Mary Ellen Mark; Dana Edelson/NBCU Photo Bank; Rick Wilking/Reuters; **224**

Chuck Kennedy/EPA; **225** (from left) Everett; Gary Hershorn/Reuters; **226** (from left) John Kennedy/Splash News; Sunset Boulevard/Corbis; **227** WETA/20th Century Fox; **228** Ebet Roberts/Redferns/Getty Images; **229** (from top) Ken Mckay/Rex USA; Andrew Redington/Getty Images; **230** (from left) Gustavo Caballero/Wireimage; Norman Scott/Startraks; **231** Peter Kramer/AP; **232** Eddie Mulholland/Rex USA; **233** (from top) Disney; Kerry Hayes/Touchstone; **234-235** (clockwise from left) UPPA/Zuma; Camera Press/Retna; Daniel Ochoa de Olza/AP; Paul Gilham/Getty Images; **236** (clockwise from top left) P. K. Weis/Southwest Photo Bank/Reuters; Ryan Turgeon/Splash News; Tara Todras-Whitehill/AP; **237** Photofest

MASTHEAD

(from top) Everett; Tasso Taraboulsi/Polaris; Disney; Chris Cuffaro-Miranda Penn Turin/Fox

BACK COVER

Kevin Mazur/Wirelmage